The
Language
of the
Land

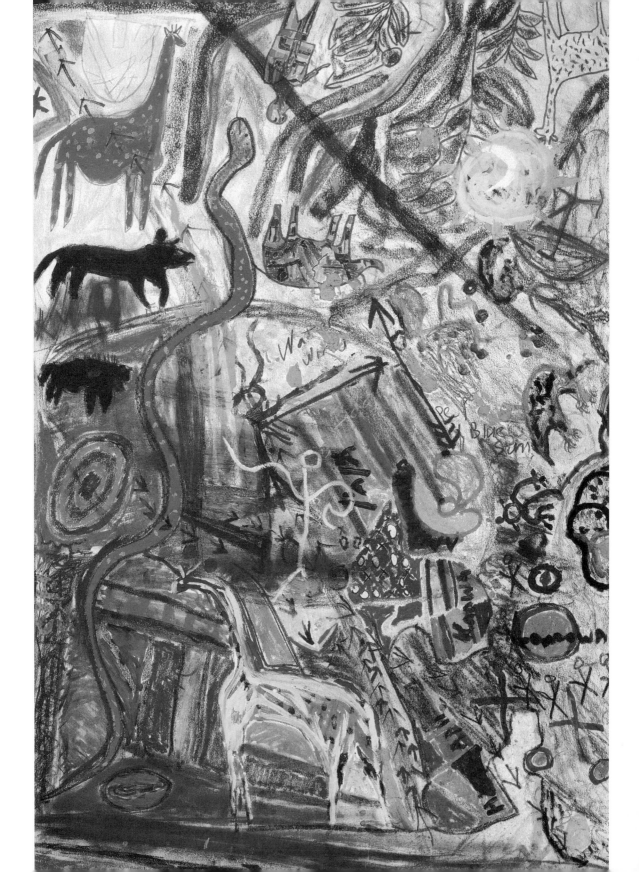

The
Language
of the
Land

LIVING AMONG THE HADZABE IN AFRICA

James Stephenson

St. Martin's Press
New York

www.stmartins.com

Library of Congress Cataloging-in-Publication Data

Stephenson, James.
The language of the land : living among the Hadzabe in Africa / James
Stephenson — 1st ed.
p. cm.
ISBN 0-312-24107-0
1. Hatsa (African people) — Social life and customs. 2. Hatsa (African people) —
Hunting. 3. Hatsa (African people) — Folklore. I. Title.

DT443.3.H37 S73 2000
967.6 — dc21 00-040263

First Edition: September 2000

10 9 8 7 6 5 4 3 2 1

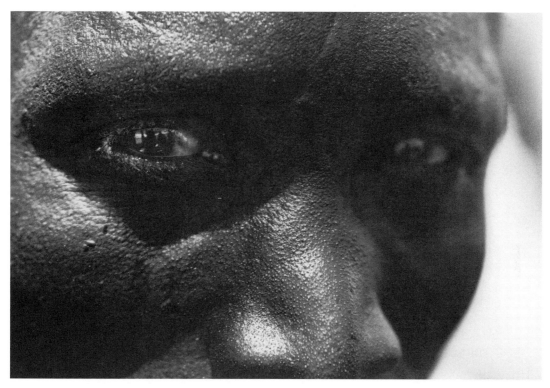

Hunter's Eyes

"All real living is meeting."
Martin Buber
I & Thou

Acknowledgments

I want to thank first and foremost the Hadzabe, in particular, Sabina, Mustaffa, Localla, Musa, Gela, Sitoti, Sapo, Salibogo, Mary, Pauola, Mzee Mateo, Janza, Giduye, Mustaffa's parents, Hamisi, and all others. The unconditional efforts of my mother, father, and sister sustained me. I sincerely thank Joe Deasy, whose efforts continually inspired me; he was always willing and ready to proof the manuscript. Grateful appreciation is due to Michael Denneny, my editor, whose enthusiasm and efforts were invaluable. Thanks also to Emerson Skeens for his friendship and hospitality, John Levi, Martin di Martino, my managers, Mike Warlow and Danny Simmons, Akiko Konishi, who printed the majority of photographs, Matthew Yeoman, Christina Prestia, Johannes and Lena Kleppe, whose doors were always open when I was in need, David Bygott and Jeannette Hanby, Dr. Kan, Linquist Design, Evelyn Hurtado, Adam Levin, Tom Green, Peter Jones for giving me the opportunity to come to Tanzania, Eric Brenner, Steve and Cathy at the Outpost Hotel, Annette Martin and her crew, the Tanzanian government, the District Commissioner of Karatu, the Katibu of Mang'ola, the lovely people of Tanzania, and all my friends who supported and inspired me while I was involved with this project.

Contents

Preface

The whole world is in the moon of one's fingers," a Mang'ati witch doctor had said to me the day I left Tanzania the previous year. "Beware of the fingers. You must learn to read fingers," he concluded. I was thinking about what this meant as the open night air engulfed the passengers stepping out of the airplane and walking down the steps to the tarmac at the Kilimanjaro airport. The familiar scent of burning acacia wood was in the air from the evening cooking fires of small households. It was good to be back in Tanzania. I was experiencing the exalted freedom that arises when you are partaking in a journey greater than yourself, a journey that has chosen you — at least that is how I felt, looking at the stars as I walked toward the customs office. After seven months of hauling trees up stairways, through elevator shafts, arguing with doormen, I was happy to be finished with terrace gardening in New York City for the season — it's the small business that allows me to support myself.

I had finally arranged to be free of all previous obligations and debts in order to live with the Hadzabe for nine months. I had absolutely no attachments and was chasing after a dream. The year was 1997 and I was twenty-seven years old.

I had first heard of the Hadzabe on a small island named Chole, in the Mafia Archipelago, about fifteen miles off the central Tanzanian coast where the Rifiji River empties out into the Indian Ocean. It was August 1994. I was sitting under a mangrove pergola covered in passion fruit, morning glory, and clematis vines, listening to the distant thundering sound of giant manta rays pounding their bodies on the quiet sea surface. I was working for a hotelier, Emerson Skeens, building gardens for his small hotel project on Chole Island. He and I were drinking the milk of *madafu* (baby coconut). My sister had introduced me to Emerson in a restaurant in New York City, but she had originally met him in Zanzibar, where he runs several hotels and where she had gone on a photo shoot for *Harper's Bazaar* magazine. The night she called me up to have dinner with

Emerson and her, I had no idea he would offer me the opportunity to return to Africa. Emerson is one of the few men I know who possesses a magical charm. He is a complex character who reminds me of Lord Henry in Oscar Wilde's *The Picture of Dorian Gray*, Freddie Mercury of Queen, and a Virginian grande madame of unrelenting southern gentility. The moonlight was fantastic. We sat surrounded by ruins that were once the homes of rich Arab and Indian merchants who had lived on Chole when it was a small and thriving island where, for over a thousand years, traders had come from the far east and west. At moments an uncanny nightmarish feeling seemed to emanate from these ruins. Possibly this was due to the horror experienced by the residents when the Sakalava warriors paddled up from Madagascar in a flotilla of war canoes and ate everyone in the early nineteenth century.

Emerson poured a little whiskey into the *madafu*. I asked him who were the most interesting people he had come across in his twenty years in Africa.

"The Hadzabe," he said, after taking a few minutes to think about the question.

"Who are the Hadzabe?"

"A hunter-gatherer group living around Lake Eyasi, southwest of the Ngorongoro Crater. Sweet innocent lovelies, the last of the old people."

"They're not so far from here?" I asked.

"No," he answered leaning back, taking a drag off his Benson & Hedges.

Emerson finished his whiskey and listened to the mangrove forest, as he always did on the island before going to bed. He commented on how the large fruit bats were returning from eating bananas on the plantations across the bay.

Three weeks later, while digging a hole for an orange tree sapling, my pickax skipped off a rock and hit me in the shin. That night I was hallucinating with fever. A rare streptococcus attacked my wound and ate down to the bone within five hours. I spent two horrible nights on the island before an emergency medical plane flew me to a hospital in Zanzibar. While caught in the claws of the fever, I had a recurring dream that was my only solace during the whole ordeal.

In the dream, I was wandering down a path alone, thirsty, searching for water, lost. The heat of the sun was unbearable. Flies were swarming around my head and feet. I was stumbling, trying to find my way to somewhere, when I saw an old man carrying a bow and arrows walking down the path toward me. He stopped in front of me and said a few sharp words to the flies — they quickly disappeared. Then he waved his hand over my head and turned into a tree — an ancient tree with dense overhanging branches. I leaned my back onto the knotted tree trunk and rested in its shade. The wind and the leaves

began speaking to me, and just as I was about to wake I realized the wind was the old man's voice. I was crying when I woke, but I could not recall the meaning of the old man's words.

After the two weeks it took to recover from the fever, I experienced an incredibly strong urge to go see the Hadzabe.

"I must go see them, Emerson. I can't go back to work on the gardens right now."

"Go. It will be good for you," he said, giving me directions.

I flew from Zanzibar to Arusha. Arusha is one of the bigger cities in Tanzania, and unfortunately, it is plagued by commercial safari companies. I had worked in Arusha for a safari company a few years prior to building gardens on Chole Island. I had also worked down in southern Tanzania near the Mozambique border as a construction supervisor. These experiences had led to my *mal Afrique,* the need to return to Africa.

In Arusha, I arranged to take a bus north to a small town named Karatu, and finally to an even smaller town on the edge of the vast bush named Mang'ola. In Mang'ola, I made my way to a campsite in an oasis where Hadzabe were known to come for water. The next morning, two little boys, named Palanjo and Hamisi, walked into my camp with dead birds tied to their bodies, their legs covered with dry mud. They were wearing tattered shorts. I asked them if they knew where I could find the Hadzabe.

"We are Hadzabe," said Hamisi with a big smile on his face. Hamisi was around ten years old and Palanjo six. Hamisi knew Kiswahili, which allowed me to communicate with him. In fact, the whole time I have spent with the Hadzabe, Kiswahili has been our means of linguistic communication — though later there were many other forms. At the time, I had a basic knowledge of the language from working on Chole Island. Over the years my Kiswahili has improved, and I now know a small measure of Hadza language as well.

Within a half an hour of meeting the boys, they invited me to follow them into the oasis forest to hunt birds. They shot a few more lovely blue birds, and then quickly made a fire, threw the dead birds into the flames and, a few minutes later, ate them.

While the boys were eating the birds, monkeys ran by. The boys quickly grabbed their bows and arrows and went chasing after the monkeys into the dense vegetation. For some time I sat in the forest nervously waiting for them to return. There was no possibility of finding my way back. I was relieved to see them coming back, and empty-handed.

We spent the hot afternoon swimming in a water hole surrounded by immense stalks of papyrus that grew in the oasis.

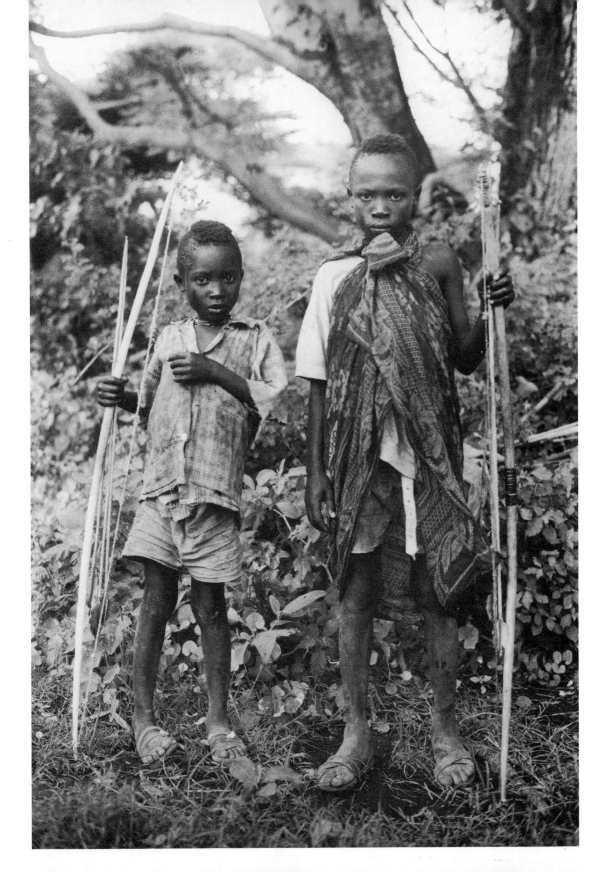

"Are you sure there are no crocodiles here, Hamisi?" I asked before jumping into the refreshing water.

"Yes. If there were, we would not swim here," he said confidently.

At the end of the day, the boys insisted I come home with them. They took me to a Hadza camp about five kilometers outside of town. We arrived at dusk. The people immediately seemed wary of my presence and kept their distance. I felt very uncomfortable and wished I had not come One hunter seemed to stare at me with a great anger. Hamisi led me to a campfire surrounded by several old men. Suddenly I found myself in the midst of an argument. The older men were not happy that the younger boys had brought me to the camp. Then the young man with the angry stare came over and, without looking at me, convinced the old men to let me stay. After he spoke, the old men started patting me on the back, saying, "*Karibu* [welcome], *karibu.*" The young man's name was Sabina.

"You can sleep in my home," he said. "Come, follow me."

There were around ten circular huts made of grasses and sticks. Hamisi and Palanjo would not leave my side. Sabina led us to his fire, and we sat down. Night had come. A beautiful young woman, who appeared to be Sabina's wife, handed me some meat. Sabina motioned for me to place the meat on the burning coals of the fire. Hamisi and Palanjo threw their few remaining birds into the fire to sizzle off the feathers. They had together eaten about fifteen birds since I had met them that morning.

For an hour or so we sat by the fire eating the buffalo meat. Sabina and his wife went about their business as if nothing had changed. I started telling Hamisi and Palanjo fishermen stories of giant man-eating sharks and killer sea demons. Soon I found many men by the fire listening to these stories roughly translated into Kiswahili. A few men told their own hunting stories also in broken Kiswahili for a minute, before unleashing a flood of Hadza language.

By the fire, the hunters talked to each other as if I weren't present. At times I caught someone staring curiously at me, but he would immediately turn away. The hunters' body language and way of communicating was absolutely captivating. They were keen imitators of animal sounds and excellent actors. They would lift themselves from the fireside and walk like lions or giraffe; others fell to the ground acting out the physical struggle of a dying baboon. I felt transported to an earlier time, listening to their stories, watching the firelight accentuate their vivid expressions, and later came to understand the importance of exaggeration, enriching the actual experience, to create a more universal truth for the listening party; which I find is the brilliance of an oral history — it is not solidified in time and space. It embodies continuous change, improvisation, growth.

Palanjo and Hamisi

In the middle of the night I woke, extremely cold. Hamisi, Palanjo, and a few young hunters were snuggled up next to me, and they had managed to take over my large blanket. I reclaimed a portion of the blanket and fell back asleep.

The next morning I asked the men if we could go on a safari (trip). They said they would take me along with them to find honey in a place called Mongo wa Mono. All I needed was some salt, *ugali* (cornmeal), and a blanket. They provided me with a bow and arrows.

"How long will we go for?" I asked.

"As long as you want. We go to find honey. You will like the honey," said Sabina.

After two months living with the Hadzabe, I returned to Chole Island feeling mentally and physically stronger than I had ever felt in my whole life. During the nights we slept by the fire and from dawn till dusk we walked miles searching for honey and animals to hunt. I lived as they did, lost fifteen pounds, and was absolutely enchanted by their culture and lifestyle.

Over the next three years I continued to visit the Hadzabe, spending months at a time in the bush between gardening jobs. I established a strong relationship with five hunters and their families — Mustaffa, Sabina, Sitoti, Localla, Sapo — and was friendly with many others. But at the time, I thought I knew much more about the Hadza culture and way of life than I really did.

Who are the Hadzabe? They are, perhaps, the last hunter-gatherers living a traditional life in Africa. They still make fire with sticks, carve their own weapons, and hunt for their food. They speak a click language similar to the Khosian language spoken by the bushmen of the Kalahari. They cure ailments with a knowledge of natural medicines passed down through the centuries.

The Hadzabe live in the Lake Eyasi region of Tanzania bordering the Ngorongoro Conservation Area. This region is not too far from the Laetoli Valley — where anthropologist Mary Leakey discovered the hominid footprints in 1978. It is possible the Hadzabe and their ancestors have hunted and gathered in the different natural environments surrounding Lake Eyasi since the dawn of human consciousness. It can also be argued that they possess an unbroken lineage of tribal awareness, a direct genetic path leading back to the first *Homo sapien* mother. Some experts say there are two hundred Hadza left, others say there are almost two thousand. There are many different local names for the Hadza: Hatza, Hadzapi, Kindiga, Tindiga, Wakindiga, Kangeju.

Ba-lan-ge-ta[1] is the Hadzabe name for Lake Eyasi. It is the fifth-largest lake in Tanzania, stretching over a thousand square miles. Locals call it a "dead" lake, because the waters are undrinkable due to the high concentration of salt. The Hadzabe live in the foothills, savannas, and oases surrounding this lake, a large unprotected area of wilderness that is near the Serengeti. The lake itself is hauntingly beautiful, and the land around is no different. At times you may be fifty miles west of the lake, but you always feel its presence. All the small riverbeds run to its basin. And the lake is often mentioned in the Hadza's stories.

In this book I have tried to communicate to the reader the perception and lifestyle of the Hadzabe, but only through my experience, which of course is limited. The stories mostly

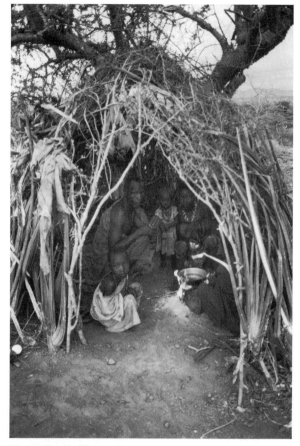

Hadza Family Hut

encompass the last nine months I lived with the Hadzabe in 1997, because that was when I made the leap, giving up all obligations and "responsibilities" to be with them. The progression of the chapters is meant to lead the reader deeper into their world. I found that actual experience, for a Hadzabe storyteller, is not always true experience, and that the role of the storyteller is to create the greater story. "Fiction" and "nonfiction" are so intricately woven together that it is impossible to separate the two, and there is no need, because one is told what one wants or is meant to hear.

[1]The Hadzabe language in this book is in bold and italicized, the Kiswahili is italicized. The phonetic spelling of the Hadza words are written as I heard them. There are many different ways to spell various Hadza words, as there are many different names for the Hadzabe. A phonetic spelling of the language has been developed through the work of professionals such as James Woodburn, Bonny Sands, Jeannette Hanby, and Gudo Mahiya. The Hadzabe language and all other information in this book is based on immediate experience.

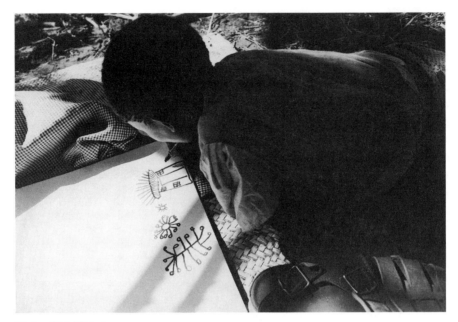

Hadza Child Painting

I think initially the two most important tools of communication I had were the sharing of my dreams and painting. Only when I started to tell the Hadzabe about my sleeping dreams did they start to fully express their knowledge of dreams to me. A level of comfort was established; they seemed to believe me and trusted that I believed them, which finally allowed us to become friends and equals. The dreams I told them related to their world. I kept having dreams of old hunters sharing their knowledge of the land. The Hadzabe were intrigued why I had such dreams. They immediately interpreted them, concluding that their ancestors were teaching me in my dreams to give me strength to live with them.

I always took art supplies into the bush. The first day I pulled out my canvas and started to paint, the Hadza became so excited that they demanded to join me. They became so focused that they would lose themselves in the act of painting. When an individual or group finished painting, everyone at camp gathered around to look at the work. The artist or artists would elaborate with dramatic skill the experience of a past hunt as if they had just lived it, pointing out the references marked on the paper. There was no top or bottom to these paintings, they drew-painted freely around the canvas.

"Here is the giant snake that ate my mother," one young woman explained. "This is the path I took to find her. I saw two lions by this tree and heard demons near the giant snake's hole; I then knew my mother was dead."

They would examine my images and explain in detail the significance of what I had drawn. When I painted with the men, the experience was very similar to hunting. Everyone worked together. There was a communication occurring beyond words, similar to the silent reliance they have on each other while hunting most animals. The painting also allowed me to spend time and share stories with the women on a level I would not have experienced otherwise. After painting with someone, we both felt more comfortable with the other. The painting was a means to transcend initial preconceptions and cultural barriers. The unconditional visual expression brought us together.

All the Hadzabe enjoyed the painting, as they might enjoy making their arrows or beads. When an individual finished a painting, he or she always made sure everyone was around to hear the story of the painting. Once the story was shared, the artist and the listeners were done with the painting, wanting nothing to do with it.

Often the Hadza would share their stories as they painted; for example, Sitoti would start breathing heavily, leaping, and imitating animal sounds. The others would stop and listen to him, cheer him on, or ask questions. The canvas painting would always lead to arrow painting, shirt painting, toe painting, finger painting, shoe painting, and face painting. The creativity grew upon itself, it became a way to pass time, a form of communication, a means of pleasure, a language for both the individual and the group.

The Hadza world is continually being reinterpreted and invented through their magnificent capacity for imagination in the stories they create as much as retell around the fire or around the painting area.

Sitting and listening to these Hadza stories, I frequently thought about the Mang'ati witch doctor's comment that the "whole world is in the moon of one's fingers." I noticed my fingers were usually covered in paint, dirt, or blood. The ambiguous complexities of the shaman's words are at times difficult to understand, but can be essential. The same witch doctor later exclaimed, "Listen to the land. Do you hear the murmur of the coming rain?" I hadn't yet learned to listen, but Sabina heard and found us shelter.

1

Arrival

In the windy late afternoon, I walked up the hill to Sitoti's bird-nest home after the long trip from Arusha. He was sitting by the fire, smoking his pipe while carving an arrow. He looked me in the eye and then, returning his attention to his arrow, he started to speak.

"*Nilikuwa na ndoto ya mkono wako Jana usiku.* I dreamt of your hand, and the blue giraffe. Today I sat next to my home and could not leave. Many times I wanted to hunt monkeys, but my legs would not follow my wishes, now I know why. It is good that you have come. I am the only one here, the other men have gone hunting. And the women and children are gathering food. You can stay until they return. Did you bring your colors?"

"*Ndiyo,* yes, Sitoti."

That night I slept under a tamarind tree in the sphere of Sitoti's silence. I dreamt of howling red winds pursuing a walking leopard. Tormented clouds ripped open and thunder rain poured across the earth. The smell of rotting hippo flesh hung heavy in the dream air. I heard baboon screams and the hunter's feet hitting the parched lake bed. A face rose from a whistling thorn tree, an ancestor spirit. He handed me three sepia-colored sprigs, branches that looked like herbs.

"What are these sprigs for?" I asked him. He looked up at me and smiled.

"This is medicine to run fast," he said. He then transformed into a zebra and galloped off into the savanna grass.

When I awoke, Sitoti was sitting, smoking his stone pipe in the rising dawn. He was staring into the fire. Always awake before me, before the dawn, he had pulled the feathers off a *di-dee-dee* bird for the ends of his arrows. I told him the dream. He listened and was quiet for some time before responding. He dropped the featherless bird onto the hot coals.

"*Wewe umeota mbabu wa zamani Zamani.* You dream of ancestors. They

showed you medicine to run fast, to run like *se-sa-may-a* [lion]. I don't know about such dreams. But my father said if you dreamt of a leopard, you would kill a wildebeest in the morning. My uncle dreamt that his friend Nakomako was bitten by a snake. In the morning he told his friend Nakomako not to move until he retrieved some snake medicine. When my father returned to his friend's camp, Nakomako was dead from a snake bite. He did not listen to my uncle's dream. One should listen to dreams. We will tell your dream to the others when they come."

After eating the toasted bird, we started drinking *pombe kale,* a moonshine the Mbulu tribesmen make illegally from boiling sugar water in giant petrol cans. I call it the "Hadza peril," because many of the hunters have become incurable alcoholics. We spent the day sitting on Sitoti's hilltop looking down into the Swahili village, passing the glass Safari Lager bottle used for the *pombe.* Sitoti drank with both hands, taking in monstrous gulps. The *pombe* began loosening him up. Whenever he drank the moonshine, he indulged in huge exaggerated stories; otherwise he didn't talk much.

He told me he saw everything from his camp on the hill. He had chosen it for that purpose. And the good thing was, no one could see him. His camp was hidden by a few acacia trees that shaded it from the afternoon sun, and his hut was made of sharp sisal stalks and whistling thorn branches. He could scout the area below. If a person was coming up the hill to kill him or if it was someone he didn't like, he would vanish. He pointed to the tree he hid behind. Sitoti was a little paranoid, always thinking that someone was going to kill him. He was afraid his wife had *jujued* (witched) him.

"*Nikaona yote.* I have seen everything from here," he said smiling.

Sitoti had an older wife and three children. Some of the other hunters claimed Sitoti's wife was his sister.

"He claims he is still paying off the bridal price to his father," explained Mustaffa the previous year. His father said, "If you want to marry your sister, you must bring me three lions, ten baboon, six buffalo, two baby elephant, one rhino, fourteen waterbuck, and seven zebra. Plus a year's worth of honey by the time the full moon returns!"

Sitoti was never able to fulfill this impossible bridal price. But then again, maybe he wasn't married to his sister — although they looked a lot alike.

Sitoti's wife had a terrible temper. She was always shouting at him. One afternoon the previous year, while she was boiling monkey brains, she had confided to me that he often ran off for weeks at a time with younger women. "*Sitoti mbaya sana, sana!* He is very bad, very bad," she said, becoming more and more infuriated. "He takes girls hunting with Mustaffa. Mustaffa is a bad man. While they hunt, the younger women search for roots and berries. When

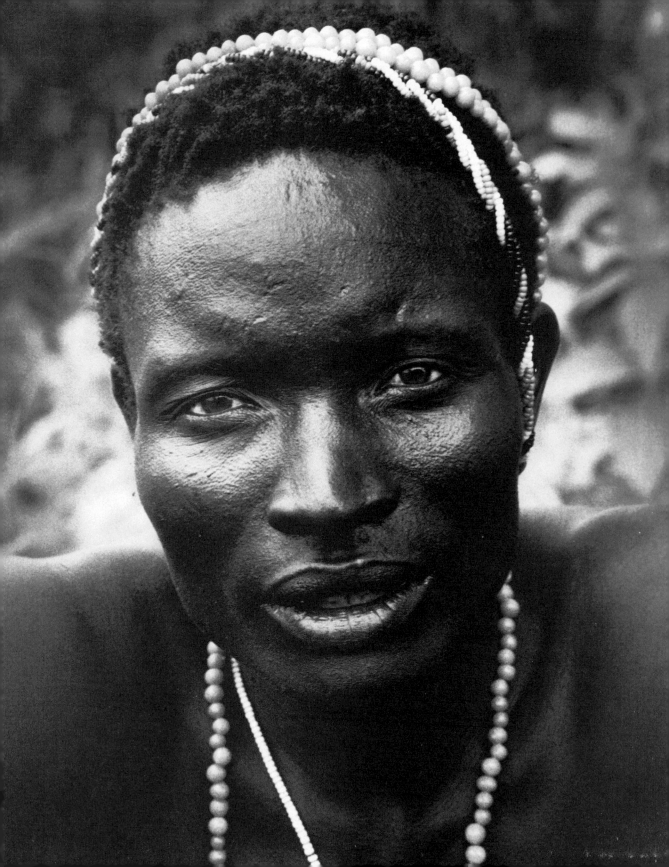

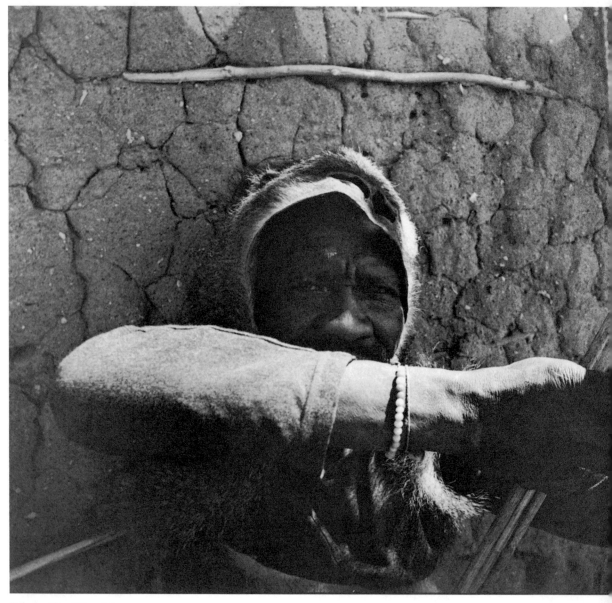

Baboon Hat, Mzee Mateo

the men return with meat they dance with the young women, sing, and eat under a shade tree. When their stomachs are full they make love while my children and I are hungry. They hide themselves so I cannot find them. After three days when he is full of *jiggi* [sex] and meat, he returns. Sitoti and Mustaffa are bad men, *wabaya sana*," she shouted, the other women in the camp agreeing with her.

There were so many stories flying around about Sitoti, I didn't know what to believe. He was the butt of the other hunters' jokes because of his angry outbursts that kept them laughing for hours. There was no one as exciting as Sitoti when he unleashed his explosive energy. This energy usually possessed Sitoti for two or three hours during a day, coming on at different times. If this surge of energy hit Sitoti while he was making arrows, he would produce ten arrows in an hour, while it would take someone like Localla three days to make the same amount. His arrows would be detailed with carved inscriptions — dancing spirit figures leaping on the backs of animals, animals he believed he would kill with that arrow.

If the hunters joked with Sitoti in one of his "energy" hours, he countered with foul diatribes, his whole being absorbed in what he said. His words literally led him up trees, sometimes to the highest branches, from where he cursed the hunters sitting below. Or, if he got really angry, he would violently wrestle with his bow in order to demonstrate what he would do to the poor soul who made the joke.

Sitoti carefully packed some tobacco into his stone pipe and pointed to the returning hunters coming up the hill in the distant mirage heat of late afternoon. I was immensely taken by what I saw. It was one of those moments when the visual impression transforms your inner perception; memories of other lives you did not know existed until that moment rise to the surface.

The hunters approached through dry gusts of dusty wind, wearing baboon-face skins as masks and baboon-body skins over their backs, carrying the dead baboons on knife-shaved bow sticks; archetypal deities approaching from another time, singing, otherworldly. The unison of their walk revealed a balance only achieved among hunters after days of hunting together. All their senses and energies were synchronized to each other. Their stern faces resembled trees. Everything about them was in harmony.

Sitoti clapped his hands in wild excitement as they arrived at the edge of his camp. He began shouting, "*Nyama, nyama,* meat, meat." He leapt up and ran to help Sapo and Mustaffa unload.

Warm smiles came over the hunters' faces as they washed their hands.

"*Itl'ik-wa ta,* Jemsi, how are you?" they asked in Hadzabe. *Jemsi* was their pronunciation of my first name.

The hunters embodied that ancient joy of bringing food back to the hearth after a successful hunt, which meant there would be a fantastic night of dancing. Mustaffa, Sapo, Memela, and Mzee (old man) Mateo set their bows down, greeted me, passed out tobacco, and talked profusely about the hunt while Sitoti cleaned and cut the meat for drying and cooking. These were hunters I had known for several years. The eating commenced as soon as the men sat to rest by the fire.

Sapo noticed that I was looking at his hands covered in baboon meat oil. He lifted his right hand, holding his knife, toward the fire, chewing on a baboon heart.

"Baboon *mafuta* [oil] is good for *jiggi-jiggi* [aphrodisiac], Jemsi. *Safi sana,* Jemsi, it is very good, it kills malaria. Do you want some meat to kill malaria?" he said laughing.

"I bet the oil is good for *jiggi,* but you use it with your hand," I replied.

"*Siyokweli,* this not true. I don't use it with my hand, but Sitoti does. Sitoti, is baboon oil good for *jiggi* with the hand?" laughed Sapo.

"*Hapana,* no!" answered Sitoti. "If you eat baboon meat you don't get *ukimwi* [AIDS]," said Sitoti, who had paused from his work and excitedly begun sucking the marrow out of a baboon shin bone.

"*Siyokweli,* this is not true. Who told you that?" I asked.

"*Kweli,* it is true. The doctor told me. I gave baboon meat to a friend with *ukimwi* and he walked three days back to Lake Victoria," continued Sitoti, eating with more enthusiasm.

"*Siyokweli,* he is *chizi* [crazy]. Don't listen to him, Jemsi, Sitoti has *shetani* [demon] in his chest. One moment he is OK and the next he's crazy. He tried to kill his wife yesterday," said Mzee Mateo.

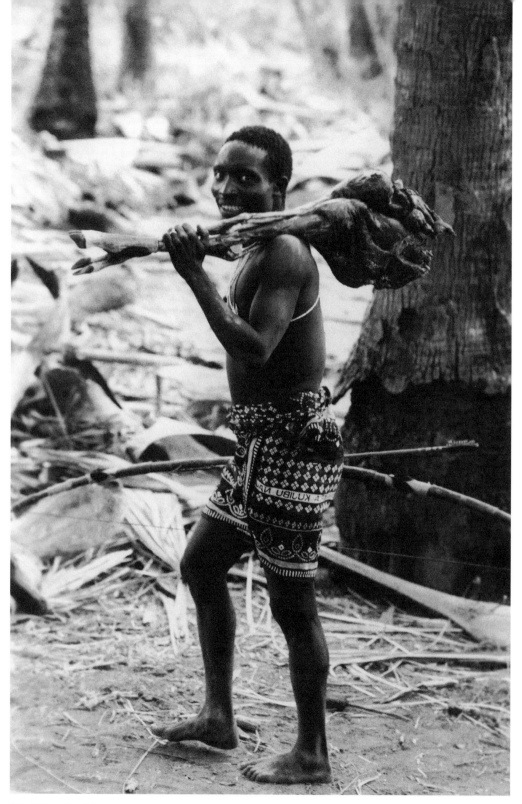

Sitoti Carrying Meat

"It's true, Jemsi, she has *jujued* me, I need medicine, crazy comes," said Sitoti, cracking the thick shin bone on a rock to find more marrow.

"Mzee Mateo, where did you get the *pombe*?" I asked.

"I told the Swahili the baboon meat was *swala* [impala]. So Mzee Juma gave me *pombe* in exchange for some meat," he said laughing. The Swahili would never eat baboon meat; they are always calling the Hadzabe "baboon eaters."

While eating, I told the men about my dreams. They listened, chewing. Occasionally they commented quietly to each other. Sapo said if one dreams of a snake, one has a child coming. He then elaborated on the demon snakes that live in the oasis. "If you see the big snake, you run and never look back, even if it is in a dream."

"How big is the snake?" I asked.

"Its belly is bigger than this tree."

"Jemsi, it is good that you have returned, because the *shetani* would have made you crazy, you saw too much last year. We have medicine, we will help your dreams now," said Sapo.

"We are sorry that our *shetani* have come to your dreams. *Leo usiku ngoma*, Jemsi, tonight we will talk with our ancestors. They will tell us why you dream of red wind and leopard; why you dream your dreams. The ancestors will tell the old people what medicine you must wear to make *shetani* leave you," said Mzee Mateo, starting a song. He sang for some time, eyes half-closed while chewing on his meat.

"What are you singing, Mzee Mateo?" I asked. He stopped chewing and looked up at me, grinning, taking another swig of *pombe*.

"I sing that the mother is the sun and she cannot find her children, the stars. But as the mother leaves, tired and sad, she sees the father, the moon, returning with her children, the stars. The mother is happy again," he said, smiling. He then pointed to the setting sun. "The day is hot and there is a big cloud near the sun as it leaves the sky. *Jua* [sun] is yellow, someone has been born," he expounded, returning to his song.

Soon all the men were singing, passing the *pombe*. The Hadzabe song always travels from one to another, and the men will either listen in a meditative state or join in. This was a slow after-dinner song. But it grew as their songs often do. Sitoti started breathing hard to add a heightened beat and Mustaffa jumped up, reacting to Sitoti's breath, dancing to the beat, sucking the marrow out of a rib bone. He threw the bone to the side, shouting:

"*Tu-ta-on-gea na wa-zee, tu-ta-on-gea, tu-ta-on-gea na wa-zee, tu-ta-on-gea, stu, stu, stu, tu-ta-on-gea na wazee, tu-ta-on-gea stu stu.*"

Mustaffa kept dancing while motioning me to join.

"Jemsi, we sing that we will talk with the ancestors. We will talk with the ancestors who will chase the *shetani* away. You can walk anywhere in the bush and be protected. No snake will bite you and lions will run from your walk."

Soon the women came to Sitoti's camp, followed by their children carrying roots and berries gathered during the day. The women heard the singing and knew the men had returned from the hunt with meat. They started shouting and laughing, surprised at my presence but happy to see the *pombe* and meat. They sat with the men by the fire, biting into strips of meat and handing small chewed bits to the youngest children. The men also sliced bits of meat for the children. The children were laughing, crying, and dancing. Many women were shouting for the men's knives; other women were silent, breast-feeding, smiling at the laughter. The song grew louder as Mustaffa and Sitoti continued their beat between swigs of the *pombe*. Children were sitting with their fathers, or climbing on their fathers' backs. Little boys, happy to see their fathers, watched them eat, watched the men move as they rolled and packed their tobacco. Many elderly people had entered the camp like slow wakes in still water and were now eating, sitting comfortably on dried *swala* skins, chewing slowly or just smoking tobacco and talking quietly. A little girl wobbled over and offered me some crushed orange **un-du-she-bee** berries from her open palm. Curious, she started to play with my hair while sucking her thumb, then she sat on my lap and fell asleep, her tummy full. The song grew louder as Mustaffa and Sitoti continued their beat between swigs of *pombe*. Mzee Mateo and some others left to prepare the dance.

Mustaffa, Sabina, and Sitoti led me through the darkness toward a fire in the far distance. There was no moon in the sky — "A good time to talk with the ancestors," they explained as we walked.

"Why?" I asked.

"*Leo usiku* [tonight], there is no diamond in the sky. The ancestors do not like the moon."

We entered Mzee Mateo's camp near a large rising rock called *Soni*. There were many Hadza living here. In the early mornings, looking out from the rock top, one can see for miles in all directions. The ancestors used this rock to hunt the big game when animals were plentiful in the Mang'ola area. Twenty or so upside-down bird-nest huts were glowing in the undulating firelight positioned around the southwest face of *Soni*. Mzee Mateo came running up and grabbed my hand, quickly leading me to the largest of the outdoor fires, where a group of old men sat.

"It is good you have come, we are waiting," he said, sitting me on a

tandala skin that smelled of fermented urine. He turned and disappeared into the night, his voice rising and falling amongst the others. I watched a scorpion attempting to find his way off a burning log in the fire. A few minutes later Mzee Mateo came running back with ostrich feathers in his hand. He held the feathers up into the star light as the women disappeared behind a cluster of growing sisal, having already sent the children to sleep in the huts. He then blew spit into the feathers, passing the feathers around my feet and hands, around my chest and waist. He brushed the feathers around his body. He leaned toward me and spit in my ears, shouting to the ancestors, taking the cigarette from my mouth, inhaling, giving it back. The women began singing from their hidden place. Mzee Mateo then lifted his head to the night, reaching to some shamanistic vision echoing down from the stars to the core of his being. The structure of his face seemed to change to many faces as he tied the feathers around his head. Then for a moment he stood in calm silence, listening. He slowly reached down and grabbed Mustaffa's blanket, wrapping it around his shoulders. He pulled strings of bells from his shoulder bag and quickly tied them around his ankles, falling over while grabbing the *pombe* bottle and taking a swig. He leapt up and spit in my crotch, while the women sang.

"We talk with the ancestors tonight, no moon in the sky. Tonight we talk with the ancestors," Mzee Mateo said, laughing, staring into my eyes. Then a seriousness overcame him. He lifted his head from my gaze, falling silent, listening to the beat building within the silences of his mind. All the men stopped talking and became transfixed by his figure. His feet started to pound the earth with uncanny power for an old man, as if he were trying to wake the dead from their long sleep.

The sound of his ankle bells rose to the stars on the high plateau. And the starlight in the darkness created illusions with the dancing feathered figure. Mzee Mateo moved with a floating ethereal presence, vanishing into the invisible night circle, whistling to the answering women. Mustaffa, Sabina, and Sitoti sat close to me. Mustaffa leaned over to my ear:

"He talks with ancestors, now your dreams will be peaceful. The children are not allowed to partake in such a dance. For two nights we will dance, then you can walk everywhere, and no harm will come."

Sindiko, a hunter I had gone on many safaris with, came running up out of the darkness and sat on Mustaffa's lap. He looked briefly at Mzee Mateo dancing, then started shaking my hand frantically, ripping the bottle from Mustaffa's lips.

"Just you and I go on safari, these other men are bad," whispered Sindiko. Mustaffa heard this and pushed him to the ground, telling him to

leave, that he was *pombe*-talking. Mzee Mateo returned to the firelight, breathing hard. He took another swig of the *pombe*, inhaled from my cigarette, and smiled with his *pombe*-rotted teeth. Sabina got up and took off the feathers from Mzee Mateo's head and put them on his own head, taking on the role of the dancer. Sindiko grabbed Sabina and demanded to dance next. Sabina pushed him aside, "*Badaye*, later."

Slowly, the dance came into Sabina, and all the men grew quiet; even Sindiko was taken by Sabina's energy, unable to lift the bottle to his lips. Sabina's right foot hit the ground with force. He let out a primal shuddering cry, quickly answered by the hidden women. He bent his head down, curling inward like a bow string in slow motion, absorbing its own release. He entered the dance space by circling slowly, building his power, gaining momentum with each pound of the foot. He lifted upward, whistling loudly. The women came running into the dance space, circling around Sabina's slow, circular dance movements, answering his whistling. And as he lifted his face, releasing his sight into the moonless shadow of ancestor time, the women seemed to hold his movement, allowing his energy to enter them before slowly dancing back to their hidden place. His dance appeared to take on its own consciousness, independent of his mind, harvesting some ancient energy from the ancestors and from the land. He looked like grasses and tree limbs in the night breeze. His postures mimicked his environment, and those watching seemed to understand what he heard from the dead, the message from the ancestors.

The dance slowly passed into a dream, and when I woke, I was twenty feet up in a yellow fever tree, shivering with cold. I tried to recognize where I was, but nothing looked familiar in the night, neither the hills nor the trees. I heard something at the base of the tree. Hyena, *fisi*, growling, sniffing. *Was I hallucinating?*

I wasn't hallucinating.

I could feel the cold bark against my bare back. I reached down to a wet, bloody pain in my shin and pulled out a long acacia thorn. The damn *pombe*. *Did I have a blackout?*

"Fuck!"

I shouted for some time; shouted to the Hadza for help. They did not answer. I thought how I had no reference point, wearing only shorts to remind me of where I came from. *This was the beginning, wasn't it? This is what I wanted. For a pocket in time I had the opportunity to reexamine and let go of everything.*

I felt the cold again and could hear every sound clearly. The hyena was no longer breathing at the base of the tree. I drifted in and out of consciousness, my thoughts and dreams running together.

"*Bocho* [come], *bocho. Bocho, bocho.*"

Half-awake, I leaned from the cold tree limb, shivering slightly. There was an old man with only a small skin covering his middle section waving me down from the tree.

"*Bocho,*" he said.

"*Wapi fisi,* where is the hyena?" I asked.

"*Bocho!*"

I started to climb down the tree, slipping and falling the last ten feet into neck-high stinging grass. The old man leapt through the grass, laughing hysterically, grabbing my wrist and gently pulling me forward, jumping lightly up and down. My whole body burned with the nettles.

"*Bocho, bocho.*"

When I didn't move, his hand became like a tree root and he yanked me out of the grass. He spit in his hand and rubbed my arms and legs to ease the pain of the sting, or so I imagined. He then patted my forehead and said, "*Bocho.*"

As we walked, he talked profusely in Hadzabe, until we heard a woman's voice calling my name. Her voice sounded beautiful, soothing, sexual. The man stopped and listened. I was enamored with the voice and started to look for its source. The old man grabbed my wrist and, like a small gazelle, quickly led me over rocks through narrow dark bush tunnels in the opposite direction. Bush tunnels are the natural pathways of the bush. Impala paths, kudu, elephant, wildebeest, buffalo paths — the animal roadways, the energy channels.

We passed immense boulders and walked along a stony riverbed. Soon the old man was singing. I was still a bit weak from the *pombe,* my step unsure. Whenever I slipped, his strength and reflexes were awesome. He grabbed hold of my arm and said, "*Bocho,*" laughing, looking up at me with watery, unearthly eyes in the night.

We climbed a bank and passed a grove of baobab trees. *How did I get this far out into the bush from the dance?* On the other side of the trees was a small camp with a lone man sitting by the fire. As we slowly came up to the camp, the

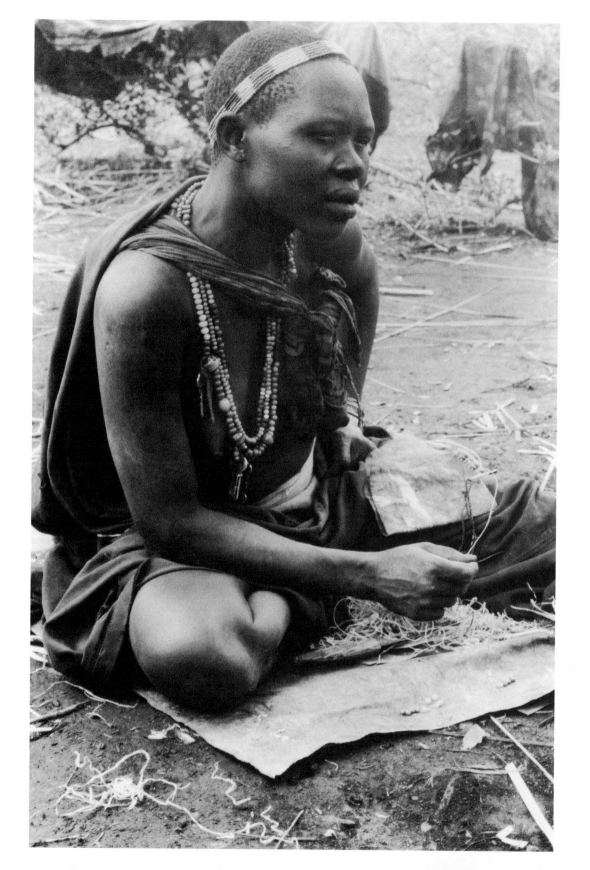

old man nodded his head and pushed me into the firelight. The lone man sitting by the fire was Localla, whom I had not seen in over a year. He recognized me without surprise. He looked up, smiling, and asked how I was, as if I had not been away. Many of the Hadza do not see each other for months at a time because they are hunting in different regions or gathering honey. I was relieved to see him, he was a good friend. I started warming myself by the fire. Localla looked around the camp; by the look on his face something had occurred to him. He inhaled on his stone pipe and passed it to me, gazing questionably.

"Have you been to Endamaghay or have you returned home?" he asked.

"I returned from my home to Hadzabe land yesterday."

"How did you know I was here? Why do you not carry a bow at night? There are leopard hunting the monkeys at night. You come like a blind man," said Localla, concerned. This was unusual behavior because Localla never asked questions. I told him the old man brought me, the one standing by the fire. Localla looked around.

"You see spirit. Spirit brought you, there is no old man by the fire." At that moment just outside the light of the fire I heard the old man's laughter.

Localla took the pipe and filled it with tobacco. He looked at me and inhaled deeply. Half choking, holding the smoke in, he said, "You have spoken with the ancestors, you are safe. This is good."

"What do you mean?" I asked, confused.

"You have spoken with the ancestors. How did you meet this old man you say is by the fire?"

The worry and age disappeared from Localla's face as I told him the story about the dance and waking up in the tree. Localla was a storyteller, he loved telling stories to the other hunters and the children and listening to them. He listened to my story with great care. When I finished, he slowly reached for a coal in the fire and threw it to the sky. He reached for another coal and quickly placed it on the end of his pipe and inhaled. He possessed a poise and an inner peace attained by living in nature his entire life. He reminded me of an ascetic. He looked hard into me, then slowly took off his necklace and bit into a seed attached to it. He lifted himself and began to chant, blowing out bits of the seed around the camp and into the fire, tapping on trees, talking to the sky. His wife came out of a small bird-nest home made of palm branches. They talked quietly. She disappeared back into the home and returned a moment later with some roots in her hands. She acknowledged me with a warm smile as she carefully placed the long roots into the fire. She sat down next to the fire, singing to herself. Localla also sat back down, handing me his necklace to wear.

"Mzee Oya has helped you. The woman's voice you heard near the oasis was *shetani,* snake spirit."

"Who is Mzee Oya?" I asked.

"*Babu, babu, babu ya zamani.* Grandfather of long, long ago."

"*Kweli,* is it true?" I asked.

"*Ndiyo,* yes, he was called in the dance. *Shetani* took you into the forest, but Mzee Oya showed you the tree and scared the hyena away or else death would have met you. He later led you here or snake *shetani* would have devoured you. Mzee will always help you," said Localla, pulling the root from the warm coals of the fire and carefully brushing the ash off. He cut the root in two and handed me half. The root tasted similar to a banana. I asked Localla if he would join Mustaffa, Sabina, and myself on safari to Endamaghay. He said he will come later. He needed to go to the caves to scrape medicine off the cave walls to sell to the Mbulu pastoralists, who use it for their cattle's wounds.

We smoked for a while. Localla's wife returned to sleep. We heard footsteps in the bush coming to the camp.

"Is it Mzee Oya?" I asked, a bit frightened.

"*Hapana,* no. It's Sitoti."

Sitoti, singing to himself, came through a grouping of acacias on the north side of the camp. He immediately set his *ka-o-wa i-cha-ko* (bow and arrows) down by the fire and pulled out his stone pipe. He said nothing while he packed and lit his tobacco. He inhaled, passed the pipe to Localla.

"Why did you leave the *ngoma* [dance]?" Sitoti asked me. "We have been looking for you."

Localla told Sitoti the story. Sitoti laughed loudly. He was in one of his hyper moods. He grabbed my hand, still laughing. "You said you were going to pee and never returned. We were worried about you. Come, we need to get more *pombe,* there are many young woman dancing at my camp. We will find a young woman for you after the hyena scare." Localla grabbed his bow, and we were off, running through the night-bush tunnels.

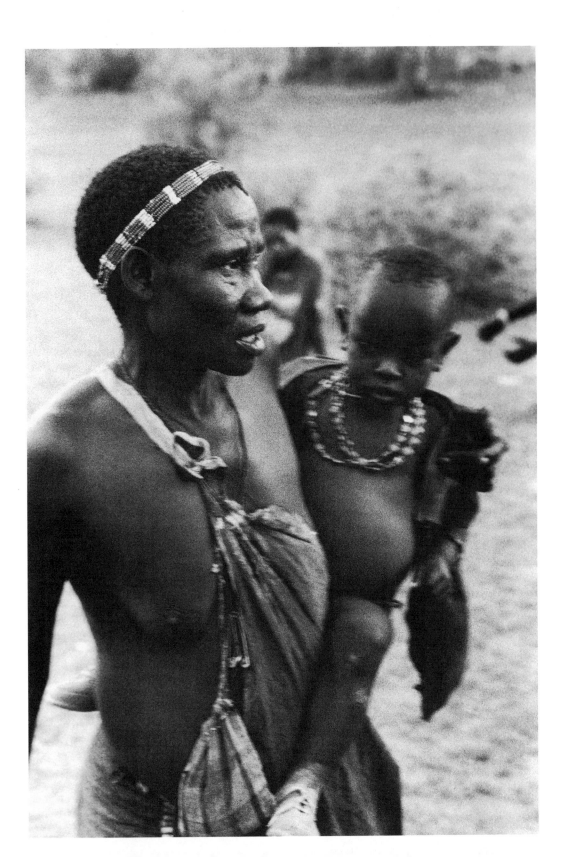

2

Dream of the Lion Mother

Yellow stingless bees poured out of the dawn sun as buzzards flew, searching for careless rodents. I woke to a cloud boy staring at me with snails in his hand and two little girls tugging at my toes. Other children were all singing and laughing, gathered around me. Localla and Mzee Mateo were eating the leftover baboon meat while Mustaffa was busy brushing off the charred fur of two squirrels he had finagled from young Hamisi, who had shot them the day before.

Sitoti was passionately arguing over his fur jacket with a young woman named Seno, whom he slept with during the night. Sitoti stood up shouting, wearing his rabbit fur jacket, purple silk bikini thong underpants, and high heels. He held his bow.

"I am not giving you the underwear or the jacket, you can have the shoes," he said, taking them off and handing the high heels to the young woman, who seemed content with the bargain. A missionary group had dropped off a huge pile of clothes for the Hadzabe a week earlier. Sitoti had selected what he felt was most stylish and comfortable. The women complained, saying he had taken all the silk panties before they had a chance to find where the missionaries had left the clothes.

After drinking some tea and eating crushed baobab seed porridge, Mustaffa, Mzee Wapo, Mzee Mateo, and Localla informed me that there must be another dance led by Mzee Wapo, whose grandfather was Mzee Oya, the one believed to have helped me the night before.

"Now we will find a quiet place to talk, away from the woman and children," said Mzee Wapo.

We all walked a few kilometers to an old Hadza camp hidden in a large grouping of immense boulders. Localla made a small fire and pulled out some dried meat.

"There is a strong *shetani* that wants to hurt you and you have heard the

snake woman's voice. I am Mzee Wapo and will talk with the ancestors tonight. When I was young a *shetani* came to my dreams and crushed all my bones with a big stone. I thought I was dead. When I woke I was fine and told my grandfather Mzee Oya. He said, 'You will talk with the ancestors when you grow old.' Now I am old. Tonight I will ask the ancestors to help you free yourself from our *shetani,* so no harm will come to you in the bush. Let me see the paper you have come to paint with and the paintbrushes."

I placed the paper and paintbrushes in front of the men and they all began to blow spit over them while shouting to the ancestors. Then quietly they returned to eating.

"You have come to paint, we must bless what you use to paint," said Mustaffa.

"*Nube'eya,* thank you," I answered in Hadza language.

Mzee Wapo suddenly took the paper and disappeared into a stand of small trees. We were sitting under a large angling rock that rose twenty meters. Five or so minutes later, Mzee Wapo returned, smiling, and carefully handed me back the paper.

"I have just placed the paper in the hole of the giant snake that used to live in this rock, sometimes he returns. He is very old and is a friend of the forest. It is good that he knows why you have come. I have left my message in his hole."

A few hours after dusk, the second dance began. The stars slowly appeared in the sky and the women sang from their hidden place. We sat around a fire as the dancer, Mzee Wapo, wrapped the half-crown of ostrich feathers around his head. He shouted out to the men and women. Then he shouted to the sky. There was silence. Then the women began singing again, answering Mzee Wapo's whistles with their sweet voices. I tried to understand what they sang, tried to uncover the ancestor spirits through my vision. But I could not see them. I asked no questions. No one looked at me; they stared into the fire, listening, as Mzee Wapo moved out into the invisible dance circle.

The dance continued for many hours, the fire burned low. Mzee Wapo slowly moved toward our fire, pounding the earth softly with his right foot. He stopped in front of the burning coals and threw something into them. He leaned down and walked on his knees toward me, grabbing my head with his hands. He stared into my eyes, his warm breath passing over my face. His eyes stared through me like dark pools of water embodying endless space. His personality seemed no longer present, as if the air and stars had swallowed his insides. He suddenly blew saliva into his hands, rubbing them together before circling them around my feet, chest, and head. Then he did the same to

Mustaffa and Sabina, who were sitting on the other side of the burning coals. When he finished he shouted out to the sky. The women answered the shout and came running out into the dance space.

"You can walk everywhere now without being harmed," he said. "The ancestors have freed you from the demon."

What demon? I thought, still not fully understanding the situation I was in.

Mzee Wapo's sweat beads ran down his face, but there was no sign of exhaustion in his eyes after many hours of dancing.

"You can live with Hadzabe now," he said, standing and passing the ostrich feathers to another Hadzabe dancer.

The next morning Sabina, Mustaffa, and I set out to Endofridge, a small camp in an oasis on the northeast edge of Lake Eyasi. Many young children had adopted us — they knew we had food and meat. The children sang a song over and over again as we all walked through the old-growth acacia forest. The song was about a young man and woman coming to the edge of a mountain. The young man wants to climb the mountain but the young woman cannot because she's pregnant. "Why are you pregnant?" asks the young man. "I met the *msenge* [homosexual]," answered the pregnant girl. "What did he do to you?" "He gave me some sweet honey, some *ba-la-ko*. And now I have a child coming and I can't climb the mountain."

Around dusk we arrived at Endofridge. Immediately we built a fire and threw some meat into it. The children were starving. They began to argue and cry over the meat. We told them to settle down, there was enough meat for everyone. They all sat around the fire while Sabina cut each *mtoto* (child) a large piece.

After the *nyama* snack, the older children and Mustaffa prepared the camp, pulling up small bushes, throwing big stones aside, clearing away any thorns, and finding firewood. Sabina, the small children, and I cooked dinner. I did not want to eat any more baboon because I felt as if I were eating a human, so I had purchased some goat meat from a farmer on the way to Endofridge. I sauteed the meat with onions and garlic I had brought from Arusha. The children stayed up late into the night singing and laughing, excited about the newness of their surrounding and the abundance of food.

We lived in Endofridge for around two months. Our camp was protected by an irregular circle of yellow acacias. We piled thorny palm branches between each tree to keep the hyena from sneaking up on us at night and stealing meat or biting our faces off. It was a short walk to the dry lake bed of Eyasi. Several Hadza clans were living in the area due to the abundance of

animals and fresh water to drink. Both Mustaffa and Sabina were excellent hunters. The rumor quickly spread that meat was always present in our camp. So, of course, the children stayed, many young woman came to visit, and a few families joined us.

I met Magwinda, better known as the lion mother, in Endofridge. She lived with her blind husband and a group of widowed old ladies who took care of dozens of children and young pregnant mothers. The lion mother spent her day gathering berries and roots for the children. Sometimes twenty or thirty children lived with these old ladies. The young pregnant women came for birth. The lion mother was also known as the birth mother, since she was a midwife.

When she was young, Magwinda was raised in the bush by a mother lion and her two cubs.

"How long did you live with the mother lion?" I had asked her.

"For a long time," she said.

One afternoon while sitting, weaving her palm mat, Magwinda decided to tell her story. She, her blind husband, and the many children she took care of came to visit us — hoping to find meat and also to talk with her son, Mustaffa. All the young children gathered around her as she began to speak.

"Time, a shadow dying on my hand; holding the grinding stone, time." She said, "Time was the hunters chasing the giraffe in the long grass.

"When I was a child I went to gather berries and heard a honeybird. I was hungry and tried to follow the bird to the honey like my father. I soon became lost. For two nights and days I walked, trying to find my home. The nights were cold and I cried. I could not find food. The second morning I walked down a dry riverbed that reminded me of where my mother took me to find water. I could not find water. I was weak. I saw a zebra dead on the rocks high up on the riverbank. I was relieved. I thought I had found my home, my *nyumbani,* because my father would lay the animals he killed on the rocks.

"I climbed the steep slope, pulling my body up by grabbing on to the

grass and small trees, shouting for my mother, who did not answer. But no one was there, my grandfather and my mother were not there. Soon I did not care, all I cared about was the meat. I sat down by the zebra and carefully took a piece of torn meat. When I looked up I saw a lioness and her two cubs staring at me, breathing heavily. I was not scared, I do not know why I kept eating. The lion walked over and nudged me to the side. She started to tear the meat from the carcass. She left the torn meat. I fought with her cubs for the meat. You must be strong with lions.

"Days, moons, passed. I would sleep close to the lions at night, they kept my body warm. When the mother lion and the cubs would leave to find food, I walked with them. If I strayed too far behind, the mother would sit and wait for me, or come to find me. I do not know how long I was

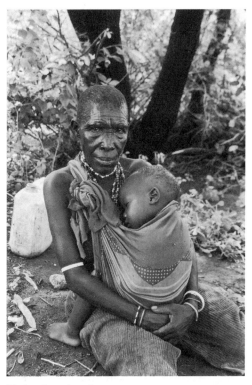

Hadza Grandmother

with the mother lion. She has been in my dreams my whole life. Since that time, I too have given birth to two sons like the mother lion."

"How did you finally find your home?" I asked the mother.

"The mother lion eventually led me back to my home. When the hunters heard the lion approaching they waited to kill her, but when they saw me following the lion, they stood in silence and did not kill her, they watched her pass. I ran to my mother. The night I returned, my father summoned a large dance to thank the ancestors for leading me back to safety, to thank the lioness." Mustaffa's mother paused for a moment and looked into my eyes. "Possibly, Jemsi, you will find your home again. My husband dreamt that you would come and I have dreamt of your ring that you wear on your right hand. Did your mother give you that ring?" she asked, sitting in the grass shadows, the cool breeze brushing through the acacia shade.

"Yes," I replied.

The mother sat with her old blind husband. There was a grasshopper in his hair that blended with the dust and the color of his skin. He did not move,

staring for hours into his world of blindness, content. He always positioned himself near the fire. The warmth of the fire was important to him. He said, "The wildebeest are coming this evening." He dreamt of their bodies marching under the moon. "If you dream of a leopard you will kill an impala or waterbuck; if you dream of a lion you will kill a wildebeest; if you dream of an elephant, you will see buffalo," explained Mzee Memelan, who had killed ten lion and four leopard in his life. Half his face was raked with scars.

"Mzee Memelan, how did you get your scars?" I asked him.

"I tried to skin a lion not dead from poison," he said, staring blankly into the blue sky, moving his hands slowly in the air to help describe the past fight. "The lion came back to life and took my face. I wrestled with the lion and killed it with my knife."

When Mzee Memelan could not find animals, he went to a sacred baobab tree and entered the tree through a small hole. The snakes in the tree bit him, giving him the sight of the tree. "The tree knows everything," he said. "It knows the times the animals will pass, when the bees come to make their nests." After the snakes bit Mzee Memelan, he sat and ate medicine so he would not die from the poison. And if he lived, he knew nothing could harm him with the knowledge of the tree and snake; no spirit or animal could kill him. Mzee Memelan also knew of the medicine to make you run fast, fast like the cheetah.

"Have you killed an elephant, Mzee Memelan?"

"No. I run from elephant, it is too big to kill. The elephant talks to me in my dreams. He is my friend."

"Are all animals your friends?" I asked

"No. Many are angry that I hunted them, but most understand," he said. Mustaffa once told me that the old men never believe they will stop hunting.

"What do you think will happen to the Hadzabe, Mzee Memelan?"

"When I dream I cannot find the Hadzabe. In my old age I am sad because I cannot find the Hadzabe in my dreams. I am afraid to know what this means." I watched his eyes unmoving as he answered me, fixed on the sky, and thought: *How far has he gone into the blue sky, into the tree leaves? How many afternoons did he sit and stare into the insect wings, the blades of grass? What reflections from his past sight now live through his blindness? What does he know, remember?*

I thanked the mother for her story, and I thanked the father for his stories. When Mustaffa and I gathered our bows to go hunting at dusk, the mother's expression became sad. I could tell she loved being around her only living son, Mustaffa. When he spoke she always wore a small smile or laughed. Often when Mustaffa was drinking too much, she would go and drag

him out of the *pombe* bars, telling him to hunt and feed his children. "Your father never drank, why do you drink like a fool? Four hungry children and you sell the meat you kill for the drink."

The mother shouted out something to us in Hadzabe as we left camp to hunt the wildebeest that Mzee Memelan had seen in his dreams.

We walked into the palm forest, quickly disappearing from the sight of the camp. The sounds and smells, the greens, yellows, siennas of the forest, the trees and the birds, the moments of stillness, suffused my awareness. The wind, the dust, the crash of dead palm branches falling to the ground; screeches of the fleeing monkeys, and the periods of inescapable silence when the wind died down. I asked Mustaffa what his mother had said as we left the camp. He looked up at me, as he often did when I asked a question that probably was unusual to him.

"You are her son now, no harm will come to you. When you return, she will give you medicine. My father will talk with the ancestors tonight."

"Why does she say this?" I asked.

"She believes everyone is her child," answered Mustaffa.

After a half an hour or so walking, we broke from the palms onto the dry dead lake bed, the colors of the fading sun filtering across the immense open space, stretching to the mountains in the west. Steam pockets rose from the cooling mud, and pink flamingoes fed in the stinking dust-salted pools that held the reflection of the bleeding sky.

"*Nyama mbaya, mingi chumvi.* The bird's meat is bad, there is too much salt," said Mustaffa, pointing toward the flamingos.

Mustaffa led the way to a small cropping of grass where we would wait for the wildebeest to pass. It was the last patch of vegetation, about a quarter of a mile into the basin of the dead lake. Mustaffa had noticed the wildebeest tracks a few days earlier. He knew the language of the tracks, knew the wildebeest would return this way in two days. And his father's dream solidified his intuition.

"*Bofu atakuja usiku leo.* The wildebeest will come tonight. We wait for them in the grass."

Mustaffa's half brother Janza, from his father's side, was already present when we arrived. He had matted down three comfortable beds of grass hidden in the center of a tall parameter of surrounding grass, which was salt-crusted from the dust winds that scoured the basin. Mustaffa explained that the buffalo would not see us in this natural blind. The wind was in our favor, hiding our scent. The wildebeest would return from the cover of the escarpment that

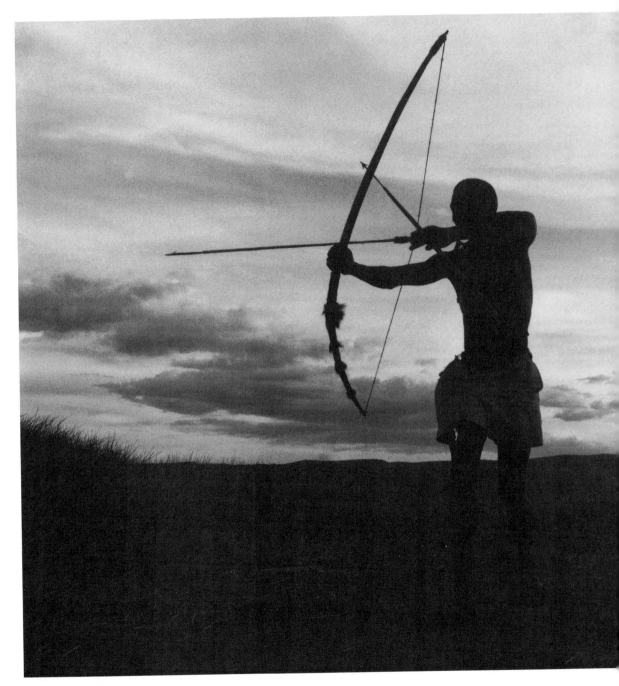

Mustaffa and Janza

separates the Ngorongoro Conservation Area from the Eyasi region. It was probably a small herd that had ventured away from the mass migration in the Serengetti only fifty or so kilometers northwest.

Janza began wiping down his bow and arrows with water stored in a large gourd. He dipped his hand in, flicking the water north, south, east, and west. He explained that he had placed the seeds, *dawa* (medicine), in the water early in the morning, the medicine and the water needed to absorb the sun. Now the water was ready for the hunt. He shouted out to the approaching night, asking the ancestors to aid us in the hunt, wiping his body down with the seed water. Mustaffa followed Janza's actions, chanting as he brushed the water over his bow and arrows.

"This is medicine for our arrows and bow, to bring us animals to eat. The old men told me to do this. Many Hadza are hungry now, they hope that we will return with meat. You must also place the water on your bow and body," said Janza.

The night rose over the womb grass. We waited, the endless stars appearing, the orange moon ark ascending. There was no need to talk. Hours passed. Mustaffa fell asleep in a fetal position by my side. Janza sat unmoving in the quiet air, listening. The sudden rush of bird wings passed above our heads, vanishing into the indescribable silence.

As I rested in the grass facing Mustaffa, I thought about his twin brother, who had died. Mustaffa grabbed me in his sleep, his legs jerked. *How did his twin brother die? Why did I feel so close to these*

people? Why did Mustaffa and Janza come to me the first day I arrived three years ago?

Only now was the mystery of their world starting to fracture the walls of my perception. *What has brought me back from New York City over and over again?* Maybe it was to be allowed to share their state of being. Of all the different paths I could have taken, I never would have guessed that at twenty-seven I would be here in this womb grass, slipping into sleep, waiting for the wildebeest and trying to ignore the mosquitoes. *Was I Mustaffa's twin brother who had died? Did his spirit pass into me five years ago when I was calling out to winds and talking with trees on an island in southern Tanzania?* Memories that were not my own streamed into my consciousness, as if the thought of the brother's spirit had birthed the possibility of his presence inside my being. I dreamt of a late afternoon. I was running through a cornfield with Mustaffa, laughing, my shirt full of corncobs. A Mbulu farmer was shouting at us from a distance.

Was this a memory from his brother? I woke for a moment, staring into the night stars, brushing the mosquitoes away from my face, then again passed into sleep, reexperiencing the visual impression of the star world. And from within the emptiness of star voids, emerged the image of Mustaffa's mother, looking down at us with lion eyes. Her arms slowly spread open.

My eyes opened to Janza's quiet figure outlined by the vastness of the sky dome. He dipped his knee into the bow, tightening the bowstring by tying it around the upper end of the bow. The pressure of the curved bow held the string taut.

He looked at me and whispered, "*Atakuja,* the wildebeest are coming." I woke Mustaffa, who then listened to the air, leaned forward into the mosquito grass, and whispered, "*Atakuja,* they are coming."

The wildebeest approached as if emerging out of a dream; in a slow, archetypal night presence.

"*Bofu, bofu,* wildebeest, wildebeest," whispered Janza.

"When they are close, shoot. Do not hurry," said Mustaffa.

Again the rush of night birds passed low over our heads. The sounds of hooves breaking the dried mud. The wildebeest came toward us with their fetid smell, as though they were coming to devour us. Mustaffa and Janza carefully chose arrows, placing them to the bows, leaning down like cats ready to attack their prey, pulling their strings slowly back. The wildebeest stopped, their eyes reflecting the moonlight; they sniffed the air. The hunters released their arrows.

The wildebeest screamed, breaking into a roaring panic, a wave fleeing from the force of the death arrows; fleeing from Mustaffa and Janza, who leapt

from the grass, letting more arrows fly into the bodies and heat of the herd, harder and harder they ran until both wildebeest and the hunters disappeared out of sight and sound. I tried to follow them until I could no longer breathe from the dust and the run. The night engulfed them. I was alone. I sat and waited, holding my bow tight, listening to the night sounds, smelling the earth. My mind neither in the past nor the future but in the raw elemental ecstasy of the moment.

Mustaffa and Janza reemerged on the flat lake bed under the stars, covered in dust, their eyes on fire from the exaltation of the hunt. They sat down to rest, packing their stone pipes with tobacco.

"The wildebeest we shot are dead now," said Mustaffa, lighting his pipe. "The poison has taken their life, but they are far, far away. We must find them tonight or the *fisi* [hyena] will find them."

We followed the tracks in the moonlight. Hours seemed to pass.

"They have run far. The poison is not strong?" I asked.

"*Bofu wkubwa,* the wildebeest are big," replied Janza.

The two hunters stopped for a moment to discern the direction the wounded animals had taken. They pointed to the various marks in the dry mud. Janza leaned down and said, "*Damu* [blood], one has turned off this way."

We veered to the east and soon saw a dead, silhouetted body in the distance. A hyena's cry broke the silence. Janza stopped and looked around, slowly separating a single arrow from the many he carried in his free hand. "The hyena is waiting. If it comes, I will kill it," he said.

The wildebeest lay unmoving with an arrow in its head and side, its body gleaming with sweat. Mustaffa made sure the animal was dead, then pulled the arrows out, cutting three-to-four-inch sections of meat around the wound. "This meat is bad, poison," he said. He threw the bad meat far from us. The Hadza's poison is made from Striacanthus berries or the sap of the desert rose. They mix water with the berries or sap and boil it over a fire until the poison turns into a thick gray liquid, letting it cool until it becomes an adhesive. While it boils, they are careful not to breathe in the fumes, which can cause death. With sticks they carefully press the poison onto the shaft of the arrowhead and let it dry hard. The poison reacts with the blood and causes the heart to stop, but it must enter the bloodstream to work. If a man is wounded by a poison arrow, the Hadza say he will die within five minutes.

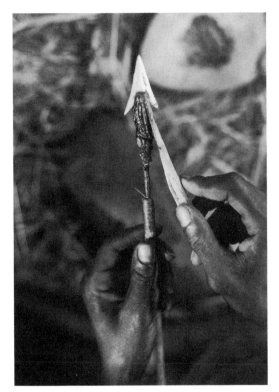

Poison Arrow

While Mustaffa skinned the wildebeest, Janza disappeared into the night.

"Where has Janza gone?" I asked.

"He is looking for the other wildebeest," said Mustaffa, holding the two arrows he removed. He handed me the bloody arrows.

"These are Mzee Wapo's arrows. We must return them and give him this leg of meat," he said.

"Why must you give him meat?" I asked.

"If an old man loans a hunter an arrow and the arrow is successful on the hunt, it is the hunter's duty to return meat to the arrow giver."

Mustaffa immersed himself in the skinning of the smelly animal, making precise cuts down the chest, legs, and neck. When Janza returned, he said he could not find a second wildebeest, though he knew he had shot it. "I will look for it in the morning, but the hyena most likely will have found it." Janza helped Mustaffa peel off the skin. It took three large tugs, making small adjusting cuts in between jerks. Janza then cleaned off the fatty tissue of the skin with his knife while Mustaffa cut and organized the meat so we could carry it back to camp. They worked quickly, laughing and singing. More hyena cries broke the silence. Janza gathered some sun-dried sticks, which were salt-crusted after being in the lake bed for years, and started a fire.

"The fire will keep the hyena from coming too close," he said, throwing pieces of the intestine in the fire to cook. Mustaffa handed me a large piece of meat and motioned me to place it in the fire on top of the burning sticks. "*Nyama safi*, Jemsi. The meat is good."

Soon Janza sat down, pulled the meat out of the fire, and started to eat with fervor. He looked up, smiled, and asked about having sex with white women.

"It's very dangerous. You have to know what you are doing," I said.

"Do you have to pay them money?" asked Mustaffa.

"No. If they like you, there will be no problems. But if they do not like you, you have no chance," I said, pushing my hunk of meat deeper into the fire. "Why don't the Hadza women kiss?" I asked.

"Some do, they have learned from the Swahili," said Janza.

"Why do they whore themselves to the Swahili?" I asked (Swahili is a term often used for people who live in any town).

"Only the ones living close to the town do this. They want to wear the clothes they see the Swahili women wearing in Mang'ola. Some young women have gone to school and no longer want to live like Hadza, so they survive by the money they get from the Swahili," said Janza.

Suddenly we saw the eyes of the hyena not too far from the fire. Janza slowly reached for his arrow, placed it to the bow, leaned forward onto his feet, and shot the animal in the head. The hyena cried, running off into the night, shaking its head violently.

Janza returned to his meat.

"My brother was eaten by hyenas walking back to camp, drunk on honey wine one evening," he said. "If you are not strong the hyenas will kill you."

"We should leave now," said Mustaffa, finishing the meat-cutting.

Blood and sweat covered our bodies as we walked with the heavy meat. Thirst now occupied my mind. I carried two of the hind legs on my shoulders. Mustaffa carried the head, chest, and front legs — twice as heavy as my load. Janza carried the torso and skin. The wildebeest smelled terrible. Mustaffa left what we could not carry behind for the hyenas.

We entered the cool night forest, dropped the meat to the ground near the sweet sound of the water oasis, and dipped our hands into the cold pool of fresh water, washing our bodies under the moonlight, drinking the water gushing out of a small hole in the ground. I asked the men about the pockets of warm air we passed through before entering the forest.

"The elephants come down from the escarpment forest to drink water. They leave the warm air behind them. There must be many elephants drinking tonight. You did not notice their footprints," said Janza, wiping away the water from his eyes.

After the rest, we loaded up and continued walking back. Mustaffa started singing when we saw the firelight in the distance. We heard shouts and laughter rise from the camp. Before we knew it, four or five young men and women came running up to help us with the meat. They joined Mustaffa's song.

"Come," he said in the song.

"Come help us, sisters and brothers, we have meat for your stomachs."

All the Hadza at the camp gathered about the fire, cutting up the meat and throwing it into the fire. Everyone was happy, singing, dancing, and eating. Quietly Mzee Wapo accepted his leg of wildebeest. He led us to a fire separated from the women and children, a place where the men eat privately and talk about the hunt. Two young men ran up and laid down *swala* skins for us to rest on. The meat eating and storytelling commenced. It lasted the entire night.

"Come children, there is food now and mama has built you a shelter," sang the pregnant women as we walked into the lion mother's camp the next morning. The orange-yellow sun was rising. Mustaffa held up the wildebeest head and a hind leg for the mothers and children. Mzee Memelan smiled as Mustaffa told his parents the story of the hunt.

I told the lion mother about my dream.

"You stared down at me with lion eyes from the star voids," I said.

"You dream well," she said, throwing some meat to a pretty young girl. "You will have twins like myself and the lioness; that is why you dreamt of me."

"I will have twins?" I asked.

"Yes," she said, suddenly shouting at some children fighting over a piece of meat. They gathered around her, asking for meat, and she and the other women cut the children pieces.

A week or so later, Mustaffa and I left for a cave.

"I find medicine for you on the walls of the cave. My mother must have medicine to protect you," he said, excited to leave in the dawn light.

"Protect me from what?" I asked. "The dance protected me from the *shetani*."

"This is medicine to give you power — power to talk well, power to help the Hadzabe, and it will protect you from those who don't want to help the Hadzabe. We will see the birth stone, the place where my mother was born, and the lion den where she was lost. We will hunt baboon. Let us go," said Mustaffa, gathering his bow and arrows.

Dancing

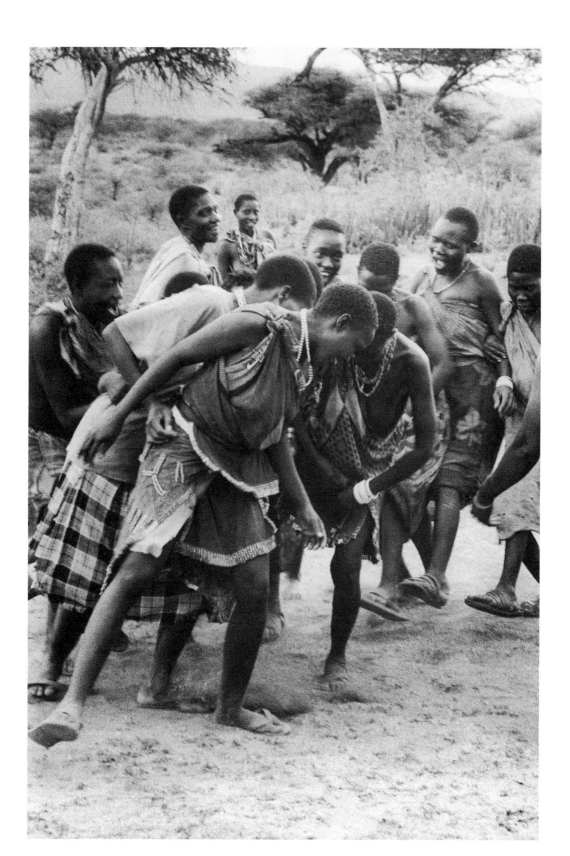

All morning we walked through the oracles of singing red birds, through the high foothills on the edge of the Ngorongoro Conservation Area. The land was dry, blackened, brittle as if a fire had swept through it. The walk was also difficult, up and down many steep ravines. Each ravine contained an environment of its own. And in a ravine called Win-pon-tini we came in sight of a mammoth-size cave the shape of a half circle located on a precipice two hundred meters up from the riverbed. It took around forty minutes to climb the steep slope. Once we arrived, the view from the cave stretched over the land below, following the dry stony river that ran down into other ravines.

"I am the only one who knows of this cave now," said Mustaffa. "My mother and father are too weak to come. The Hadza no longer live in this area of the forest, because there are few animals and too many Mbulu cattle. The cattle do not graze in this ravine. I hunt baboon here. This is a cave of ancestors; the ancestors live peacefully here in Win-pon-tini, though the world is changing. You mustn't show anyone. I don't want the others to come and hunt baboon. The ancestors do not understand or like greed. The younger Hadza see too much in the village and want to live like the Swahili. I will never send my children to a Swahili school. I will never allow them to lose the way of the Hadzabe. In school they learn to be ashamed of being a Hadzabe and when that happens, it's best to leave the ancestors alone to live forever as they always have," he said.

Mustaffa pointed out a leopard resting in a tree on the other side of the ravine.

"He is waiting for the nightfall, for the baboon to return. They live above the cave." He spoke softly as he pointed to the baboon feces covering the cave floor. A large acacia grew in the flat ground above the cave. The baboon lived in the acacia.

"How many baboon do you kill when you come here?" I asked.

"Two or three."

"Will we kill baboon in the afternoon?"

"The baboon will not return until the sun starts to leave the sky. We do not want to climb away from the cave and find the baboon when the sun leaves the sky because the leopard will also come at this time. If we can shoot *ne-a-yako* [baboon] from the protection of the cave then we will hunt them."

Mustaffa pointed out a beautiful, worn stone about three feet in length and two feet wide, it was raised up six inches from the ground with four legs of stone underneath it.

"This is the birth stone," he said demonstrating how the women use the stone to sit and give birth.

The stone was worn down from the women's buttocks. *How many thousands of women must have given birth on this stone? I thought. How many generations?*

"They sit on this stone and birth like this," said Mustaffa, demonstrating. "There are no men present when the baby comes, but I saw my mother's sister giving birth on this stone when I was a child. The older women help the younger women. The child is from God. After the child is born, the father and a close friend go hunting. If the animal comes quickly, this is good. They return with the meat and hang it to dry. They invite many people to come and pray for the new child who has come into the world. Addressing the baby, they say, 'You are a nice person, thank you for coming into our world.' The meat is not touched while they are praying. Sometimes for one week we pray, and if the meat — reserved for the child — does not go bad, this is a good sign, the child has accepted his journey into our world. The grandmother will then take the meat of the child and cook it in the fire, everyone will share the meat and

Birthing Stone

bless the child. Then the grandfather will give a name to the child. If there is no grandfather, the first sibling will name the child. If none of these are alive, the mother will name the child," said Mustaffa.

"What happens if the father does not kill an animal for the child?" I asked.

"The father and friend return, and all the men come together and pray. No women or children are allowed to be present. An elder will come forth and give the father a blessed arrow. This arrow has been chosen by the ancestors, and if the child is meant to live, the arrow will find meat," responded Mustaffa, sitting quietly and looking out over the ravine.

"After the name has been given to the child, the father waits. If the child becomes sick or cries, the child has not accepted the name. The father will then take control and pray to the ancestors and know what is right. If the father has a lion skin, it is good to wrap the child in the lion skin; the child will be protected while the father is thinking of the name."

We sat for the entire afternoon in the cave's shadows and talked about the different elements of our worlds. Mustaffa said he worried about his future. This was the first time he had ever mentioned the future to me.

"I have five children, and the animals are harder and harder to find," he said. "The Hadza only have the land, without the land we are nothing. I do not want my child to be a slave to Mbulu farmers or to the government."

Mustaffa had a gift for understanding dreams and premonitions, but when he went to the villages, he was always blasted on the Mbulu's moonshine. He also had the potential to become a great leader, if he could shake the moonshine, which was doubtful. One of his half brothers had drunk himself to death.

Mustaffa was tall, possibly half-Maasai or Mang'ati; maybe the lion mother had once fooled around on the side or been hungry. Mustaffa was physically stronger than most of the other hunters. His speed was awesome. He was an excellent tracker and knew the land well. His father, Mzee Memelan, was a famous hunter and taught Mustaffa all he knew. His father used to hang him up in a tree as leopard bait, and when the leopard came his father shot it.

I told Mustaffa the dream I had the night before, of a woman cutting the heads off her two babies by the fire.

"It was terrifying, Mustaffa. I could feel the women crying."

"You dream well," he said.

When he was a boy he watched the elders banish a young woman to the

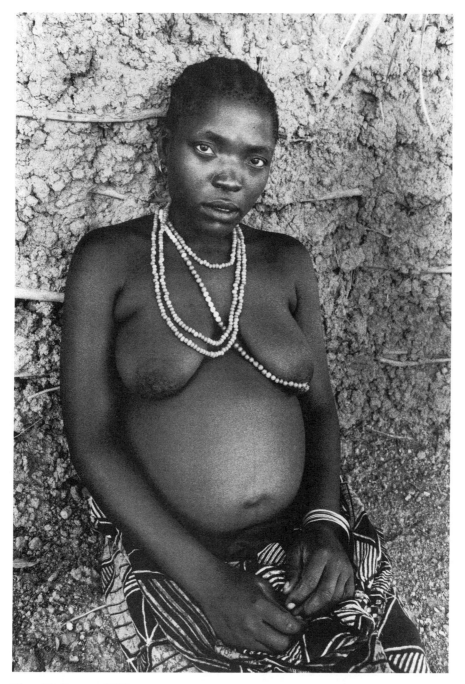

Mustaffa's Pregnant Wife

Baboon Tracks

bush. He watched her leave alone, never to be seen again. She had killed her two children, cut their heads off, and threw the babies into the rocks. The Hadza did not know why she did such a thing; possibly *shetani*. The young woman defended herself by saying there was no food to feed her children. The elders did not agree.

"Why did I dream this, Mustaffa?" I asked.

"I do not know, maybe my mother will understand your dream," he said, examining a piece of porcupine feces.

In the late afternoon we heard the screams of the baboon returning to their tree. The leopard slowly disappeared from his limb and vanished into the dense bush near the riverbank.

"Leopard comes, it is best we go back now," said Mustaffa.

When I visited the lion mother's camp a few days after returning from the birth cave, I told her the dream about the young woman killing her babies. She was silent for a while. Then she stood up from crushing baobab seeds and said, "You will understand your dream, later." She picked up a child that was tugging at her skirt and walked off.

Time passed and returned. One day in Arusha a year after going to the birth cave, I understood why I had dreamt of a young

woman cutting the heads off her children. Another young woman was sitting across from me on a bed, crying. Sadly, probably more sad than I have yet to realize, I learned how the lion mother's premonition had come true while I was in America.

"You will have twins," she had said.

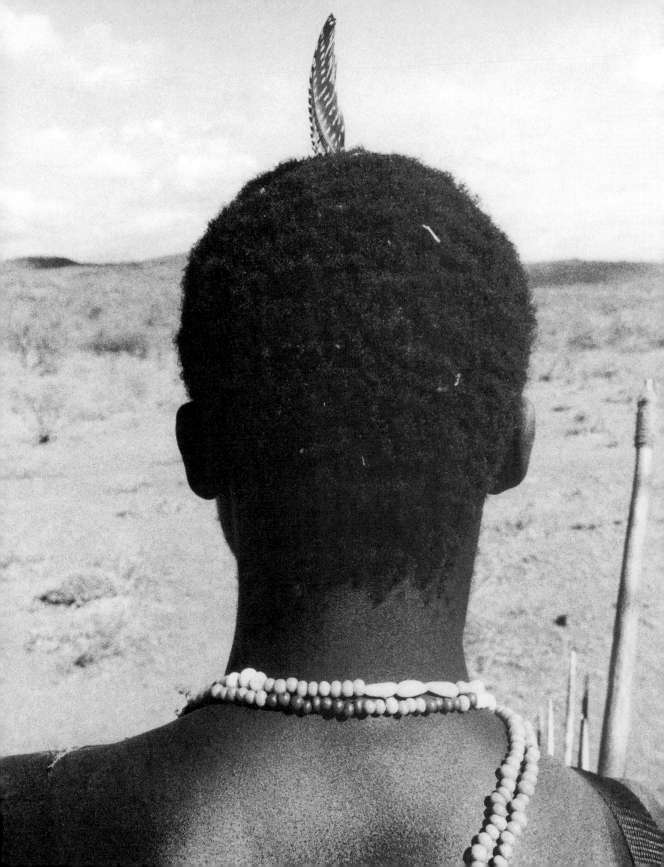

3

Following Lions

The cool breezes pressed lightly, brushing the sleepy faces of the pre-dawn risers. I laid by the fire staring into the darkness, listening to Pauola's breath, listening to her songs, her melody flowing into the men's coughs. Whenever more than one hunter started smoking *bangi* (marijuana), sleep was impossible. They were unable to contain the irritation to their lungs — long drawn-out suck-in coughs that sounded like drumming underwater. Pauola always sang at this time. Her voice blended with the waking birds. She smelled like warm grass and when she slept, she curled up and sank into my body.

Mustaffa walked over from another fire, sucking on a dik-dik hoof, asking if I was awake.

"It is time for us to go. We must find the medicine," he said.

"Medicine for what?" I asked. "I am tired, Mustaffa."

"We must go to a cave where I lived as a child. Come, the walk is long."

I never knew what to expect when Mustaffa was elusive. I always accepted and followed, but sometimes the following took days and nights, which led to drunken oblivion, angry buffalo, women, or Mama Ramadan's (a bush bar that sold safari beer). Mustaffa was a mix of the old hunter and the new Hadzabe, and had adapted to the changes of his environment. He still lived in the bush with his family but also went into the villages, trading his poison arrows for clothes, or for drinks of *pombe*. Sometimes, when he came through Mang'ola, he would convince a tourist to give him money. When he knew I had no money, this became his ploy. He would say, "I must try to get money from the tourist," and then he would disappear for a couple of days.

Mustaffa was not Mustaffa's real name, he had changed it. His real name in Hadzabe was "Stone," *Cle cwa*. Anyone who was not Hadzabe would have a terrible time trying to pronounce it, due to guttural nuances.

Mustaffa Scouting the Land

He explained that one afternoon, while he was hanging out in Mang'ola village, a Swahili man had asked his name, and he said "Mustaffa." It did not concern him in the least bit that his adopted name was common in the Islamic world.

"Are you Muslim?" I asked him.

"What is Muslim?" he replied.

As Mustaffa prepared to go, he looked concerned. He needed more medicine for his unborn child. The birth cave was the first stage of the medicine journey, now we were beginning the second. He had told me about his unborn child a few days after we returned from the birth cave.

Mustaffa's wife woke, sensing our departure. She called to Mustaffa. He didn't answer. She lifted her pregnant body and walked over to his side. She was very beautiful, especially in the firelight. This was her seventh child coming, but two of her children had died at birth. She was about twenty-four years old, but it was difficult to tell. She wore a *kanga* around her body, a cheaply manufactured Indian sarong. She probably bought it in one of the Swahili *dukas* (small stores) with the money she made selling the palm mats she wove during the day. She whispered in Mustaffa's ear for a few minutes. He listened, not saying anything; he looked at the ground. When she was finished, they both turned to me; she looked directly in my eyes. It was then I realized that somehow I was involved in the unborn child's future. Mustaffa motioned for us to leave.

I said "*kwaheri*" to Pauola, who had also got up to make tea. She convinced us to drink some before leaving. The first time I'd actually met her, I was painting on a little rock ledge, looking out over a small valley. I was painting a forest of baobabs; the trees seen from the distance created unusual patterns of circles. The small growth trees filled in the spaces between the larger ones, so the baobab configurations stood out clearly. I was at peace painting in the bush. I took the canvases, paint, and pastels on our long safaris. Often the rolled-up canvas or paper (in a cardboard tube) served as protection because other tribesmen thought we were carrying a gun as we walked through the bush. If we wanted to scare someone off a path, we would point

the rolled canvas at the walker and the person would immediately run off. Pauola suddenly asked what I was doing, startling me. I had no idea she was standing behind me. She had been gathering berries and silently came upon me.

"What are you looking for? Are you hunting? Why are you putting the colors of the sky and leaves onto the paper? Where are you from? Why have you come to live with the Hadzabe?" she asked.

Before I had a chance to answer, she sat down and drew a flower over my trees. She then drew a red giraffe and four green baboons. She had seen them the day before near the large tree that grew in Endofridge, telling me as if I knew which tree she was talking about. Suddenly she leapt up and started clapping her hands in celebration of her drawing and said she must now draw a *lu-ta-to* bird. As she talked, she anxiously examined my oil pastels.

What is a *lu-ta-to* bird?" I asked, curious.

"It is a bird that sings in my dreams."

A bird that sang in her dreams; I didn't have the Kiswahili to probe into that answer.

We spent the entire day drawing together, and then in the late afternoon she showed me how to find roots. One type could be found by locating the delicate, yellow flower that feeds off the root, and the other, the size of a potato, could be detected with her tapping stick. But I hadn't the ability to discern the slight change in the soil which indicated where the roots were.

"You will learn," she said smiling.

I had seen Pauola a few months earlier when Sabina and I were returning from a two-day safari. We had unexpectedly found Pauola's grandfather's small camp, where she lived with her grandparents. Her grandfather was a very respected hunter and did not spend much time with the other Hadza clans. He was a quiet man. You knew he liked you if he shared his meat. Sabina and I slept by the fire that night. I woke at dawn before Sabina. The old hunter was already out and about. When I looked up, Pauola was standing by the fire. She smiled at me and then took off her *kanga*, her eyes falling to her exposed naked body. She stood there for a moment before rewrapping herself with the worn blue *kanga*.

Later in the morning, Sabina and I departed, giving our thanks to the grandmother and grandfather. As we left the camp, I told Sabina how Pauola had taken off the *kanga*.

"She must like you. We will bring her to the camp one night," he said.

Mustaffa and I quickly finished the tea, filled our water bottles, and left. We walked all morning and into early afternoon hours, advancing on the forest

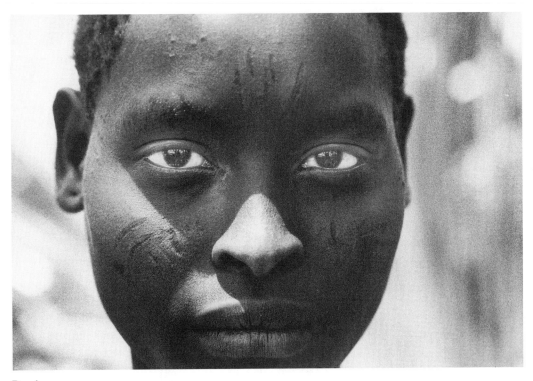

Pauola

line of the volcano called *San-sa-ko*. The Hadza do not go into the mountain forest. They say it is haunted by spirits. The forest, seen from the lower lake bed, is a green sea of trees carpeting the upper regions of the mountain's volcanic mouth.

"Why do you not go into the forest?" I frequently asked when I saw so many Hadza hungry. "There are animals in the forest, you could find lots of meat there." But they would not go into the old-growth trees.

"You go there, you will disappear," said Mustaffa.

Many times he had walked along the forest's edge searching for honey. The ground was always littered with elephant, buffalo, and lion dung. He said he often saw spirits beckoning him to enter. "Come, we will show you food," they would say. Mustaffa never let the spirits enter his mind and trick him.

The rain forest harbors many of the last elephant and lions of the region. The lions in the forest are known to be more ferocious and smaller than

the savanna lions. They are hidden by their fur coats, a natural camouflage that blends with the leaves and trees.

"*Se-sa-may-a* [lion] in the forest is similar to the *a-gey-reta* [lizard] that changes its skin," said Mustaffa.

The storms come up quickly on the mountain slope, and the rain is caught by the trees. Every day the mountain disappears into the clouds. When the savannas below are in need of rain, the Hadzabe say the spirits go to the mountain forest for water, laughing at the thirsty man and his dried-up farm below. Soon they tire of playing tricks on elephants and return to play tricks on the men in the lower waterless valleys. They bring the rain down from the mountain. Hypothermia is a definite possibility in the mountain forest. The cold violent winds will kill a man in a night, because it is difficult to find dry firewood. Spotting animal tracks is almost impossible in the lush undergrowth. "No warning before a buffalo charges," explained Mustaffa. Over the years many Hadza who had ventured into the forest did not return.

We were walking parallel to the forest toward the great escarpment. We headed down a steep ravine through a small bush tunnel created by *tandala* (large antelope, kudu). When you disappear into such a tunnel you feel the energy of the *tandala* moving quietly toward the water. That is why so many believe the Hadza can turn invisible; they know of all these natural channels and find them when the bush seems impenetrable.

"Walk slowly," said Mustaffa.

His warning was too late. A branch came swinging into my face. I did not have time to close my eyes. The shock of the blow knocked me off my feet. Mustaffa leapt forward and grabbed my shirt before I tumbled down the steep slope. I could not see, and something was running down my cheek.

Mustaffa took my head and looked into my squinting eye.

"Your eye is bleeding," he said, concerned. He wiped away the blood with his hand and asked me to sit. He leaned down, spread my left eye wide open with his big dusty thumb and finger, and blew into it. I quickly pulled my head away. He insisted, saying he saw many thorns in my eye. He blew one last time and gently dipped his shirttail into the corner of the eye, then proudly showed me a few thorns he had removed. He reached into his leather pack and pulled out an arrowhead covered in dry blood.

"This arrow is good for your eye. It was soaked in wildebeest blood," he said, tying the arrow above the wounded eye with some bark string he shaved off a tree with his knife.

Riverbed

"*Siyo baya sana.* Your eye is not too bad, tomorrow or the next day it will be fine," said Mustaffa with the authority of a doctor. He lifted me up by my arm and brushed off my back.

"This happens to me many times. The branches are dangerous for your eyes. This could have been *shetani*. We must move on, we are now close to the cave. It is not good to stay too long anywhere, many demons. They know we are coming," he said quickly as he moved down the rocky path.

After four or so hours of hard, fast walking, we came to a high ledge. Two large baobabs, as old as stones, rose like gate pillars. We rested under the dome of their shade. The breeze trailed up the mountain, cooling the sweat streaming out of our pores. Flies devoured the salt-tear tracks on my left cheek, and within an instant after I sat, any stick scrape or broken skin was covered with the same quick black flies. I usually spit in a leaf and pasted it onto the wound, so the flies couldn't get at it. The hunters let the flies clean out the wounds, most of the time never taking notice of the insects.

My good eye followed a small animal path winding down from the ledge into the immense gorge that fingered along the side of the mountain slope, blending into many other gorges and small ravines. In the rainy season these now silent gorges rage with the thunder of water rushing down to ease the thirst of the ancient salt lake.

Mustaffa looked seriously at me and said, "Jemsi, *se-say-may-a yupo*, lion live in this ravine."

"Are we going down there, Mustaffa?" I asked, secretly questioning my own strength.

"Yes, that is where the cave is," said Mustaffa, pointing out where he saw two large male lions disappear into the brush.

"Aren't lion dangerous, Mustaffa?" I reminded him. "Are you sure it's OK to go down there?"

"Any Maasai who walks down there with his cattle would die and most hunters would be afraid. But you are with me and I am not afraid."

"Maybe the lion will eat me because I am from New York City and he doesn't know me," I said, unable to contain my fear.

"*Se-say-may-a ma-na-ko*. Lion is meat, how can I be afraid of it when I hunt it for food. Anyway, we are wearing medicine to keep the lion away. Follow me, and do as I do."

Mustaffa pulled a necklace from inside his shirt and bit into one of the large umber seeds, the shape of a small spiky gumball. He spit the seed saliva into his hand and smoothed the substance over his arms and legs, chanting softly to himself. He took the necklace around my neck and bit into its seed, chewing on it for a while before rubbing the seed spit onto my arms and legs. He stopped for a moment and stared down into the ravine. He turned back to me and glanced into my eyes, telling me in his silent way not to worry. Then he spoke, "*Dawa ya simba, hamna shida, twende*, medicine for the lion, there is no problem. Now let us go." He picked up his immense bow and long arrows and motioned for me to follow him.

We departed from the safety of our lookout underneath the baobab trees and were soon swallowed by the gorge. Bird sounds filled the air in the dense forest that grew along the river basin. From the view above I had no idea of the thickness, the fecundity of vegetation we would find below. A canopy of acacia limbs shaded our walk for twenty minutes. The gorges each held their own ecosystem, some were isolated units safe from the Mbulu's and Mang'ati's cattle. They were filled with game and undisturbed by humans. No wonder the lions lived in them. We saw two rather large horned male *bo-po-a-ko* (impala) and a few *gay-we-da-ko* (dik-dik) on the way down. Mustaffa pointed out baboon and buffalo tracks.

"Many baboon passed here and ran from the buffalo. I ran from a black mamba over near that tree," said Mustaffa, pointing to large acacia.

"I shot an impala and when I went to find it, the snake came after me. *Mimi nili kimbia sana.* I ran for a long time before I escaped the long snake. God helped me that day," said Mustaffa, examining the terrain carefully as he walked.

Mustaffa found our way to the smooth blue stones on the dry riverbed.

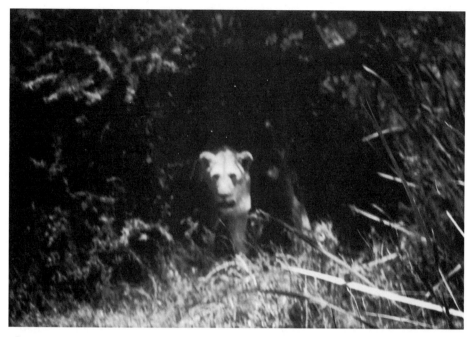

Lion

The bush came right up to the bank. The riverbed was the easiest way to walk because of the open space. The distant ravine walls were dotted with lion dens, holes about four foot square. The dens seemed to stare down at us, menacing in their own right. The air was cooler on the riverbed. We walked in silence for some time. I followed Mustaffa's steps, watching his hands and body. He was strong, his bow string was so taut and the bow so thick that it was impossible for the regular-size hunter to pull his string back; I could barely move it. Every few minutes his eyes scanned the bush ahead. In the pockets of sky openings between the tree branches, buzzards flew in slow circles, hunting the parched, flat, open sweeps between the gorges.

Strangely, the listening land fell silent. Mustaffa stopped and listened too. His face became stern. He seemed to be waiting for a sign; something was making him uneasy. The feeling in the air reminded me of the time I was off the coast of Mozambique diving to check fish traps. I was alone in the water checking the last trap. My friend Gitu, a fisherman, had already begun swimming for the anchored dhow. I dove down and felt an ominous presence. The small reef fish that usually kept their distance from the

divers swarmed about me, so close I could reach out and touch them. They sensed a danger I was not aware of, then they disappeared. The reef became quiet like the air was now. And out of the dark sea, where the reef dropped into the underworld, appeared a giant hammerhead. The beast slowly swam twenty feet above me, passing gradually like a bird of prey in the sky of water.

I was thinking about the shark when we heard deep lion breaths on either side of the riverbed. Mustaffa knelt down. I quickly moved the few strides to his side. Mustaffa sensed my fear and looked at me with such bravery that I knew he was not afraid. But I was. The idea that lions lived in the gorge hadn't taken a strong grip on me until now. The inescapable reality was cold and sank into my feet, making my whole body heavy with unrelenting dread. The lion breaths faded into a slow gust of wind weaving down through the still gorge. Mustaffa studied the wind for a minute. Then he picked up the pace again, moving steadily among the large boulders of the riverbed. The sound of the breaths returned. For around an hour the lions followed, nowhere to be seen, their quiet grumbles always present. I kept imaging the lion tearing out from the bush, low to the ground. A professional hunter's story circled inside my mind. He had lost a client to a lion with three bullets in it. "There is nothing as fast as a lion when it charges low to ground like a beast out of hell," said the hunter, taking a shot of whisky. Maybe he was full of tall tales, but the story was in my mind.

What was a poison arrow going to do? And if Mustaffa happened to be attacked and somehow I lived, there would be no means of finding my way back. I guessed I would have to follow the riverbed down as far as it went, hoping it drained out into Lake Eyasi. If the lion charged he would probably devour me, because obviously I was the weaker one. The lion are aware of the Hadza. *I must have faith in their medicine,* I thought.

Mustaffa stopped, and separated three poison arrows from the bunch he held in his right hand. He slowly unwrapped the protective leather off the poison arrowheads. He handed me two.

"If the lions charge, shout what I shout. Shoot when I shoot. Stay still when I am still," he said, his face becoming fiercer than any face I had ever seen.

As we came toward a bend in the river veering off to the right, Mustaffa stopped again and placed the deadly arrow to his bow string. I did the same. A lion den was positioned on the edge of the riverbed.

"*Simba yupo,* lion present," he said.

"Shit!" I whispered.

Mustaffa did not look at me. His whole being was focused on the lion den. His voice rose to a thundering rhythmic chant. He moved, walking slowly past the den, his arrow pulled back in readiness. Grumbles came from within the den; dust seemed to rise out of it. Mustaffa's voice grew uncannily louder and louder, his face became more and more austere. The earthy lion stink filled my nose, as my eyes scanned the bones of many animals scattered in front of the hole. Then I realized that it was my turn to pass the hole. I wanted to turn back; several times on my journeys with the hunters I had wanted to turn back. But whenever I wanted to, there was no possibility of it. I looked at Mustaffa, hoping to gain some power. His face now held an endless pattern of age, his cheekbones piercing out of the skin, his dark eyes burning like coal fires. He looked like he had at the beginning, fearless. The hunter vision came to me at that moment when I needed it most. Mustaffa did not stop shouting, beckoning me to do the same. A year earlier I was with Sabina on a rock far in the bush watching the sunset. I heard a hyena, its hungry whine revolved over and over in my mind until I suddenly felt fear. So I focused on the back of Sabina's head to forget about the fear, and experienced the most profound acuteness; my eyes rolled into his eyes, everything I saw around me was connected to my hunger. Sabina's vision cut through the forest, afraid of no animal, no person, his hands seemed like blade and wind, and the strength was surging through his body. From that point on whenever I became nervous, I remembered the experience, the feeling I had looking into Sabina, and fear left me.

That hunter vision came over me — I shouted what Mustaffa shouted and passed the den, shouting but not feeling the words coming out, communicating some ancient message to the lion. Mustaffa knelt, crouched, also shouting, his bow pulled back, the arrow pointing at the den. As I passed him, he grabbed my arm and pushed me in front, telling me to go ahead. He stayed behind for a moment, then walked up to my side, staying close.

"We walk together now. I have told the lion not to follow us or attack us, because we come in peace. They may kill us, I told them, but they too will die in their attempt because we have arrows that hold their death. The lion will not come," he said. The mighty force inside him had now subsided. I knew through his change of expression that the danger had passed, but I will never know the extent of the danger.

We walked for some time, my one good eye examining the bush line. The riverbank grew steeper, rising twenty meters above the riverbed. The lions were no longer heard. The blue stones of the dry riverbed grew larger and larger. We

Medicine Horn Cave

leapt from stone to stone — each seemed to hold the underside of the sky, so blue, as if the stones' colors had dropped down, born from the sky.

"If we were Maasai, we would be dead now, the lions would have devoured us. They hate the Maasai. They know to beware of the Hadza, the lions are afraid of our medicine. When I was young, a pride of lions had attacked a Maasai *mboma* [a small cluster of homes] in the Ngorongoro Conservation Area," said Mustaffa, pointing to the east of the mountain on the high slopes where the Maasai live. "Every night the lions waited outside the Maasai *mboma,* the Maasai were unable to sleep. They heard about my father's medicine and searched many days to find him. When they finally found my father, they offered him a cow if he rid them of the lions. My father went with the Maasai and placed medicine around their *mboma.* The next night the lions disappeared, afraid of my father's medicine," said Mustaffa.

The riverbed finally dropped off into the blue winds, falling into another ravine a hundred meters below. The long stretch of Lake Eyasi was in the distance, its salt pools shimmering in the late afternoon sun. We had arrived at our destination. For some time we stood on a ledge near the lion cave, looking over the vista.

"Living in this cave allowed the hunters to see all animal movements below," said Mustaffa.

The cave was formed out of two immense spheres of ledge rock on a high bank above the last bit of riverbed. Mustaffa led me through the tall entrance, which was around thirty meters high. The cave ran back into the earth another twenty or so meters. He lived here as child when the riverbed was flowing from the rains, gushing over the ledge to the valleys below. The cave gave shelter from the rains and the mountain water was good to drink.

"My father shot two lions at the mouth of this cave. The *simba* had come to kill us," said Mustaffa, making a small fire.

"Come, Jemsi, many ancestors are now here with us. My father has made medicine. His grandfather came to my father in his dream and showed him the medicine that will protect us from all dangers. My father's grandfather died in this cave. He is now with us," said Mustaffa, who began his guttural chants to the ancestors. He pulled out from his shoulder bag two small horns attached to a beaded necklace.

"Are those dik-dik horns?" I asked.

"They are horns of the dik-dik's rare brother who no longer lives in these forests. I have only seen one such animal in my life. These horns have

been passed down from my grandfather, they are powerful medicine horns. Do not let the rangers see these horns," he said, showing me the medicine stuffed in the horns.

"The medicine in this horn was made by my mother, and it must be carried with you always. No living animal, spirit, or demon will harm you while you wear these horns." Mustaffa then got up and knocked on the cave wall whispering to the stones. The cave floor was covered in guano and dry bones.

"How did your mother know what to use for the medicine?" I asked.

"She dreams such things. The ancestors come into her dreams and tell her which medicines to use. If she cannot understand the dream, there are old women who know the secrets of dreams, and the knowledge of medicines. My mother's mother also died in this cave," he said.

"The second horn is filled with medicine from my father. This medicine will give you the power to talk with the government, police, and all those that need to listen to your words in order to help the Hadzabe," he said, spitting into the horns, passing them around his back from hand to hand. He suddenly stopped, caught in midmotion, as if listening to something from deep within the cave. Still captured in this posture, he began an answering chant to the ancestors, conversing with them for two or three minutes by only moving his lip muscles, his body stone still. His hands were the next to move, shaking the horns, and he leaned and spat into them again. He paused, his head turning toward the unheard voices, toward the cave wall. Then he stood up and walked to the wall, knocking while shouting out single phrases. Absorbed in a meditative state, he began passing the horns around his feet, around his midsection and chest, around his face, and finally rubbed them over his arms and legs as one might dry themselves with a towel. He then spat again into the horns, passing them around the whole of my body, breathing out his chants, gripping my shoulders, whispering to my neck and stomach. At one point he lifted my feet, talking to them, demanding that they listen to his orders. After he set my feet down, he asked me for my water bottle. He carefully poured a small amount of water into each of the horns.

"We drink now," he said, taking the shot of water medicine from the father horn, feeling the substance for a moment, leaning over. He then took the water bottle and carefully poured my portion, placing his thumb over the top of the horn, shaking it to mix the medicine. He passed it with both hands and motioned me to drink.

The mother horn was next. He sprinkled a bit of its medicine water on

my feet and his feet, smiling, saying, "With this medicine your walk will lead you away from harm's path." We both drank.

"I now tell you many secrets about my family and the cave, about the Hadzabe, things you can never tell others outside the tribe. You must know about these secrets for the medicine to work. If you tell anyone, you will lose your first wife and eventually go insane. *Shetani* will haunt your mind."

He told his tale of dreams and coming into manhood, the relationship the Hadzabe have with the ancestors, and why I was brought here to drink this medicine.

When Mustaffa was finished, he placed the horns around my neck and said now we are brothers brought together by the horns and the ancestors' knowledge. He showed me the elephant and rhino tusks that his ancestors had pounded into the cave's wall a long time ago.

"When the grasses were tall as the trees and no one else but Hadzabe lived in this land," he said.

"In what way you will help the Hadzabe I do not know. Soon the forest will be destroyed and the animals will leave. As I told you, I have five children and there are questions in my mind that have only entered the mind of the Hadzabe now," he said. His eyes looked down into his chest, and he began singing.

"What does the song mean?" I asked.

"This is a hunter's song, a song that my father sang in this cave when he was a child," he said, falling into the song, drifting into his memory.

I listened, absorbed in its slow harmony. The song seemed to express the tired strength and fulfillment of returning from a hunt with meat. A song, I imagined, that had evolved among those who risked their lives during the hunt.

Mustaffa slowly lifted himself and walked over to the end of the cave, where the cave ceiling angled down into the earth. He laid on his back and took a little bottle from his shoulder bag and began scraping off some substance from the cave wall into the bottle, possibly mold. He sealed the bottle with a small rag, tying string around the bottle neck. He then got up and walked out of the cave.

"*Twende*, Jemsi, let us go. We must leave before the night comes. There is another way back so we will not have to pass the lions again. Now they are more dangerous because the sun is leaving the sky. They will soon go hunting. I did not realize lions were still living in this ravine."

"Mustaffa, what was that you scraped off the wall?" I asked as we began climbing up the steep ravine.

"Medicine for my unborn child. I had a dream that if I did not retrieve this medicine where my mother's mother died, the child would be born dead. Hold on to the small trees and pull yourself up. Be careful of snakes when we get to the rocks," said Mustaffa, leading the way.

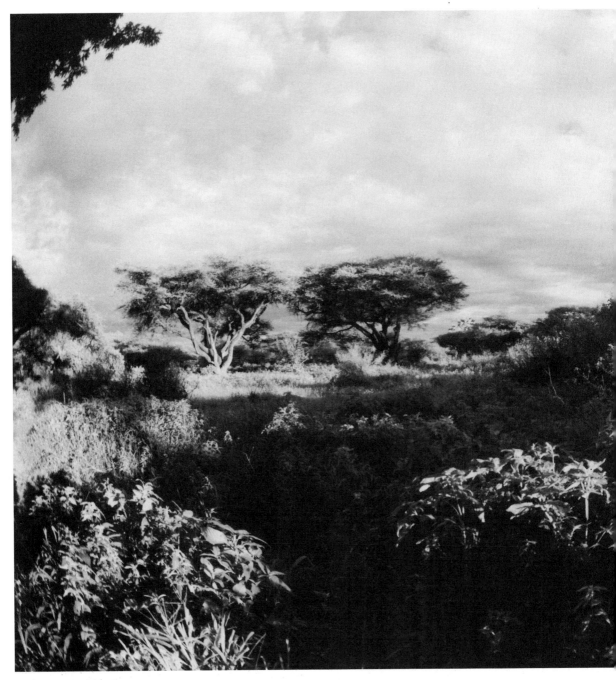

Oasis Near Big Tree Camp

4

A Night in Mang'ola

Mustaffa and I made it back to a Hadza camp on the outskirts of Mang'ola late in the evening. Many fires glowed, cutting through the blackness. We had seen the fires before hearing the distant laughter and singing. The steep slopes from which we descended ran gradually down into the wide savannas that are the last plateaus before Lake Eyasi and the oases. We walked through the small acacias toward the distant wavering fires appearing and disappearing between the tree spaces. I felt safer with the three-inch horns around my neck and possessed the sweet clarity and confidence gained from such a strenuous and dangerous safari. An exalted feeling seemed to rise between Mustaffa and me; maybe it was seeing the camp, knowing that we would soon be relaxing by the fire. He excitedly broke into a long laugh as he began to tell me a story.

"I was walking through the forest near Edamaghay and came upon a bunch of Swahili drinking banana wine. They invited me to sit down, saying, 'If you share some of your honey, you can drink with us.' I was carrying a big jar full of honey. I agreed. We all drank for a long time until the men left. I would have left also, but there was this mama who sat across from me. She kept staring at me, grinding her hips on the log she sat on, singing a song in her native Sukuma language. Suddenly she got up,

twirled herself around, placed her hands on the log she had sat on, and raised her wiggling buttocks into my face. She pulled up her *kanga* and said, '*Haraka, haraka!* Quickly, quickly give it to me before my husband returns.' So I gave it to her. When I was just about to finish I heard the men returning, but I didn't want to stop. As the men entered the drinking space, I pulled out, grabbed my bow and honey, and took off into the forest. I could hear the men and the woman shouting at each other. I wasn't finished, so I snuck back around and hid in some bushes near the group. I motioned to the woman, who was then sitting with the men. She saw me, and quietly excused herself to the bathroom and came to where I was hiding. I started again, but she began to moan, '*Nataka asali yako, nataka asali yako,* I want your honey, I want your honey.' She was too loud, the men came running after me. I barely escaped. I decided it was best to return to my *nyumbani*. On the way home, I saw a young Mang'ati woman fetching water. I called her over and showed her my honey. She agreed to help me finish if I gave her some of my *ba-la-ko* [honey]," said Mustaffa with a smile.

"Did the Mang'ati know how to give good *jiggi*?" I asked.

"*Ndiyo,* yes."

Mustaffa looked at my necklace right before we entered the firelight in the camp.

"Other Hadza will feel this medicine, and if they are bad Hadza and want to hurt us, they cannot, the medicine in these horns will protect us. Show no one these horns," he said, tucking the necklace underneath my shirt.

Many Hadza were gathered at Mzee Mateo's camp. Sabina grabbed our hands greeting us, leading us to a place to sit by the fire. A buffalo skin was hanging from a tree. The people in the camp were celebrating, cutting up meat and roasting it in the coals at the edge of the large raging fire. Some hunters had killed a buffalo and brought the skin and meat for their young children, who lived with Mzee Mateo's strong wife Segwita. Many of the children sat on their fathers' laps, playing with their chewed-up food. Adawan, the hunter who killed the buffalo, sat proudly by Mzee Mateo. He was a big man, his bow almost the size of Mustaffa's. He yelled for my attention, "*Karibu,* welcome," throwing me a piece of meat. His wife had died the previous rainy season from a pain in her stomach. His children now lived with Segwita. He comes in from his wandering hunter's life once or twice every month to see his children.

"Adawan, where did you shoot the buffalo?" I asked.

"Near Endofridge. I saw a wildebeest stuck in the mud on the edge of the lake bed. As I walked to kill the wildebeest, I saw the buffalo near a pool of water. It saw me, too, and by the look of it, I had little time to climb the

small acacia closest to me. *Na-ko-ma-ko* horns smacked right into the trunk, just missing my ankle. I shot the *na-ko-ma-ko* through the eye from the tree as it stared at me. It ran off sideways crying with anger, and when it returned to kill me, I shot it in the other eye and one arrow in the heart. If the poison was not strong I could have died. Two more blows from the buffalo charge and the tree would have fallen," he said. Everyone was absorbed by his story, staring at him; not a word came from any man sitting around the fire.

After Adawan finished, Sabina, one of the men sitting by the fire, came over to me and whispered in my ear, "Jemsi, *wengi waHadzabe, wengi kina dada,* there are many Hadza that have walked in from Sanola, many women, let us search the fires for women. We will buy *pombe* and go back to 'big tree' camp. I will tell the women to come to your camp. There are too many people here tonight. OK?" said Sabina

"*Hamna shida,* Sabina, no problem," I said.

Sabina ran off. Within five minutes he was back, "*Twende,* let us go."

Mustaffa shouted at Sabina in Hadzabe saying that we were tired. They argued for a while. Then Mustaffa began laughing.

"Come, Jemsi," said Mustaffa, "it is better if we go to the 'big tree' camp, we can rest there."

Before I knew it, twenty or so men, women, and children all paraded behind Sabina, Mustaffa, and me, heading down to a camp under a large acacia in the oasis — a camp that I usually stayed at when I came to the Mang'ola area.

"*Mti mkubwa, Mti mkubwa, Mti mkubwa,* the 'big tree' camp," they sang.

The "big tree" camp was an old Hadza camp. It later became the first market site back in the 1960s, the market was moved to another place, and soon people forgot about it. It was hidden by a grove of fan palm trees in a swamp on a high piece of land that sheltered us from the growing village of Mang'ola. Time and farming had changed the shape of the oasis. The Swahili, Datoga, and Mbulu who came to fetch water did not know we stayed in the oasis. This privacy was important, otherwise we would be bombarded by visitors every day looking for food and money because of the color of my skin. The Swahilis' paths led to the new market site; they no longer knew that our camp existed, believing the irrigation channels had flooded the old market site.

The huge acacia that grew on the small island offered ample shade for our camp. It gave a calming sense of protection, and sometimes monkeys lived in its limbs. They could not escape their curiosity about the newcomers, but once they realized there were Hadza underneath them, the monkeys screamed off in panic, leaping into their tree-limb roadways, just barely escaping the

arrows. If I was in the camp alone, the monkeys would almost eat from my hand, they did not fear me one bit.

A strong breeze constantly came through the palms and down under the acacia, keeping the mosquitoes away. And a fresh stream of drinking water flowed from the ground not far from the acacia, uncontaminated by the cows and donkeys the pastoralists brought to drink in the oasis. All day long one could hear the insane screams of goats and donkeys running toward the water after their hot hours grazing in the semidesert terrain around the oasis.

Often, sitting there under the acacia in the prehistoric-looking oasis, I imagined the abundant game that once thrived here before the Swahili came and formed the village of Mang'ola. The older Hadza knew the lore of the oasis — stories of hippo hunts and rhino charges, giant woman-eating snakes, crocodiles, and lion attacks. For hours by the fire, they shared these stories. Now only a few leopard lived in the oasis — the only possible danger other than the poisonous snakes. The animals had been hunted or driven out by the growing village, which was positioned on the western side of the oasis.

They called it Gor-o-fan. We came there once or twice every couple of months depending on where we went in the bush. The hunters always wanted to return to the oasis the day before the market. They would spend the money they earned during our safaris on shoes, *kangas*, knives, metal for arrows, anything that might help their families, and then, of course, *pombe.*

The wives, girlfriends, children, old men, and women usually stayed with us for the few days we lived at the camp. Meat was present. Most likely there was *pombe,* and every Hadza knew this. So any Hadza in the area showed up at the *"mti mkubwa,"* "big tree" camp, ready to dance, drink, eat, and talk about their journeys in the bush. If we were returning from the west, Sitoti would pass on messages from other Hadza he had come across who seldom ventured to the east, Hadza from Sukuma and Matala. Many people came to Mang'ola just to hear news from these distant relatives and stayed for the festivities.

The Hadza in the area were happy when we returned to Mang'ola. Hadza from Endamaghay and Sponga would sometimes walk all day to attend our dances, which were becoming legendary. These dances were never planned, they came on as naturally as a sudden gust of wind. Depending on the people present and the energy of the collaboration, the dance could last a half an hour or a full night. Sabina, Mustaffa, Gela, Localla, Sapo, Sitoti, and Sindiko — the hunters who took me on these long safaris — were leaders, medicine men, famous hunters, singers, and spirit-talkers; after being away from their fami-

lies and friends, sometimes for months, the excitement of returning with money in their pockets and stories brought a great joy to the hearts of many Hadza. When these dust-covered, sun-baked hunters walked down into the Mang'ola oasis, their energy was explosive — their anticipation had built up for days before arriving.

We often filled the final nights of each safari with stories of what we would do when we returned to Mang'ola; how many women we would perform the *jiggi* with, how much *pombe* we would drink. But after three days in Mang'ola, the excitement had been released, and we were totally exhausted. Everyone would be complaining that their money was gone, the wives would be yelling at their husbands for acting like children, and so it would be time to return to the serenity and peace of mind found in the bush.

"There is *shetani mkubwa* that lives here, the big demon. We become crazies, drinking ourselves to death. Never again do I want to come to Mang'ola," Mustaffa always said. Sure enough, at the end of the following month or two, Mang'ola was pulling us back.

The big open air market was the fifth of every month. Mbulu, Datoga, Sukuma, Chagga, Isanzu, Jita, Iramba, Langi (all different tribes), a few Maasai women who are not afraid of the Datoga (if the Maasai men came there might be fighting), Swahili, all came to this market — trading cows, goats, sheep, donkeys, bulls, knives, arrows, poison, bush medicine, snakeskin, wild game, food, drink, tobacco, beads, radios, pans, and shoes made from tires, everything one could sell was traded in these markets. Hadza from the entire Lake Eyasi region often arrived out of the bush carrying their bows, trading what they could. Some came to drink or just sit around and share stories. Many of the Hadza came the night after the market, when the wild boars ventured out from the oasis to eat the forgotten remains of the slaughtered sheep and cows. The boars were easy targets for the hunters. So, whenever we came into Mang'ola it was near the market time, either a few days before or after.

Sometimes, when we were a few days late for the market in Mang'ola, there were young unmarried hunters waiting for us. They had already gathered firewood, started a fire, swept out the camp, prepared everything and finally had decided to live there, proud of their work. As we broke through the underbrush, to the clearing of the camp, the young hunters leapt up to help us unload. A few would run off to fetch drinking water and the others sat staring at us, giggling, eyes bursting with anticipated joy. The young men returned with the drinking water from the springs. There was nothing like that water, especially after drinking mostly muddy insect-infested water in the bush. The rest of us immediately went to bathe in the fresh, cool oasis stream a few

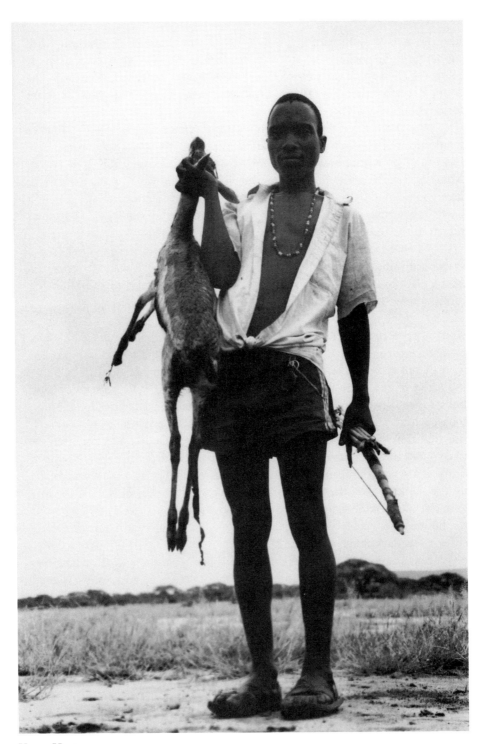

Young Hunter

hundred yards from the camp. Weeks of dust were immediately washed from our bodies as we laid in the stream's currents. The initial shock of the cold water was almost unendurable after the semidesert heat, but the rejuvenating powers were indescribable. It made you smile and begin to sing. The hunters could not contain their joy — washing, splashing, and giving each other haircuts with used razor blades they had found in the town or with their knives.

Sitoti often tore out of the stream naked to run after young Swahili girls who would pass by with their water jugs. They would scream in utter terror and run off, dropping everything. The hunters got such a kick out of this that they goaded Sitoti to wade up like a slow-moving crocodile and leap at the Datoga women washing their clothes. We would carefully walk up the stream until we spotted both the tired old and the beautiful young women washing clothes and filling their water jugs in the stream. Papyrus branches hid us from the women. We pushed Sitoti forward, he prepared his breath, and slipped in like a smooth fish, swimming or floating as close as he could get before being spotted. He then disappeared under the surface of the water. I never knew how he learned to swim so well.

Within a minute he came leaping up with amazing force, right in the middle of the women, waving his arms, moving his hips violently, and wiggling his member. The women panicked, falling into the water, running into each other, screaming in desperation, shouting in horror: "Water demon!" He screeched like a baboon, and if he was really carried away, he leapt on the women, pulling them into the water, humping their heads or backs while imitating fierce lion sounds flawlessly. This terrified the women, but before they had a chance to stab him or realize who he was, Sitoti leapt back into the deep water, vanishing under the surface without a trace. The women stopped washing their clothes at each water hole he attacked. And before long, rumors of the "water demon" spread rapidly throughout Mang'ola.

We returned from the bath, laughing, sometimes chasing each other through secret footpaths only the Hadza knew about. The tea or coffee, which I had previously taught the young men how to prepare, was usually ready. A few older Hadza were now present at the camp, wandering in while we were bathing. In camp, the old men and women spent their time telling and listening to stories, eating, and drinking the *pombe*. The old men were excellent *askaris* (camp watchmen) because the five days we were in camp, they didn't leave. During those days the old men usually shot a bird or two, gathered firewood, made arrows, built shelters, or played with the children. Often they led the dances, rising to the occasion after a long day of resting.

All sorts of children arrived at the camp at different times of the day; even if the mothers were a bit weary of coming to our camp, they sent their

children, knowing they would be well fed and looked after. In addition, all of Sapo's and Localla's young boys would show up, totaling eleven, ranging in age from two to fourteen. These boys were wild, always playing tricks on the old men, and shooting varieties of birds and monkeys. The older boys always managed to steel Localla's fresh supply of *bangi,* which infuriated him. He tried to find the thief and chased after the boys, who screamed in joy, knowing there was no real danger from the gentle old Localla. Each boy who was caught would plead innocence and say it was another. Localla would believe the caught boy and go after the other. The boys loved to get Localla riled up because everyone laughed uncontrollably. Usually by the third boy Localla tackled, his anger had been released. Localla just held the boy and also began laughing. He loved his boys. He often demanded that the older ones join us on the long sa-faris. He knew it was important that the boys heard the stories and learned to hunt. Localla usually found his *bangi* mysteriously returned to his leather bag an hour or so after the ordeal, when the boys had smoked enough.

After the evening fell, two or three hunters and myself sneaked off to the village of Mang'ola, when the others were not paying attention. We had to do this secretly or everyone would follow us. It took the others a few hours to realize we were gone. I preferred to go to Mama Ramadan's — a small shanty home made up of a bedroom and one L-shaped room with a rickety table that she used as the bar. At Mama's place, "Mama" sold safari beer trucked in from Karatu. Mama was a very tall, big-boned Mbulu lady with four kids. She loved the Hadza and held no prejudice toward them. When we arrived out of the dark night, entering from the shadows, she usually gasped at my appearance.

"My God, Jemsi, you lose too much weight," she might say.

She would shout at the Hadza, telling them to leave their bows and ar-rows outside. The Mbulu men who were drinking inside her bar usually got up and left, rather frightened by a rough-looking white guy wearing ten or fifteen necklaces and carrying a bow; they were even more terrified of the strong hunters next to me, whom they did not see often in such close proximity. The Hadza are exotic, foreign, and incomprehensible to the "modern" Tanzanian. Sometimes potato salesmen, tough-looking street boys from Arusha, who were driving the Indian merchants' trucks to pick up tons of potatoes and onions in Mang'ola, would be sitting in Mama Ramadan's drinking warm Safari beers, exhausted from their long journey on the horrific roads. When the hunters and I walked in they were totally stunned, fascinated by the hunters, shocked by my appearance. Sometimes they just burst out laughing or became silent. After half an hour or so of observing us, they began buying the Hadza and me drinks, learning the Hadza songs, asking about the animals, spirits, and about the bush. When they started asking me questions, I told

them I was a Hadza albino with a German father. The Hadza confirmed this and that was that.

The men from Arusha's connection to the land and tribe was one or two generations removed. They seemed to yearn for something they could not explain, yearn for this closeness to the land. Talking to the Hadza allowed them to address their yearning. This yearning made others in the bar hate the Hadzabe, because the Hadzabe reminded them of something they did not understand, something that left a pain in their psyches, something empty that needed to be filled. They were uneasy, so they immediately struck out at the Hadzabe, calling them baboons before quickly disappearing out Mama Ramadan's low door and into the night.

The first evening after returning from the lion cave, we spent a few hours dancing and eating buffalo meat at the "big tree" camp. Mustaffa, Sabina, Sitoti, and I decided to sneak off to Mama Ramadan's. Sitoti persuaded us to

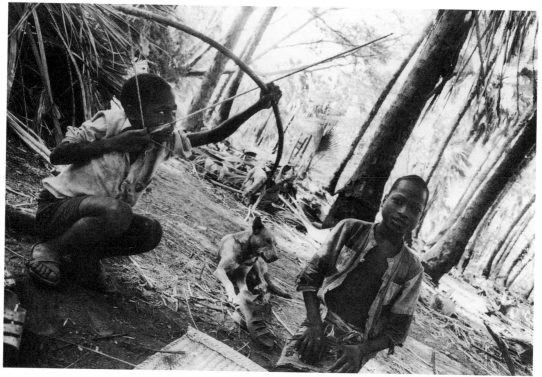

Localla's Boys

leave, saying he was convinced the large acacia was going to fall over that night. Many of the larger acacias had fallen that year, attacked by some insect, but it was highly unlikely the "big tree" was going to fall. Nevertheless, Sitoti's enthusiasm was convincing.

"We all will be crushed while we sleep. We can go to Mama Ramadan's and sleep there."

"*Siyo kweli, Sitoti antaka kumtia Mama,* this is not true, he wants to give it to Mama," said Sabina.

"The tree won't crush Sitoti, Mama will. Do you like Mama Ramadan, Sitoti?" I asked.

"*Ndiyo,* yes. *Ndiyo, ndiyo, ndiyo, ninapenda mkubwa,* I like big Mama," said Sitoti, giggling like the little devil he was. He then broke into a wild, primal birdlike dance, shouting, "*Ndiyo nataka,* yes I want," in deep beat-breaths.

"Ndiyo nataka, ndiyo nataka stu-stu, ndiyo nataka stu-stu."

Immediately Mustaffa and Sabina began to move their shoulders, possessed by the intensity of Sitoti's sudden energy. For thirty or so seconds all three reached to something beyond the simplicity of the immediate impulse, a raw flowing dance celebrating the power of their libido; a gratitude for the driving strength it brought. When they finished, we all broke into laughter and ran down the path toward Mama's place.

Again, Mama was shocked at my thinness and immediately ordered us to sit down. She quickly swirled her big body into her bedroom-kitchen, humming to herself, ordering her daughters about. The bedroom-kitchen was hidden behind a pink sheet that took the place of a door. Soon Mama burst through the sheet with five big plates of beans soaked in a thick lamb broth. The plates stayed unmoving on her wide forearms, which were as big as her neck. She set them on the rickety table, ordering us to eat up. Suddenly she screamed and hit Sitoti with a lightning sweep of her arm. He flew off the bench like a thrown rag doll and smashed against the wall, then slowly lifted himself up and ran out the door into the night without a sound. Mustaffa and Sabina paid little attention to this, they were too busy eating.

"Mama, what did he do?" I asked.

"*Sitoti mbwa ndogo,* he is a little dog," she said. "Shut up and eat. At least you're a good boy."

"Why did Sitoti run out like that, Sabina?" I asked.

"He is going to cry."

"What?"

"He's going to cry. Whenever he is hit hard in the chest he cries and gets embarrassed if he is in front of others. He'll return. He won't try to touch Mama's crotch any more tonight."

I was already full from the buffalo meat so I didn't eat the beans. Mama Ramadan opened three Safari beers and placed them in front of each of us, then she sat down and ordered one of her girls to bring her a bottle of *konyagi*.

"You're in for a big one tonight, aren't you, Mama?" I asked.

"*Hapana,* no, my throat hurts, the *konyagi* [sweet liquor] is good for the throat," she explained while looking at me, rather hurt. "Jemsi, why don't you eat?"

"I ate buffalo meat earlier, Mama, I am *nimeshiba sana*, very full," I said, taking a bite of the beans. "This is so good! I wish to God that I did not eat the buffalo meat before coming here."

Mama Ramadan smiled shyly. She grabbed my plate and pulled it toward her. She smiled, then gulped down the food in a few seconds. She handed the empty plate to her skinny, frail daughter standing behind her in the candlelight.

We sat for a while, still unaffected by the drink, talking in Hadza and Swahili about the safari. The other Hadza had not arrived yet — they knew that I was more generous after a few hours at Mama Ramadan's.

Then Mama got up and looked out the window, shooing away the town drunks hanging on her window bars, begging for drinks, insanely mumbling to themselves. If they didn't leave, she pulled out her big stick and ran outside to smack them away. They cowered and hid in the shadows until they felt it was safe to return. It was a bit horrifying to look up and see these ghoulish harmless madmen staring in at us, begging with their eyes.

When Mama drank Konyagi, she asked all sorts of questions, usually the same ones concerning America. Mama Ramadan had somehow come across an American "big woman" fashion magazine. She often pulled out the magazine to show me the models marching down the runway with Texan cowboy boots and hats. The Hadza would crowd around and comment on the hats the women wore, asking me if I could get them each one. The accompanying story in the magazine was about a famous African-American cowgirl rodeo champion, who held the world record for wrestling down a bull. The images of the runway models and the wrestling cowgirl profoundly excited Mama's imagination. Of course I indulged this and created outlandish adventure stories about superstar cowgirls flying in spaceships filled with thousands of male slave lovers. The Hadza always confirmed my stories and nodded their heads to enhance the stories' credibility, sometimes adding their own interpretation, which they pretended they knew from previous stories I had shared with them in the bush. Some would even say that the cowgirl was their girlfriend when they came to visit me in America. Mama didn't believe that.

The first storytelling session with Mama Ramadan had spellbound the Hadza, who later asked innumerable questions in camp. I told them I was

making everything up, there was a bit of truth but not much. After that evening, they took part in the exaggeration game; we all improvised stories, feeding off each other, eventually leaving Mama Ramadan in exalted ecstasy concerning America. If Mama was totally swept away with the stories, she would give us free beer or forget to charge for the food. The exaggeration also worked when the men from Arusha asked the Hadza questions. I played a big part in the Hadza tall tales.

"Is it true?" the men from Arusha might ask me, wanting to believe the story, whispering to each other that the *mzungu* (white man) would tell the truth.

"*Kweli*, sure it is," I would say. "The Hadza always tell you the truth. You must eat baboon shit and put kerosene on your balls if you want your dick to grow as big an elephant's."

After three or four beers the Hadza began singing and dancing. More Hadza would enter out of the night, and within an hour or two, the singing and dancing echoed through the village of Mang'ola. The songs drifted out of the windows into the still night air. Mama Ramadan's felt like a ship in the great sea of night and stars. Four or five hours would go by and Mama would beg us to leave, saying it was time for her to sleep. Or, if she was in a festive mood, the party went on until the beer ran out and I had spent all my money. Then we would rush out singing, as we danced under the moon shadows of the palm trees on our way to the "big tree" camp in the oasis.

One night, while we were telling Mama Ramadan about the adventures of the cowgirl, a tall, skinny Datoga man walked in followed by two others carrying long-bladed spears. He had circular scars dragged around his eyes. "Leave your spears outside!" shouted Mama. The tall man looked like he had AIDS. He followed Mama's orders and handed his spear back to the younger ones, who disappeared out the door. He was staring at me.

"What are you staring at?" asked Sabina.

"Nothing, sir, *humna shida, bwana*," said the tall man in an amazingly gentle voice that went against every aspect of his dreadful appearance. He turned away and found a few seats in the other corner of the room. The two Datoga warriors came back in, decked out in their traditional dress — beads, silver bits of metal woven into their long braids, red robes draped over their lean bodies, and long daggers hanging from their hips. Mama Ramadan went over and served them Safari Lager beers. The two younger men had similar circular scars around their eyes. The tall, skinny man was obviously older and of some importance by the way he ordered the younger ones around. At that moment, Sapo, Localla, Mzee Mateo, Mzee Wapo, Adawan, Mama Segwita,

and ten or so Hadza came from the camp and crowded into the small room. We tried to make space at the long table. Mzee Mateo sensed Mama Ramadan's impatience and ordered the younger hunters and women to leave; the place was already filled to its capacity. Mzee Mateo had brought his own *pombe* and the singing and dancing began as he pulled the bottles from his shirt. Soon everyone was leaping around dancing and singing. Mama Ramadan, not wanting to disturb the joy, hid in her bedroom the bows and arrows the hunters forgot to leave outside (one never knew what might happen between the Hadza and the Datoga). The Datoga were so taken by the energy of the dance that they also joined in, performing their traditional leaping dance to the Hadza songs. Sitoti burst into the room out of the darkness, performing his bird dance. While all the commotion was happening, I felt a long, thin hand softly pressing my shoulder. I looked up and saw the slender Datoga smiling.

"Come outside with me, come," he said, leaving through the door.

"Sabina, *twende,* let us go, this man wants to talk with me."

Sabina grabbed his bow he had hidden from the eyes of Mama Ramadan under the table. Sabina was never too far from his bow, and didn't like anyone to touch it, especially a woman. The ends of his bow were covered with lion fur.

The night swallowed us and the stars seemed to fall from the vast sky. It was so black you could only see three or four paces in front of you. I felt a cold, ghostly hand on my elbow. I swung around, a bit spooked.

"What do you want?" I demanded, thinking the skinny Mang'ati was just interested in money for some drinks. So many times I have come across people in a similar setting. They will befriend me, calling me outside or to a corner in a room, with an expression that says everything in the world would be destroyed if I did not hear the matter at hand. They most often ask kindly, if they are not an obvious drunk or beggar, making up some long story about why they need a beer, a car, new high-top tennis shoes, a camera. Only a few have something they want to trade or sell — this I find polite. One evening a woman pulled me aside and opened her blouse. Between her bosom and down past her crotch was an elephant tusk tied to her body. It was incredibly erotic. She asked me to buy the tusk, because her children were sick. I believed her, but I told her she could go to jail for selling such things. She said her husband had found the tusk on an elephant that had died naturally in the bush. Her husband was now dead.

"Give me a beer," another man once said.

"I wish I could, but I haven't had food today and a beer for weeks. I have no money," I replied.

The man invited me to live with him, and I did, helping him work his

farm every day in southern Tanzania. He became one of my best friends. In most cases the generosity of those asking would probably exceed mine if the situations were reversed.

The tall Mang'ati convinced us to follow him through the night, explaining that someone wanted to see me. Sabina told me not to go, but I was curious about the Mang'ati (Mang'ati is the name the Maasai gave the Datoga, which means "respected enemy." Around a hundred and fifty years ago there was a battle in the Ngorongoro crater and the Maasai were triumphant in pushing the Datoga down into the lower regions.).

We walked for twenty minutes until we came to a large baobab tree outside of the village. There was a fire with three men sitting around it. As we walked into the fire circle, the tall Mang'ati shouted out a strange scream in his native tongue. A giant figure of a man sitting by the fire said, "*Karibu*, welcome," in Swahili. The tall skinny man ran over to the big man to help him stand up. The big man came forward to greet us. He was a monster of a man, maybe seven feet tall, weighing about five hundred pounds, wearing an intricately patterned cloth wrapped around his body. He held a thick ebony walking stick and his hair was white. He was a rather terrifying figure in the firelight. His hand moved out from under the cloth like a slow-weaving snake as he greeted me with his eyes. He didn't shake my hand but tapped it as if I was a child, motioning me to sit down.

Both Sabina and I immediately sat down, awestruck and a bit frightened by the man's presence. There were two other elder Mang'ati men sitting around the fire. Neither of them looked at us. They each gripped a bottle of *pombe* in their laps. Sabina leaned over to me and whispered, "*Wachawi*, witch doctors."

The big man had a bellowing voice that echoed through his body. He turned and said something to the others in his native tongue. There was a moment of silence that followed. Then one of the elders carefully passed us a bottle of *pombe*. Sabina grabbed it, saying "thank you" in Mang'ati. The other pulled out a little glass container and sprinkled something on the back of his

thumb. He sniffed it, falling back for a moment. He regained his composure and poured some more. He leaned over to me, offering the powdery substance on his hand. I looked at Sabina.

"*Tum-bac-tay-o*, tobacco for the nose, no problem, Jemsi," Sabina said.

The entire time the big man was standing still looking down at me with a giant pumpkin smile across his face. I sniffed in the snuff and almost fainted, falling backward, coughing violently. The snuff was burning my nose. The big Mang'ati roared with laughter, and the tall skinny emissary came running over and patted me on the back, taking my face in his hands.

"We are sorry. We are sorry your nose is virgin," said the emissary.

The big man shouted out some orders and the emissary dropped my head and helped the big man sit down. The big man moved himself about, getting comfortable on his cowhide, and thus began the meeting.

He positioned the emissary as a translator between us. He spoke in his native tongue and had the emissary relay his questions to me in Swahili. Before he began to talk, he pulled out a small glass and poured some hard-grain *pombe* into it and took a shot. He then filled it again and passed it on to me. His eyes did not leave me, he looked through me as if studying every minute detail of my character. It was his concentration and presence I felt more than the eyes, because it was dark. I was glad it was dark, so I didn't have to see his disturbing eyes. When he spoke to the emissary, his giant sausage fingers and hands jumped about. And while the emissary explained the question, the big man's fingers and hands continued the dance. He looked like a deranged symphony conductor.

"Do you have a gun?" asked the emissary.

"No, I don't have a gun."

"Did you ever have a small gun?"

"Yes," I answered. The emissary translated this to the big man, and patiently waited for the big man's words before turning back to me.

"He dreamt that you lost your gun and you have been searching for it."

"I never lost the gun," I said.

The emissary's smile vanished. Again he relayed the message. The other elders leaned in to listen. The big man shifted his huge rump on his cowhide, his hands shooting out in different directions. His wheezing breath slowed. He pulled out the bottle and filled his glass, downing it in a second. He filled my glass. It took me about four tries to finish. He then filled and handed Sabina the glass, who finished it as fast as the big man. The skinny emissary took the glass and demanded some. The big man said something in Mang'ati, and the emissary seemed to plead. When the big man didn't budge, the skinny man

asked the other elders for some *pombe*. The big man hit the skinny man with lightning speed on the side of the head. The skinny man fell to the ground.

"My son has the body of a woman, he drinks too much," said the witch doctor in broken Swahili, concerning the emissary.

The big man was about to say something else but was captured in mid-sentence. He leaned back and came forward, letting out a monstrous burp that almost extinguished the fire. Both Sabina and I began laughing. This did not seem to please the big man, whose face looked twisted after the burp. I quickly excused our laughter, saying that his burp has the power of a truck's horn and only the strongest of men can burp like that. The big man chuckled. I further explained that he must please women with such power. The big man suddenly pulled the skinny emissary up, pouring him a half glass of *pombe*. The skinny man took the glass with shaking hands, quickly downing it. The life came back into him. The big man whispered in the emissary's ear in the odd-sounding language of Mangatiga–Datooga–Barabaig.

"Do you have a wife?" asked the emissary.

"No," I answered.

"Do you want a wife?"

"No."

"Why don't you have a wife?"

"I am young and moving about in my life, I don't have the time or money for a wife. I prefer many woman."

"The old man dreamt that the gun is hidden under your bed. If you give him a car he will give you his daughter."

"Tell him I need four daughters for a car. My *mboo* [penis] is very hungry and wouldn't be satisfied with one daughter," I said.

As the emissary translated, the big man laughed with joy. Strangely my head started to feel dizzy as the big man's laughter grew louder and louder. Suddenly I could not hold back and vomited into the fire. I had to lay down. A look of horror passed over all the elders except the big man, who kept laughing.

"Virgin nose, tobacco makes him sick. He will have to sniff more tobacco in order to have four daughters of mine," he said, laughing even harder to himself.

"Come! You sleep at my place, but first we stop and get more *pombe*."

"I cannot, but thank you very much," I said, unleashing another seizure of vomit.

"Virgin nose," chuckled the big man.

Sabina seemed to sense my anxiety, and politely, while helping me up, explained to the Mang'ati witch doctor that my stomach had an insect in it from a long safari.

"It is best that Jemsi walks," he said. The elders agreed. But the big man shouted, "Wait!" He ordered the emissary to help him up. He brushed himself off and looked at me, his hands flying everywhere. His voice rose quietly, mysteriously poetic, soft, talking now in a gentle tone.

"I have something for you," he said, reaching inside his cloth as his immense godlike figure walked over to me. His hand shot out, grabbing hold of my hand. His watery eyes looked into mine.

"I will tell you the secrets of the rain. Please come visit my *mboma* in one week." He then carefully placed a ring onto my middle finger and smiled. I looked down in utter astonishment and saw the ring my sister had once given me, that I had lost two years ago in the bush. I looked up at him, baffled.

"You take too much Mang'ati tobacco in your nose. I will teach you to take a good amount; the tobacco will make you strong for women."

Sabina grabbed my arm, pushing me into the night.

"*Kwaheri*, good-bye," I said.

"*Mchawi*, witch doctor, *mganga*. *Mchawi* is one that passes spells on others to hurt or kill them. *Mganga* is one who heals people from these bad spells. The big man is both. Powerful witch doctor, changes the rain," whispered Sabina as we headed back to Mang'ola town.

I met up with the *mganga* several times after our first meeting. Once, Mustaffa, Sabina, and I had dinner at his *mboma*. When we arrived, he was lying on a giant cow skin and ordered us to do the same. For an hour we just laid there staring at the stars; he said nothing and so we said nothing. Finally his many young sons cut off the heads of a few chickens and he ordered us to get up and eat. That night we sat around talking about why the trees were being cut down, and that the oasis water was being poisoned with onion pesticide. He was very keen on the subject and believed if the trees go — everything goes. He was going to call a large meeting with all the Mang'ati and tell them to stop cutting the trees down. He did say that he had used all his strength to bring the rain, for three years there had been no rain and his people's cattle were starving to death. "The rain will come, but the work has made me tired with so many trees gone. Trees help me create rain!"

One morning when several hunters and myself were about to depart on safari, his emissary came to the camp and wanted to talk with me.

"You must not go into the bush without petrol for starting your fire, the rains are coming soon. The old man told me to tell you this," said the emissary, who sat down to have some tea.

The old man was right. El Niño hit hard and life would have been

extremely uncomfortable without fire. Petrol was the only way for us to start a fire on the move, because the wood was soaked through.

People said they saw the *mganga* often at night talking with trees. They also believed the *mganga* could disappear and turn his hands into snakes or become a hawk to make sure his cattle were being well looked after. If you wanted to hurt or kill someone, "you better have a good reason" or else he would turn you into cow dung, dry the dung out, and burn you as fuel for his evening meal. When you talked to him there was a blade that wavered in his eyes — a kindness for those who deserved it, or destruction for others. The town officials and thieves were terrified of him.

"When I watch the children around the school, they are very unhappy. Government is about as useful as a tick's swollen ass," the witch doctor said to me and the hunters the night we ate at his *mboma*. "The world is being devoured by governments and policies, they will destroy everything and make people believe they're happy with nothing."

When I returned a year later, the witch doctor had died. Before knowing about his death, I felt something was missing from the landscape. A change was in the air, in the trees — a feeling extremely difficult to explain. I think when these traditional people die, who knew nothing of the western world, their perception of time and space also dies — and thus, an original expression dies. An opening of energy is gone forever.

Now, if you ask the people in the area when the rain is coming, they say, "We do not know. The witch doctor always knew, but now he has gone to *Mungu* [God]."

While Sabina and I walked back to the village of Mang'ola after meeting the witch doctor for the first time, we heard the old man's voice fifteen minutes after we left the fire. We stopped still and listened. Nothing.

"*Samahani* [excuse me]!" said the big man, standing a foot behind us. Sabina and I fell to the ground in surprise. His mountainous figure was looking down at us.

"There will come a time when you must go on safari alone. *Sawa*, OK. You hear, OK. Take no one but yourselves. I will tell you when the time comes," he said as he turned slowly and walked back down the path, disappearing in the night.

"Where did he come from?" I asked Sabina.

"*Mganga mkubwa*, big witch doctor," whispered Sabina as we both began laughing.

When we finally arrived at the "big tree" camp in Go-ro-fan after talk-

ing with the *mganga,* the old men had the fire roaring, and they were singing. Sapo, Sitoti, and Mustaffa were lying around with some young Hadza women who were married to Mbulu men in Mang'ola. These women had left their homes that night, homes that I think no longer made much sense to them. When they found out that we were returning from our long safaris, they usually waited for us in the camp. The women would lodge a few days with two or three of the hunters, making love, laughing, and dancing, then realizing how much they missed their tribe. Their Mbulu husbands would never come looking for them; they were afraid of the poison arrow. If the wives did return to their Mbulu husbands, they said they had spent time with their families.

The Mbulu men look down upon the Hadzabe, and often a Hadzabe woman does not make a good farmer's wife, because she knows not the way of the farm life or keeping up a home — and thus, she is usually not treated very well. Often these Hadza–Mbulu wives never return to their Mbulu husbands. Taking leave on safari with us, they become the surrogate wives of the hunters for two or three weeks, slowly shedding their Mbulu Swahili clothing. And then one morning they suddenly say good-bye to us, and disappear to live with another Hadza clan deep in the bush.

Mustaffa walked over to the fire and excitedly explained to us how some tourists had come into Mang'ola and paid Mzee Wapo money for taking pictures of his permanent Hadza home on a high plateau above the oasis while we were at the lion cave.

"We have a big bucket of *pombe*!" exclaimed Mustaffa. "Mzee became so drunk that he passed out with the money in his hand tonight. I have protected the money for him."

"Sure you have, Mustaffa," I said.

The Hadzabe are being destroyed by the money the tourists give them. The money is spent on *pombe.* The specialized safari companies are now taking tourists to remote areas, where the Hadzabe culture is still somewhat intact, and are paying the Hadzabe cash. So the men have a new burden with this money and decide to walk to the closest towns and drink themselves into oblivion.

At first I was apprehensive about drinking with the Hadzabe, but the Hadzabe had been doing it long before I arrived, even back in the old days with honey wine. I was going all the way, even if I took part in one of the many things that were destroying their culture. The drinking was a link in the chain. In defense of the *pombe*-drinking, Mustaffa once said to me, "It is good the old men drink, they are not tricked by the government to send the children away to school."

I later understood Mustaffa's statement when we visited Hadza clans

that had been totally destabilized by outside organizations, influencing them to live a way that was incomprehensible to them. Many of the older men who selected themselves as leaders imitated the movements and gestures of the westerners who were convincing them that it was good to send the children to school. The drunkards would have nothing to do with these outside organizations. One afternoon a Hadza man, who had been converted into a Christian, showed up at a large Hadza camp and started violently preaching to his tribesmen. The drinkers finally tied him up and sold his bibles to get more *pombe.*

As we sat there drinking the *pombe,* Sabina got up and left.

"I'll return soon," he said.

Young Juhano came over and showed me a leopard skin. He and his friend had been hunting the night before and saw the leopard in a tree. His friend shot it and the leopard came after them, dropping dead right at his friend's feet. I told Juhano to be careful. He sat back down and put some *bangi* in his pipe.

"I told my friend not to shoot it. But he was hungry and not afraid," he said.

"Don't show the skin to any of the *wazungu* [white men] who live here, they may report you to the police."

I felt someone tugging at my shirt. I turned around to see two very beautiful young women standing with Sabina, who was smiling.

"*Twende,* Jemsi, *kina dada wanataka pombe,* the girls want *pombe,* let us go back to the village."

"*Sawa,* OK," I said, a bit tired.

So we were off to Mang'ola again, a poor example of Nyereres's *Ujamaa* (brotherhood) village. Actualizing the idea of the *Ujamaa* village, the government in the sixties and seventies pretty much wiped out tribalism by taking people from the north or east, repositioning them in the south or vice versa. The people were forced to live together in these little towns. They adopted patriotism, and the next generation slowly lost the vital flowing connection to their original tribal ways, becoming pawns to play their roles in the emerging economy.

We entered the town singing, passing the Datoga *waboma* (plural form of *mboma*), Mbulu mud huts, concrete tin-roofed Swahili homes. The arc moon broke through the sky and the distant dead volcanoes took form under the moonlight. The little town seemed so ridiculous on the edge of the bush. We found our way to Mzee Rhapheala's, a more primitive *pombe*-bar-home than even Mama Ramadan's. She was now sleeping, and had kicked Mustaffa and the others out. A pungent smell of goats and cattle hung in the air as we

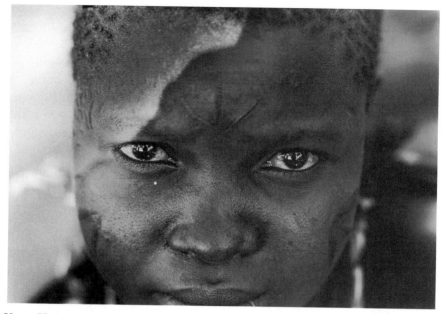

Young Hadzabe Woman

entered the dimly lit Mbulu home. All the old drunken farmers looked up from their sitting logs. Mzee stored his livestock in the room adjacent to the bar. We found some stools in the corner. The young women, a bit afraid of the place, snuggled in close to Sabina and me. Sabina again gave me one of his knowing smiles, and shouted for a bottle of *pombe.*

Mzee Rhapheala was at one time a Makonde fishermen down near the Ruvuma River in southern Tanzania. Along the coast, the river is the natural border that separates Tanzania from Mozambique. Rhapheala loved talking about the sea when he had drunk too much. When he was young, he was a Mozambique bandito fighting the Portuguese. He said he became sick of the fighting and early one morning swam across the river and set up his home in a little palm tree grove. His stories of hunting shark in a carved out *mtumbwi* (wooden canoe) kept me and the hunters intrigued for hours. In the seventies he moved to Arusha to work as a truck driver, then followed a Mbulu lady he met in Arusha to Mang'ola. He married her and set up a home. He claimed that he had about ten children near the Ruvuma River, four in Arusha, five here in Mang'ola with the first Mbulu wife, and now two with a middle-aged Hadza woman he lived with. His Mbulu wife had moved to Karatu.

The Mzee didn't mind the Hadza and was generous, but could become

extremely tough when he thought he was being taken advantage of. He was old now and didn't really mind that his Hadza girlfriend only lived at his place when she felt like it, returning to her various Hadza boyfriends in the bush, or staying the night with whomever gave her a good sum for the evening.

In the past, when we came back from the long trips, I usually gave the hunters' wives food or the men's salary. The wives would pull me aside and beg for the money, knowing well the men would waste any money on *pombe*. But the longer I was in the bush the more I became like these hunters, feeling the hunger, the raw energy surging through me, the libido. There came a point where the wives no longer trusted me.

Mzee Rhapheala smiled when he saw Sabina and me in the corner of his *pombe* bar.

"You have been away for too long. Here is a bottle for you on the house."

We sipped slowly. I could never come to this *pombe* bar for long, it was worse than Mama Ramadan's, because within half an hour the Hadza would come pouring in looking for a free drink. Everyone would start dancing and singing. If Mzee Rhapheala was in a good mood, he would pass out the bottles, laughing — in a way, similar to Mama Ramadan. Many of the older Hadza were his good friends. He knew some Hadza songs, and was one of the only men living in the town who treated his Hadza friends as equals. Soon, he too was singing, dancing, and drinking. The old farmers in the bar who didn't like the noise would leave, grumbling. Any Hadza in the area would appear out of the darkness with his bow and arrows, greeting friends who handed him a shot of the *pombe*. He gently grabbed hold of the small glass or bottle, slightly shaking. In reverence he lifted it to his lips, his eyes passing over all the surrounding faces, then he would smile and sit back down.

The Mang'ola village reminded me of a tiny fragment of modern civilization that is bound to grow like a fungus. But for now, the town's seduction is not too overwhelming for the tribal groups that pass through it.

Sabina and I had sat in Mzee Rhapheala's with the beautiful young ladies for about half an hour. Both of us were silent. I was thinking about what the witch doctor had said.

"Why does the witch doctor want us to go alone on safari?" I asked Sabina.

"It is dangerous not to listen to *mganga*, he knows something we do not. We must go on safari without the others."

"When? I thought we were going to the mountain of Nudulungu in the next few weeks."

"I cannot go to Nudulungu."

"Why?"

"I do not want to go," he said, taking a sip of the *pombe*.

"Is it dangerous for me to go?" I asked, concerned. "The witch doctor said we must go alone on safari."

"The time has not come for us to go alone. The *mganga* will tell us when it is time to go. Do not worry about going to Nudulungu with the others,"said Sabina, sleepy-eyed in the dark corner of the *pombe* bar.

"OK," I said, noticing I was about to pass out as the sun was rising.

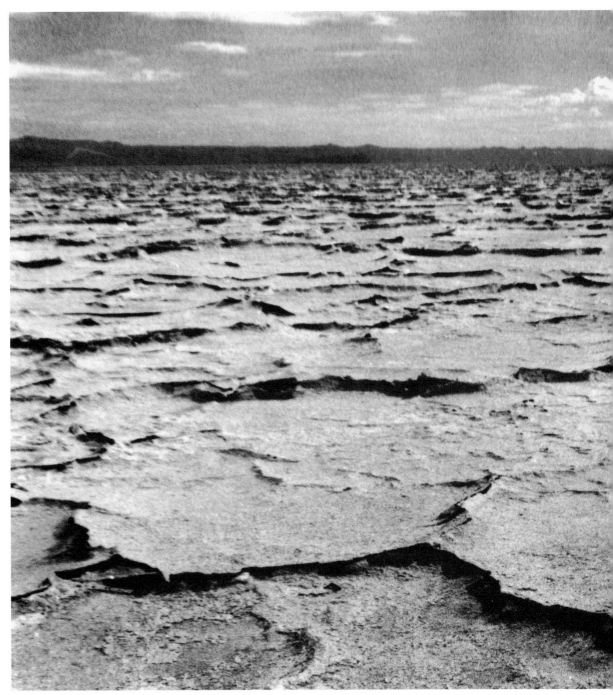

Lake Eyasi

5

Search for Nudulungu

We walked along the dry lake bed in the morning, following the ostrich tracks, through the dry mud flowers — patterns of crystallized salt cracking under our steps. The vast, dead lake bed retained evidence of all the animal migrations over the past three years, like a lost language written and forgotten. Tracks of every sort: hyena, wildebeest, vulture, leopard, dik-dik, lion, elephant, hippo, and gazelle headed toward the mountains bordering the Serengeti along the northern side of Lake Eyasi, marking out the path of our direction. In March, if the rains came, all would disappear. The lake bed, over a hundred kilometers long, would fill up with water. If the rains came.

We were headed to the mountain named after Nudulungu, the Hadzabe Christ-like figure. Nudulungu came to the Hadzabe a very long time ago. He was a big man who could carry a wildebeest on his shoulders and hunted with a spear. He healed the sick with his touch and taught the people many things. A very long time ago, he told all the Hadzabe to gather at Nudulungu — a mountain named after him. "Here is the home of the Hadzabe," he said, and then disappeared before the people's eyes.

Nudulungu was known to have split the waters of Lake Eyasi, helping a family escape a great

danger. He could walk on water, and demons feared his presence. Some of the old men had seen Nudulungu in their lifetime. He appeared to them from the spirit world, when they were alone in the bush, thirsty and hungry. He brought them tobacco, fresh meat to eat, and water.

"He lived with the Hadzabe in the time when the hunters still painted on the rock walls," said Segawazi. "These are markings etched on his mountain's walls," explained the old man as he drew circles and crosses in the dirt.

The old men had told us that a safari to Nudulungu could be dangerous at this time of year, due to the lack of water. It was the dry season, and there had been a drought for three years. The old men spit medicine into the fire to see through the window of fortune. After interpreting what they foresaw, they discussed the plans of our safari with the ancestor spirits. Several days and nights passed before they advised us to go.

The evening before we left, the old men told us in detail where the water sources were located. We would come across possibly four oases that could have water, maybe fifty miles between each other on the northwestern side of Lake Eyasi — a four-day walk through southwestern sections of the Serengeti and into areas so remote that even pastoralists do not herd their cattle there.

"Remember," said one old man, "Nudulungu will give you a sign. Then you will know if you should turn back or continue on."

"Nudulungu will find us, we will not find the mountain," said Mustaffa, as we departed.

Gela, Mustaffa, Sitoti, and I had been walking six hours under the hot sun, headed for one of the oases in the distance. The salt dust rose into our nostrils. Space and distance is an illusion on the lake bed, and the distance is unending, unfading as it blends into the heat mirages. White saliva gathered at the corners of our mouths. We knew there was no turning back. I hoped there was water in the oasis, the hunters didn't seem to care. My tongue was swollen. I focused on the earth, listening to the sound of our footsteps to forget about my thirst. They were laughing and singing, at times also walking in silence. Every once in a while one of the hunters would say, *"Jua kali sana*, the sun is angry."

Gela was an older man. He spoke little, tended the camp, and disappeared every early afternoon for about two hours, sometimes returning with a dik-dik or small birds. His dreams seemed to guide his hunting. He would wake, and say something like, "I dreamt of a *kwe-ka* bird near the big tree where Mzee Saga was killed by a buffalo, I must go now."

Mustaffa had the means to sabotage the safari to Nudulungu or make it a successful one. In fact, it was his idea to go. He seemed very curious about

my interest in Nudulungu. What his reasons were, he never fully explained. Possibly his motive was monetary, because he knew, as always, I would be giving him a gift at the end of the safari. But Mustaffa was a hard person to figure out. There was always an underlying shaministic quality in everything he did, which made me often think he was a hypocrite. One moment he would condemn the modern world, vowing never to leave the ways of his culture — and the next, he would beg for money to buy sunglasses he saw a Swahili wearing in the Mang'ola village. *Tamaa* (greed) had possessed him, said many of the other Hadzabe. But once in the bush Mustaffa was free from the temptation of the Swahili village, and his true self emerged. He would gather medicines, talk with the spirits or the ancestors, and spend the nights sharing stories. He knew all the Hadzabe lore. Maybe Mustaffa had no concept of hypocrisy. Maybe everything one does is genuine when one has to survive. It was just that his world was changing and he was confused; anyone would be perplexed in his grim situation.

It truly seemed that on this safari Mustaffa felt some responsibility toward me; toward my search which, in a way, he had adopted as his search. I had a need to see the mountain of Nudulungu, and hunters like Mustaffa sensed this need and would assist me if they knew they could gain something from it — or possibly there was another reason why they helped. Others would go simply because the journey came to them, especially the younger men without wives. "*Wanyama wakubwa,* the big animals live near Nudulungu," they would say excitedly. Why not go, their stomachs would be full.

Most hunters were not just going to leave their responsibilities to guide me to a mountain legend created over hundreds of years by excited imaginations enveloped in the warmth of the campfire. No. In exchange for their time, business had to take place. *Ugali* (cornmeal) and tobacco must be given to the wives.

One can't take a hunter off his individual path. Although they live in an egalitarian society, with everyone sharing everything, by the time a child is around eight years old, he can survive on his own. Existence is about survival — an everyday duty, especially when the game has dwindled and there is a drought.

The hunters must also have *ugali* on the safari, in case they are unable to find animals. The food I had brought on our previous journeys was always gone after the first two days, and the food left with the women was probably devoured in one. Hadzabe don't just feed their immediate family, they feed whomever hears that they have food. Within an hour or so of my arrival, maybe twenty or thirty Hadza may show up at camp expecting to be fed. There is no concept of rationing. They have it, they eat it, even if it takes all night. After we ate all the food I had brought, we then subsisted on hunting and berry gathering.

Tobacco and more importantly, *bangi,* were necessities if the men were going to stay away from their family clans and become a new wandering clan with me. If the tobacco ran out, we sent emissaries to find it. Sindiko or Sitoti were the best. They would sometimes be gone for two days, walking incredible distances to find the tobacco, and even farther to find the *bangi.* They always came back. Someone like Mcolocola or Soto would take the money, full of good intentions in the beginning, but they would just happen to come across a *pombe* bar, or a pretty young woman, and that was that. Sitoti and Sindiko foresaw the temptation, and would first inform me, saying something like: "The farm closest to where we are now has tobacco and *bangi.* The wife's husband is in Sukuma at this time of year, and if I give her a little extra money she'll give me *jiggi-jiggi.*" So I gave them extra money, and they would return a day later with the tobacco and *bangi,* smiling faces, and a good story to tell.

If we had no money then we would use the "white man" ruse, telling the Mbulu that I, "the European," would pay them later, it's just that our money was lost. The Mbulu farmer would walk the distance back with them. I would serve him tea, and make him believe it was OK to give us tobacco and maybe a chicken. We would pay him when we saw him next. This usually worked. And when this didn't work, we were so far away from any farm or Hadzabe clan that we had to rely on each other to survive — or rather, I had to rely on them or else I would die. The hunters were gentlemen, always making me feel comfortable and watching over my shoulder for possible danger.

On the nights when there was no tobacco, we would talk about tobacco, then tell stories to keep our minds off the nicotine cravings, until eventually we just forgot about it. Hunting took over and became the passion. Without women, *bangi,* or tobacco, it was difficult to stay in the remote bush longer than three weeks. The hunters may be in the bush for three months, but there was a difference between totally undisturbed, rarely-visited-by-the-hunters bush, and the normal, lived-in bush. The mountain of Nudulungu was in the deep, deep, deep bush.

As our journey progressed, we finally came to the first oasis. The water hole was dry, scorched by the sun. Mustaffa said there were many lions in this area two years ago, roaming about the man-size boulders, hunting the dry lake floor, now peeling away like dead skin. For three years the relentless sun had burned every ounce of moisture from the land. No one knew where the rains had gone, except the Mang'ati witch doctor, and he didn't reveal this information. Some said the rain would not come because the Mbulu were cutting all the trees down, others claimed it was the Mang'ati's cattle that ate all the grass,

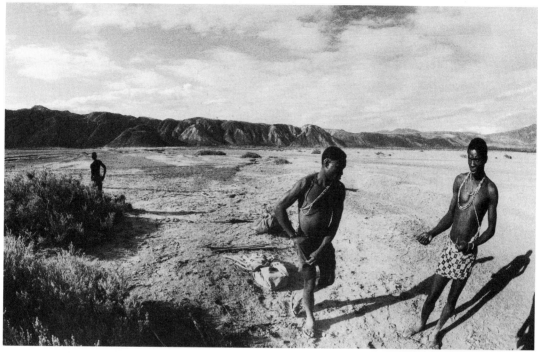

Passing Tobacco

and many believed a demon had come to destroy the world. The Hadzabe agreed with whatever opinion was presented at the time. They were still healthy, but complained about the lack of meat and water. They were never as desperate as the farmers. In time of famine many are known to seek out and live with the Hadzabe because the Hadzabe are always able to find food. Often we came across a broken, blank-eyed farmer on the edge of starvation, cursing the heavens for the lack of rain, roaming aimlessly through the dry oasis like a madman returned from the desert. The trees in the oasis were all leafless skeletons. There was no place to hide in the shade. To traverse the dry lake bed one must endure the inescapable sun. The wind was the only relief.

Gela decided to follow the northern edge of the lake bed, which disappeared into a rising escarpment. As we walked thirst was the only reality. The men no longer sang or laughed. If there was no water in the next oasis we would be in trouble.

At dusk we came to the second oasis. Small acacia trees and brush shrubs jetted out into the lake bed. A few wildebeest grazed on the shrubs and the ostrich darted off into the cover of the trees when they saw our approaching

figures. There was a small Mang'ati *mboma*. Their dogs started to bark as we approached. A young, beautiful man came out with four children hiding behind him. He was smiling, and told us the water was near the mountain's edge, we must follow the stones. He understood our desperate thirst and ordered his children to run back to the *mboma* and bring us a bucket of drinking water. The farther one goes into the bush, the more friendly the people.

We sat down and shared news. The kids returned laughing, a bit afraid of the white man. We drank, thanked the Mang'ati, and carried on through giant irregular boulders strewn around as if thrown amongst the palms. We walked through mazes of small ravines that became greener and greener as we closed in on the water. We could smell the water. Mustaffa started to sing a song about water: "The water, the water, let us go drink the water." We climbed up a hundred yards, following a steep path. The rocks were covered in cow dung, not a good sign for fresh water. We came to two pools surrounded by steep rock faces, reflecting the evening sky. A narrow path led to the water. Cow urine and dung rose to the surface at the muddy edge of the pools — an obvious sign to boil the water. It is hard waiting for the water to cool down, when your tongue is burning from the salt dust; when you can barely swallow or talk. The Mang'ati man had saved us to a degree, but we were still extremely thirsty and dehydrated.

We made camp underneath a large, angled rock face, sleeping on smooth boulders. First we gathered wood for a large fire, as Gela sprinkled medicine around the parameter of the camp to protect us from dangerous animals. We made sure our bows were near us as we slept; there were many leopards in the area. The men had spotted tracks near the water hole. With the dung water we boiled some tea and ate the last of Sitoti's dried giraffe meat, which was not enough to satisfy our hunger after the long day of walking.

Night soon came upon us. The fire roared as it devoured the drought-dried branches, its flames accentuating the tired, hungry faces of the hunters. They had seen many dik-dik on the way to the water hole, and wanted to wait in their sleep for the moon to disappear into the night in order to hunt with my flashlight. The light stuns the eyes of the dik-dik, making it an easy target. If the moon is high and strong the flashlight will have little effect. So the hunters waited, sang softly to themselves, listening to the sounds of the fire, drifting slowly toward sleep. They had improvised this style of hunting to overcome the shortage of animals, but they seldom had flashlights or batteries. Hunting by torch is rather gruesome and unnatural, as well as illegal. But the Hadza's game is survival, and survival is no longer easy with the destruction of their environment. They will never kill or take more than they need. A dik-dik would usually offer itself to us and immediately we returned to camp.

Normal times for hunting were from dawn until about 10 A.M. or when the hot sun cooled into the last vestige of light. Sometimes the Hadza wait hidden in grasses, near water holes under the light of the moon. Night hunting with the flashlight is the last resort — because night is also the prowling time for lions, leopards, and snakes. In the last couple of years several Hadza have disappeared while night hunting. Without a flashlight, or a bright moon, one does not leave the camp.

The night was moonless when Sitoti woke me. The hunters were ready to go. Mustaffa took the lead, finding his way down the narrow stony path. The light slowly panned the oasis forest for movements and eye reflections. There were none. So we made our way to the open lake bed. Sitoti believed there might be some *swala* resting in the small shrubs growing along the lake edge.

The open expanse and the night winds blasted us as we left the cover of the oasis. We hunted for hours following boulderless land where the slopes of the escarpment blend into Lake Eyasi.

Mustaffa found a dry riverbed suitable for a brief rest. We sat to smoke our cigarettes in order to hide from the salt winds. Sitoti started to make a little fire using his fire stick. When he finished he said, "Hadzabe do not walk the way the wind takes the smoke from the fire stick. *Shetani* are there." He then got up and walked in the opposite direction, disappearing into the night.

"Where is Sitoti going?" I asked Mustaffa.

"*Sijewee.* I don't know."

Mustaffa began talking about the lions he and his father had hunted here years ago.

"When I was a boy there were many animals: elephant, rhino, giraffe, thousands of wildebeest, and buffalo. Now there are few in this area, due to the lack of rain. But there are lion. I saw a mama *simba*'s tracks today, not so far from here. Remember, if we come close to a lion in the bush, kneel down slowly, and do not take your eyes off the lion's. Make sure it knows of your bow. In the past, when we were hungry, we followed the lions, and they led us to food. My father and I saw many lion and followed them. The land told us that they were hunting a giraffe. We walked from the early morning until the late afternoon, finally arriving at the high stone over there," Mustaffa pointed to a rise in the rocks about a half-mile away.

"From that rock we saw the lions were eating the giraffe. We waited for the lions to fill themselves and sleep. Then we came upon them slowly. When I shot the large female lion, it leapt into the air as high as a small tree and then ran off. My father shot the other. It ran straight toward us, then veered, disap-

Giraffe Eaten by Lion

pearing into the bush. We hid in the grasses, knowing the lion would return looking for us if the poison did not kill it first, which it did. We took the giraffe meat, and then found and skinned the lions. They had not run far. The poison was strong."

Sitoti returned with his shirt full of *un-dush-she-be* berries, a sweet orange berry that grows profusely in the dry season.

"There is big snake near the *un-dush-she-be* tree," he said, passing us each a handful of berries. He then sat down by the fire and packed some tobacco into his stone pipe.

After finishing the orange berries and smoking, we walked back into the salt winds and followed the night expanse. The hunter's intuition led us to two *swala* resting near whistling thorn trees. Mustaffa quietly stopped.

"*Pale, pale,* there," he said.

The *swala* were not moving. Their orange eyes glowed in the fading flashlight, resting like soft leaves, unheard on the ground. We approached. Mustaffa was ten feet away, getting ready to shoot, when Sitoti let an arrow fly

Zebra

from quite a distance behind Mustaffa. It missed, and both *swala* took off, disappearing into the swallowing night space. Mustaffa started shouting angrily in Hadzabe at Sitoti, who began laughing hysterically.

"*Tamaa,* Jemsi," said Mustaffa, frustrated, "*tamaa,* greed, greed, Sitoti is possessed by greed. We are going to have to take him to the witch doctor. He does not know when to shoot. How can he shoot from that distance in the night? You are a child, Sitoti!" Sitoti began laughing even harder.

We looked for Sitoti's arrow and then turned back. I followed Mustaffa closely. While hunting, one is never too far in front or behind the other, walking in a natural unison. Following him when we hunted, I started to learn all the reactions and signals of Mustaffa's body language. His whole being was absorbed into the land; as he walked the land seemed to run through him, transforming him into many personalities and presences, because one must take on different guises to hunt such a wide variety of animals. Mustaffa knew everything about the animal tracks, the sounds, the changes of the wind, the

time of day, and how they interplayed with the movement of the animals. The land helped him understand the animal's motives, their thoughts, their drive. He could re-create what had occurred.

"The zebra was shot here. Wounded, it returned to the mass herd. Hundreds and hundreds of zebra," he might say. Mustaffa could then pick out which tracks belonged to the wounded zebra.

He could also foresee what would be.

"Look, Jemsi, the ostrich will come to the water hole tomorrow morning. They were drinking here yesterday."

The land also held memories, passing moments that would never occur the same way again. The hunters respected these memories, for they held the hunters' history. Mustaffa would say things like: "I killed a buffalo near that rock," or "In that tree my friend was eaten by a leopard," or "Over near that hill I lived with my father for two months hunting ostrich," or, "Do not whistle, there are *shetani* haunting this area."

There were different demons for different areas, some were friendly and some were extremely dangerous. The most haunting places were the old Hadza camps, especially those that had been forgotten, remembered only by a few or rediscovered on our safaris. No one doubted spirits. Walking through these ancient sites, especially in the evening, I saw in my mind flashes of the ancestors huddled around the fires. The memories of the dances, the hunts, the laughter, seemed to be held in the rocks and trees and to fall into us as we passed, like a petal blown into one's hair. An eerie silence was felt, containing some sort of portal or passage of cyclical time, from the sleeping world of the dead into the present moment of the living. Mustaffa, Gela, or Sitoti would knock on the rocks and shout to their ancestors when we came to the old camps. This was to greet the ancestors. They then explained why we had come. They asked the ancestors for advice and invited them to sit down and have a smoke. They talked with the ancestors as if they were talking with another Hadzabe man, understanding the spirit's needs, personality, anger, and humor.

One starts to experience the folds, dimensions of the land, chambers, shelters, sources of food, sounds, smells, seasons, movement of animals, blossom periods, the time of good honey, and the time of baby birds. They are all interconnected. The time of honey is right after the time of baby birds. The time of berries and roots supplements the dry, parched landscape before the rains when animals return. The Hadzabe have moved through the different regions of Eyasi searching for sources of food for so long that their way of life is as natural as breath. They know when the animal herds will come to the different regions seeking out the water sources. Sponga and Gilgwa are excellent places to find baby birds and honey in what we would

call the fall and spring; Endofridge near Endamaghay is good for animals in all seasons.

The land no longer holds any threat, it becomes a reflection of your state of mind, of your perception. The land is a part of you and you of it. All is balanced and you are no longer concerned about having food tomorrow; today will deliver or the next. You are cold at night, you freeze in the rains, but the slight fire keeps you just warm enough, and when the sun comes out in the morning, you lay on the warming rocks and with your whole cold being truly welcome the sun. When you haven't eaten for two days, the honey someone gives you after searching for hours is a gift like no other. When the hunters return with meat, the whole clan, gathered under a slight rock cover in the vast forest, explodes into song, laughter, and dance. Or maybe there are just two or three people, but their expression of joy leaves a fleeting temporal mark needed by the forest as it needs rain. Then, suddenly the rain comes, and the next thing you know there is a torrential downpour, and a mud slide sweeps away your camp; the fire is gone, you are cold again. You huddle together to stay warm, and you sing to forget the discomfort. The rain dies. You think you can rest, but then you hear the mosquitoes coming. The Hadza live beyond expectation. They are open, totally open, as the tree is to the rain, the wind, and the storm. I was thinking about all this when Mustaffa suddenly whistled and stopped. He knelt down, we all knelt down. It was now black night, and my flashlight batteries had died. We were following the starlight.

"*Simba,*" said Mustaffa, pulling out his arrow.

"Are you serious?" I whispered.

Sitoti crept up to Mustaffa, also pulling out his arrow, whispering. Both Mustaffa and Sitoti grabbed my arm at the same time, "*Simba.*" Mustaffa told me to get my poison arrow ready. We knelt, our bodies forming a natural triangle. There was no cover. Each of us faced a different direction. The wind was hard and shifting. The lion breaths rose up and disappeared, sounding far away, then close.

It was difficult to tell in the vast space of the dry lake bed where the lions were located. A roar broke out, its echo filling the whole dome of stars and night, the rocks, then dying to dead silence. The salt winds burned our eyes straining to see into the blackness.

"*Simba anajua sisi tuko wapi,* does the lion know we're here?"

"Yes, but the lion has gone now."

We waited for ten or so minutes, listening. As we got up to continue the hunt, we suddenly heard running footsteps and voices. We knelt back down onto the warm lake bed. A group of fifteen men ran by twenty yards from us, unaware of our presence. The hunters definitely did not want them to see us.

"Who are they?" I asked

"Maasai, cattle robbers. You can tell by the way they run. They are going to raid the Mang'ati, or already have," said Sitoti. "Some Maasai have teamed up with Somalians, coming all the way from Kenya to steal the Mang'ati and the Mbulu cattle." Before leaving on this safari we were warned about the dangers of the cattle raiders. So we waited to make sure the Maasai were far gone.

Slowly, through the salt winds, we carried on. As we walked, I was thinking about the ancient lineage of the Hadza perception; a perception that may reach far into the early roots of the human subconscious and its archetypes. Societies, cultures, countries, kingdoms have come and gone, while the Hadzabe have continued, almost unchanged. *Why have they lasted? Is it because of what they have learned: their harmony with the natural environment, their unconditional sharing, their lack of judgment, of condescension — no religious dogma, no perversion of the mind? Or was it simply their isolation from the outside world?*

They are free, absolutely, fantastically free with an indescribably profound knowledge of the land. They have numerous whistle languages, hunting languages, animal-track languages. But huge volumes of their knowledge, their wisdom are disappearing with the destruction of land and game. One of the last of the oldest cultures has now met its demise, and not by its own hand.

What is the loss? The Hadza's profound absorption into the moment, and their ancestor access will disappear. Probably when I return in fifteen years, some of these men I am now with on this star-void dry lake bed, humming to themselves, will be watching TV and eating Pop-Tarts.

You live with Hadza for two months in the bush — two months in the real bush — and when you return, even the smallest of towns seem contaminated and polluted; towns that before you thought were part of the forest. For the Hadzabe food will always come — it is in their faith in this that their freedom lies. The freedom from never having taken the leap into the insecurity of not controlling one's food supply.

"Jemsi," said Sitoti, breaking my contemplation.

"Yes, *unasemaje,* what did you say?" I said.

"*Unataka maji,* do you want water?"

"Please, thank you."

He handed me a little canteen he had acquired somewhere, filled with water.

* * *

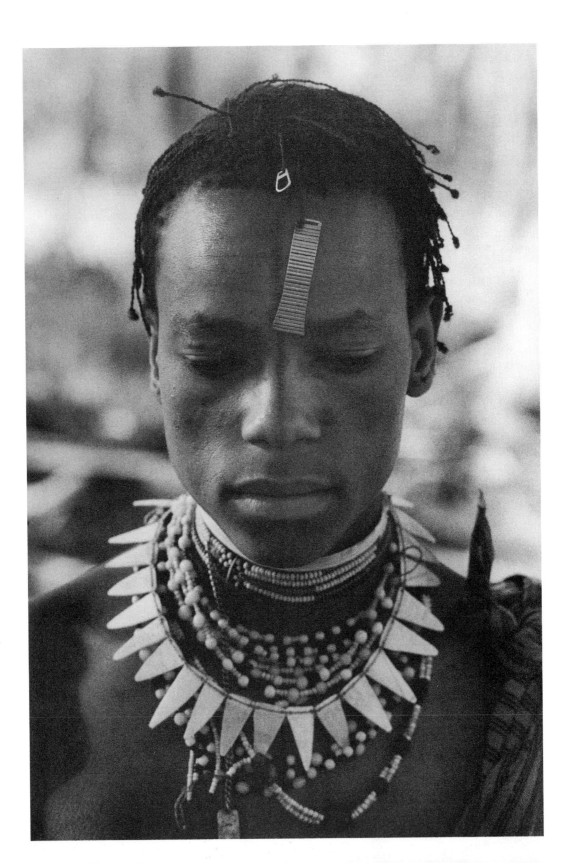

For three more hours we walked along the rocks and down small ravines, hoping to come across wildebeest drinking. Tired, we sat and smoked. Sitoti told us a story about his father. He said that back in colonial days the Mang'ati were killing all the Hadzabe, very often for fun, and raping the women. The Mang'ati loved skin oil that made their skin soft, oil from animal fat. A white hunter gave Sitoti's father a can of petrol to help the men with their fires during the rainy season after they had tracked an elephant for him. So, Sitoti's father and two other Hadza went to a large Mang'ati *mboma*, where many of the men that were causing the Hadza problems had gathered. They told the Mang'ati they had a gift for them. "What is it?" asked the Mang'ati men. "*Mafuta ya mzungu,* it is the white man's oil for the skin, it makes your skin soft," said Sitoti's father. So all the Mang'ati, twenty or thirty of them, violently took the petrol can from the Hadza and started to rub the petrol all over their skin. One of the Hadzabe lit a match the white hunter had given him. Then he flicked the match into the fire the way the *mzungu* did it. He flicked the match at another Hadzabe. The Mang'ati laughed and were amazed how he shot the fire off the matchbox into the sky. A big Mang'ati grabbed the matches from Sitoti's father and lit the match. "No, no you flick the match like this if you want to see fire in the sky," said Sitoti's father. So the big man flicked the match at his friend and his friend went up in flames, screaming. The big man tried to help his friend and he burst into flames. On the way out of the *mboma,* Sitoti's father lit the sticks they had soaked with petrol that surrounded the *mboma.* The sticks went up in flames. When the rest of the Mang'ati tried to fight the fire they too became one with the flames.

Sitoti's hands moved wildly while he told the story. Mustaffa was intrigued, enveloped in Sitoti's tale. The embers of his cigarette glowed in the night. Suddenly we heard footsteps again, coming close to us.

"*Nani wewe,* who are you?" shouted someone from a farther distance than the sounds of the footsteps revealed.

"*Sisi wahadzabe,* we are Hadzabe."

"*Umewaona wamasai,* have you seen the Maasai?"

"*Ndiyo,* yes," answered Mustaffa.

Then like a slow mirage of ghost figures, a party of twenty or more Mang'ati appeared, their faces lined with black paint. They asked us in which direction we saw the Maasai running. In exchange for our information, Sitoti asked them for tobacco.

"We saw the Maasai running that way some time ago," pointed Sitoti.

Not to arouse suspicion as to why a white man was so far out in the bush, I kept my hat low over my eyes. The Mang'ati laughed with us for a while, smoked cigarettes, and told us how they had been tracking the Maasai

since the previous night for killing two young Mang'ati men in Endamaghay. They almost caught them this evening but the Maasai escaped. A strange cry suddenly broke through the wind. It sounded like nothing I had ever heard, a death cry of some sort. All the Mang'ati stopped talking in midsentence. In the next moment they were gone, running toward the cry.

"What was that cry?" I asked Mustaffa in astonishment.

"A Mang'ati cry for help."

After the night hunting we reentered our camp in the rocks unusually silent; our physical exhaustion had bled into a mental lucidity. We quietly laid down our bows and arrows as we sat by the fire, waiting a turn for drinking water. Sensing our presence, Gela woke, hoping to find food. He listened to our story and apologized for not helping us find food for our hungry stomachs. He responded with a story about a similar unsuccessful hunt he had experienced in the same area and, how during nights like this, it is very difficult to kill animals even if one had seen many in the day.

Slowly, the men reached for their pipes and tobacco, masterfully packing their stone bowls, while talking or listening to the stories flying about the fire. One hand packs the tobacco, the other hand brushes through the warm ashes looking for a coal to light the pipe. They talked for hours, the tobacco easing the pain of their hunger. They talked about the great hunts, past and future. They think they will never stop hunting. Ask an old man if he has ever killed a lion. If he hasn't, even if he is physically inept, he doesn't say no, he says, "*Badaye,* later, soon in another time I will kill a lion."

Sitoti tossed coals into the premorning night sky.

"I make the rain come," he said.

Gela and Mustaffa had pulled their sleeping cloths over them, underneath a boulder where we were trying to sleep after the talking. The sun was soon to rise, and the many birds living in the foliage of the mountain burst into song. Sitoti pulled some roots from his shoulder bag and carefully placed them into the warm ashes of the fire. He said his wife had given them to him. After some time he pulled them out of the fire and peeled the skin off with his teeth. He cut the stringy potatolike root into three sections.

"*Safi,* Jemsi, it is good?"

"*Safi sana,*" I replied.

At dawn Gela started talking, telling us how he went to jail for five years, blamed by the Datoga for shooting one of their cows and eating it. Most people say five years in an Arusha jail is a death sentence due to malaria, skin diseases, and malnutrition. But Gela survived.

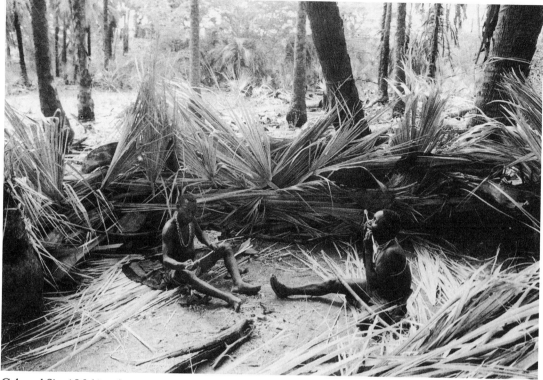

Gela and Sitoti Making Arrows

"Did you shoot the cow?" I asked.

"No, I just happened to be the first Hadzabe they saw after the lions ate their cow. But I have shot their cows before. Not this one. They knew the lions ate their cow."

"What did you think about when you were in jail?" I asked.

"Nothing. In jail you only think of jail, otherwise the day lasts too long," he concluded and continued to make his arrows.

I hadn't really talked to Gela. He was always quiet. A gentle old man around sixty, well known for his hunting skills, always smoking his *bangi*. Whenever you tried to talk with him while he was smoking, he would say there was a *ngoma* in his mind and he couldn't talk.

He loved the arrows he made. After hunting monkeys, many arrows would be lost in the trees. The others would just leave the arrows and go cook the dead monkeys. He stayed, sometimes an entire day, climbing the trees for his arrows. They teased him about this.

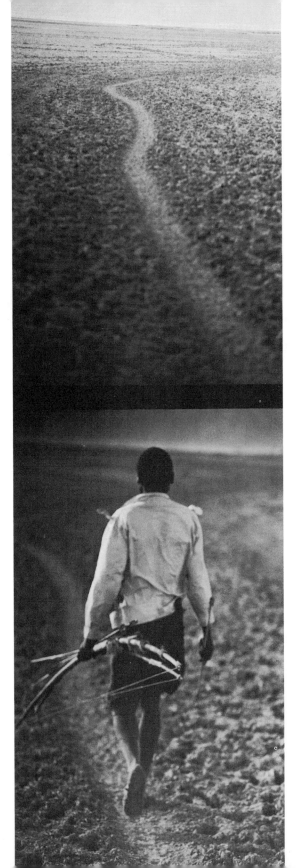

"Where's Gela?" I might ask.

"He's looking for his arrows," someone would say, as if I should know.

The men were usually quiet in the early dawn hours. They fixed their bows, hummed softly to themselves, and stared out over the landscape for signs of animals. They liked to camp on high sites with a magnificent view of the landscape below. Most of these ancient Hadza camps were also under angled rocks which protected one or two sides of the fire hearth.

The hunters are patient, like fishermen. It appears they are just staring, thinking for hours, rolling their cigarettes. But suddenly, in a matter of seconds, they will grab their bows and disappear. This particular morning after Mustaffa finished his cigarette, sitting on a rock staring over the landscape, he got up and said he heard a leopard last night near the water hole when we were sleeping. He heard the leopard hunting the hartebeest.

"The leopard's tracks will lead me to the hartebeest," he said, leaving the camp just as the rising red sun overwhelmed the last vestige of night. His silhouetted figure followed the path of stones and disappeared behind irregular rock slabs rising into the sky. The way Mustaffa talked, we knew he had to go alone. He was known to hunt only by himself since his twin brother had died and his father could no longer see. He often went hunting with the others, but only tracked. When he went off with his bow, his whole presence changed from a laughing, joking charlatan to a fierce, lone hunter.

Path to Nudulungu/Lone Hunter

There is no image older, nor more calming, than watching a solitary hunter disappear into the vast bush.

"Did you have a boyfriend in jail, Gela? A little *jiggi* here and there?" I asked.

Sitoti burst into laughter. Gela looked up, unsurprised.

"No. But others did. The men were afraid of my magic. I had to scare their dreams for them to stay away," he said, looking back to his arrow.

"What was the greatest day of your life, Gela?" I asked.

Again he looked up from his arrow and smiled; such a smile that I had never seen from him. Sitoti grew silent, putting his thumb to his mouth like a child. Sitoti always did this when his full attention was captured.

"When I was a boy," Gela said, "a little younger than Sitoti is now, a dream told me I must go hunting alone near the hills of Nudulungu. I remember the winds were strong, filling my mouth with dust. I first tracked some gazelles on the edge of a forest. I was not quick enough for a gazelle. In the night I dreamt of *na-ko-ma-ko* [buffalo]. I woke in the middle of the night, and heard what I did not want to hear. The breath of *se-say-may-a* [lion], he was standing over me, looking in the direction of Nudulungu. I did not move, fearing the lion would eat me, and soon fell back asleep. When I woke again the lion was gone, the morning had come. I drank water held in a *baobab* tree. I followed the lion's tracks, which led down the hills along the dead lake. I was spared by the lion for some reason, so I followed him. The lion tracks led me to a high ledge overlooking a small valley I had never seen. He was hunting buffalo in my dream the night before and showed me the way to the buffalo. The slopes of the valley that I just arrived at were covered with grazing buffalo. In the afternoon I killed a buffalo. I knew I was not to share the knowledge of this valley. It was sacred, the domain of the lions.

"I cut up the buffalo and hid what I could not carry in a tree far from the valley. Others would return later to find the meat. I arrived at the camp during the night. Everyone was pleased that I brought meat. They were surprised at how much I had carried. We ate and danced during the night. Mzee Salay and his wife saw that I was a strong young man and decided that I should marry their daughter.

"I ate the buffalo heart and felt strong and left the camp to hunt again. Other men wanted to join but I told them it was not possible. The next day I killed another buffalo in the valley, and carried what I could back to the camp. Mzee Salay and his wife immediately called me over, '*Bocho, bocho.*' Palela, their daughter, was sitting with them. They sat me down and asked if I would join them to eat. Palela smiled at me, she was beautiful and no men had slept with her yet; some had tried, but she would not. I agreed to marry their daugh-

ter. Mzee Salay was excited and led a dance that night to ask the ancestors to grant us the marriage. We waited for two days while Salay's wife made marriage shirts for us. The shirts were made from *swala* skin and decorated with seeds," finished Gela, carving his arrow.

"How long were you with Palela?" I asked.

"I had one child with her. Both of them died at the child's birth," said Gela, still carving his arrow. Sitoti explained that Gela has not had a wife since, and now his wife is *bangi*.

We decided not to leave our camp near the water hole until the following morning. Mustaffa would be tired when he returned from his hunt. So, with nothing to do, Sitoti and I went to bathe in the oasis pools; we were filthy with salt dust after two days of walking the dry lake bed. We had covered around sixty kilometers since we left Endamaghay.

We leapt into the water pool, washed the salt winds off each other, and then swam around a bit, laughing. The Hadza have no insecurity about nakedness. I looked down in surprise and brought Sitoti over to examine what I saw living in my pubic hair.

"*Hamna shida*, Jemsi, *ndudu*. No problem, insect." It was a thriving colony of living crabs.

I must have picked up the crabs from a Mang'ati woman who came to our camp one night in Endamaghay. Every afternoon for about three weeks after fetching water this young woman would come and watch our camp from the bushes. Whenever we called her over, she ran off.

"Does she want the *jiggi*?" I would ask Sitoti.

"Yes. She will come when she's no longer afraid."

"Have you ever had sex with a Mang'ati woman?"

"Many times. They love honey. I give them honey, they give me *jiggi*."

One afternoon when the other men were not at the camp, I felt someone staring at me. I turned around quickly. The Mang'ati woman was standing at the edge of our clearing. I waved her over with a piece of freshly baked bread.

"Come eat, have some tea," I said politely in Swahili.

She slowly came up and delicately took the bread from my hand, then

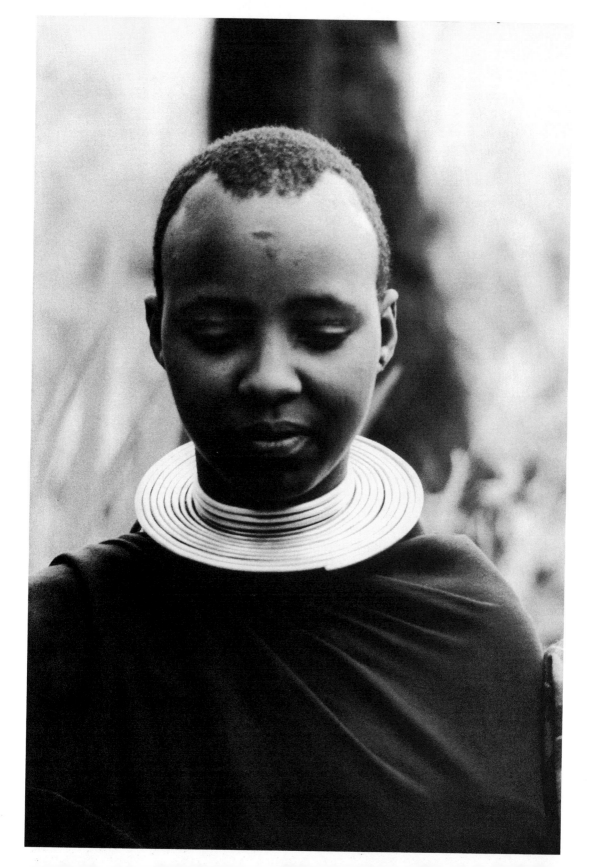

sat on her water bucket. I didn't realize how beautiful she was until she was close. She watched me boil the tea in silence. I handed her a cup with many spoons of sugar, she nodded her head in thanks, looking directly into my eyes for the first time. When she heard the other men coming she quickly got up and left.

A few nights later, I was sleeping quite a distance from the others, to feel the cool winds. The night was hot. When I began drifting off, I felt a hand touching my face. I slowly opened my eyes in terror, only to see the lovely Mang'ati woman standing over me. She quietly untied her long cowskin skirt and took off her shirt without saying anything. The moonlight fell on her pointed nipples. Delicately she grabbed my hand and placed it on her belly, leading it down, kneeling to the earth. She then laid next to me, pulling me to her. Her hands were strong and callused. Her skin smelled of cow milk. Biting my neck and shoulders, whimpering, she led me inside her.

The men told me she was a witch, crazy, spoke no language. They were afraid of her, but they agreed she was exquisite. She wore marriage bracelets, but, "You need not worry, her husband is dead," said Sitoti. "Killed by Somalians. She lives with her mother."

"How do I find her?" I asked.

"She will come to you at night, do not search for her. She will come again."

"Have you ever had crabs, Sitoti?" I asked him while he examined me.

"*Ipo*. I have them now. It's best if you take a knife and shave yourself."

Later, sometime after dusk, we heard the insane howling of a hyena, its lone cry blasting through the rock caverns. "*Mkubwa, mkubwa fisi!* Huge hyena," said Sitoti. Mustaffa had not returned.

"*Wapi Mustaffa*, where is Mustaffa?" I asked, wondering why he had not returned from the hunt.

"*Sijui*, I do not know," said Sitoti, unworried.

"Gela hates the hyena more than any animal," continued Sitoti.

"*Kwanini*, Gela, why?" I asked.

Gela had not spoken a word since we had talked earlier that morning. He had spent the day making bird arrows. He reached slowly to find a coal in the fire for his pipe and asked me to pass the cow milk. We were given some cow milk by a Mang'ati man, when he had stopped by in the late afternoon. In exchange, we shared our tobacco and news from Endamaghay. He told of the game he had seen while herding his cattle. There wasn't much game now with the lack of water, he said. They were probably farther north. He bid us his farewell and returned to his home at dusk, his stomach full with tea and sugar

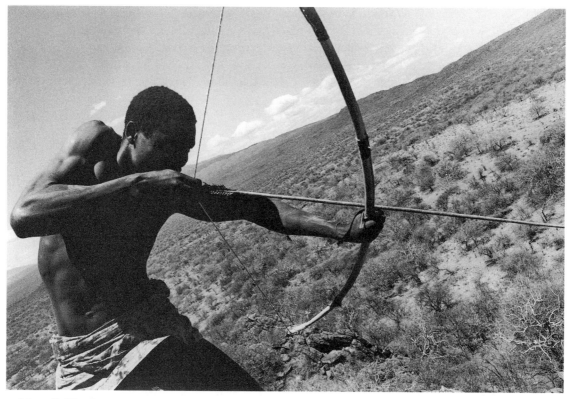

Mustaffa Hunting

milk. He told us that when the Somalians and Maasai passed the area a few days ago, he hid his family and his cattle in the hills. He hopes they will not return. We told him that we had seen the Mang'ati the other night pursuing the Maasai.

"I hope they kill the Maasai. It is not good that the cattle raiders have come this far. Bloodshed is bound to happen," he said, departing through the rocks.

We heard the hyena again, near the camp. Sitoti grabbed his bow and asked for my small flashlight.

"Where are you going?"

"To find Mustaffa, he must be close and with meat. The hyena are following him. You stay here with Gela." Sitoti was off into the black night.

"*Matatizo,* problem, Gela?"

"*Hamna shida,* no problem."

"Gela, why do you hate hyena?" I asked again.

By now Gela was used to my questions. He smiled.

"I had killed a small elephant when I was younger. There was too much meat to carry by myself. When I finished skinning the elephant, night had arrived. I surrounded the meat with thorn bushes and made a large fire. The hyena had already started gathering. I stayed up all night keeping the fire going. It kept them away. They were very close. In the morning their hunger overcame their fear, too many had gathered, and they attacked the camp, jumping over the thorns. I used all my arrows shooting them. I killed one with my knife that bit my leg. There were too many. I climbed a tree and watched them take all the meat of the elephant. I was in the tree for a long time, hungry and tired until they left with the meat. I took the little they had not eaten and returned to my *nyumbani*. Hyena will only attack if you're alone."

We heard laughter coming down from the hill. Mustaffa and Sitoti entered the firelight both carrying huge legs of meat. Mustaffa was covered in sweat and blood. He looked tired. Sitoti was beyond excitement. Gela jumped up and helped them with the meat.

"Jemsi, hyena came for Mustaffa, he was hiding in tree. I shot the hyena in the head. It ran off screaming like a *di-dee-dee* bird."

As they cut up the meat, Mustaffa told about the journey of the hunt. He said during the morning, he had walked in the direction of Nudulungu, following first the tracks of the leopard and then the tracks of a giraffe. Around midday he found another oasis. Near the oasis he saw a *swala* (impala) and killed it. Mustaffa pierced it through the heart. It dropped there before him. He cut the meat up and hid the meat he could not carry in a tree, spreading medicine around the tree to keep the leopard away. He was so hungry that he brought more meat than he should have. At dusk, the hyena started to follow him. It came after him not far from the camp, just over the ledge. Mustaffa pointed toward the looming ledge, which pierced the night sky in the moonlight.

"I shot the first hyena that came after the food through the chest. I did not hear any more hyena. I was tired, and hid my bow under some small rocks. I needed my hands free from my bow to hold the meat steady as I climbed down the steep slope. A second hyena came after me close to the water hole. The hyena must have been very hungry. I had to climb another tree to protect the meat. I was happy to hear Sitoti calling my name," said Mustaffa, handing a piece of meat to Gela.

For the next five hours we ate, the men singing, "*Ica-cu-nico a-co-ata, nom-be-go, nom-be-go. Ica-cu-nico a-co-ata, nom-be-go, nom-be-go,* sister Hadzabe, come to the bush with us, we hunt animals, come join us, come join us, sister

Hadzabe, come to the bush with us, come join us. You will eat well and you will be happy. We are strong."

When they think of the past, they sing and the past seems to emerge into the present moment. The fire song becomes all times, places, memories, a consciousness of the land, an echo of the ancient tributaries of wind that have blown across the savannas for millions of years. What they imagine is no different than what they are. I listened to their singing for hours and experienced sources in myself I have never known. It was there in that star-mountain-rock world that I truly realized the loss — their voices are vanishing. I knew there was no way their world, their perception, their culture would survive. They knew it, too — I heard it in their voices.

At dawn we left for Nudulungu. As we walked down the boulder-strewn ravine, our stomachs full, I asked Mustaffa about the mountain of Nudulungu.

"Sometimes one cannot find Nudulungu," explained Mustaffa. "The mountain rises up like an arrow and there are great birds flying around the tip of the mountain."

Gela and Mustaffa were the only ones who had been to the mountain. They told me the big animals were there; many elephants, which probably meant it was in the remote Serengeti, making it a rather dangerous journey. If the rangers saw us they would probably shoot us, thinking we were poachers. They have orders to kill all poachers on sight. They shoot from a distance for fear that the poachers are Somalians and will shoot back.

Who was Nudulungu? I wondered. They were rather elusive when I asked questions about the man, always saying he healed people.

"Why did he carry a spear and not a bow?"

"*Sijui*, I do not know," said Mustaffa.

"Was he born a Hadzabe or did he come as a grown man?"

"He appeared, had the strength of twenty men, it was a long time ago. Sometimes people go to pray at the mountain of Nudulungu. I will pray for the animals to return, and for the Mbulu and Mang'ati to leave our land," said Gela.

Mustaffa changed the subject. He told us that a Hadzabe man was murdered, killed near Endamaghay the same night we were hunting the dry lake bed.

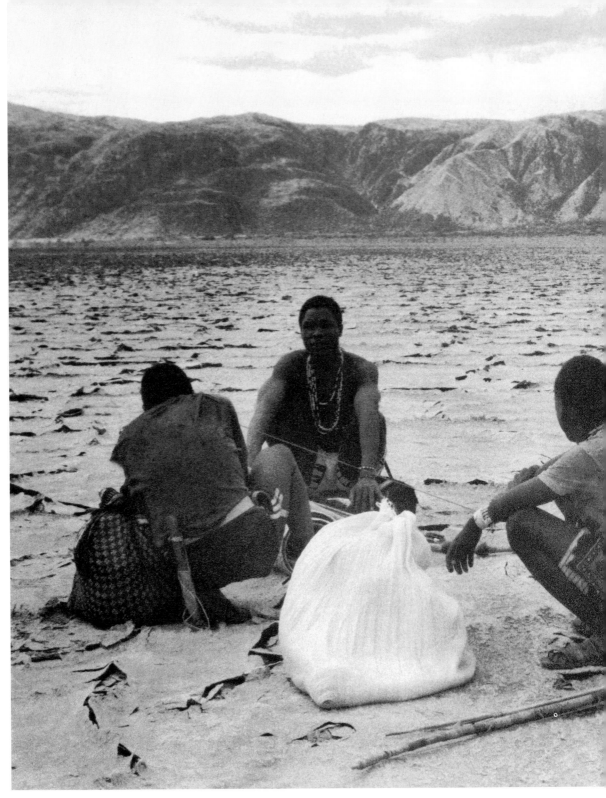

Hunters Resting

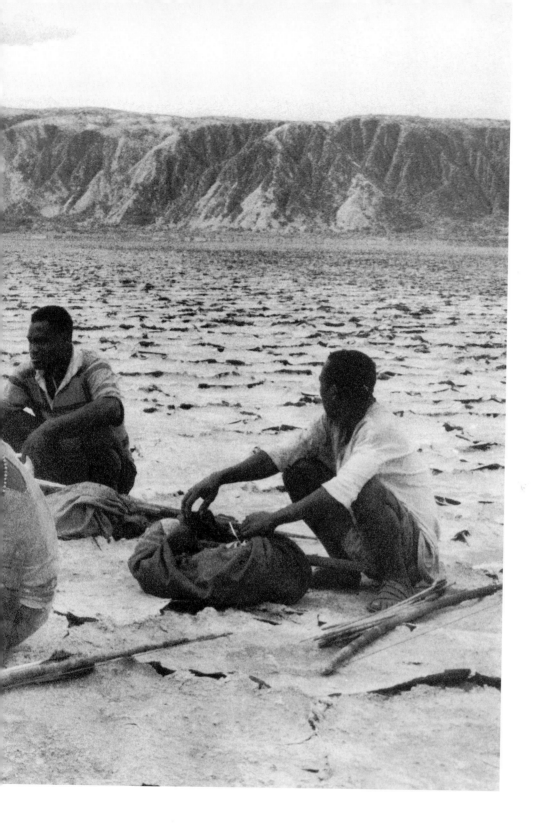

"This is why we could not find the animals," he said.

"How did you find this out?"

"I met a Hadzabe headed to Sanola while I was hunting. He said two younger Hadza men waited in the bushes for an older man and his young wife. They were drunk on *pombe*, it was the day of the market. When they saw the older man they jumped on him and tore out his eyes and bit into his stomach. The wife has disappeared into the bush with the two young men. His wife is a witch. The man had tried convincing them to just take his wife but the wife told the young men to kill him."

"I thought he was dead, how do they know this?" I asked.

"He died a day after they found him. He told them everything. This is why the animals did not give themselves to us. Nothing has happened like this ever, there is a great demon in the land now," said Mustaffa, rather distressed.

"There is a great demon, *shetani mkubwa*, taking over the world," I responded to Mustaffa.

"That is true, the world is changing. We must kill this demon, but how, I do not know," responded Sitoti.

"Nothing lasts under the sun, the demon will go," I responded.

"There is a demon that guards Nudulungu, it has wings, I saw it when I was a child. We must find medicine and talk to the ancestors before we go near," said Mustaffa, cutting four suitable branches from a small tree.

"What tree is that?"

"Fire stick tree, not many left, I am happy that we have found it before the elephant. The elephant likes to eat the fire stick tree," said Mustaffa, handing a branch to Gela and Sitoti. "It is hollow inside, look. Good for starting fire."

The feeling of freedom and awesome nothingness — that you are nothing in the face of such a vast and harsh natural environment — is liberating and humbling. The farther into these rarely penetrated regions of nature you go, new pockets of energy seem to enter your inner state — intuitive sensations never experienced because one has not had the opportunity to put one's physical being in such a raw, physical environment. Land and animal worlds have their own spheres of communication. Pockets of animal and bird domain that have never been unbalanced by the human presence rise into one's consciousness somehow needing to be felt, shared.

Unremembered sensations mingled with the fabric of one's being — haunting, really. In such regions, the hunters become quiet and tell me not to whistle, for "we have now entered a land of *shetani, wajini,* spirit walkers." These fragile spheres of nature are the holy realms felt by the hunters, the

spirit regions manifested in nature. *But what spirits, what essences are these that you can feel but never explain?* The seeds of our source seem to dwell here. Regions where trees will talk to men, and animals are symbols of the hunter's inner journey. The mysteries of our ancient psyches dwell in these places and once destroyed they never return.

For two days we walked through such a place, through semidesert terrain and lush oasis forest where the immense old-growth palm trees fed us with their fallen fruit. The meat that Mustaffa had stored in the tree was gone. And one morning we woke and the meat that we had dried was also gone, no tracks to explain the theft. This disturbed the hunters. We experienced strange sleeps, and the hunters became slightly scared, performing ceremonies and constantly talking about the senectitude of the land — the land of the ancestors. Here was a place that if your intentions were not true, you could be destroyed — this was a spirit forest their grandfathers talked about.

"My grandfather went hunting with other men to this area. After many days three of the men disappeared and my grandfather became very hungry. He lay in the shade under a *dum-ba-ya* tree. He heard a voice: 'Why do you come to my forest? What are your intentions?' He looked around and saw no one. Then he realized that it was the tree talking to him, or maybe it was a bird. He did not know but he answered the spirit voice, 'I come to find food.' 'Is there no food from where you come?' returned the spirit. 'The animals have vanished like the rains, my family is hungry.' 'Sleep now and when you wake, walk toward the large tree near the three stones that point toward the salt lake, there you will find a buffalo waiting for your stomach. Cut the buffalo up and do not eat it. Run to get your family and return, the meat will be dried and ready. And here in this valley you will find all the berries, roots, and animals you will need,' said the spirit. My grandfather did what the spirit said and all came to be true."

As we walked toward the far oasis we heard a terrible noise rising from the distance. The noise was extremely distressful. Mustaffa said, *"Gari,"* Land Rover, rangers. We had been watching a herd of wildebeest in the far distance, roaming through the violet sun, disappearing and appearing into a mirage. We hid behind some rocks. It was not good for the rangers to see the Hadza or myself. You never know what would happen. Some rangers are corrupt. They would see me and with their guns might try to get money out of me. Many of the rangers have been paid off by the professional hunters in the game reserves to arrest any Hadzabe they see carrying a bow within a few miles outside the game reserve. A few professional hunters are afraid that the Hadzabe would kill the game that had wandered out of the reserve's parameters. The game that some fat-ass jerk or egomaniac would kill for thousands of

dollars. In these areas the professional hunting has destroyed the Hadzabe way of life.

The motor grew louder. A month without hearing a motor and it sounds foul beyond description. A pickup Land Rover tore by, headed for the wildebeest in the distance. The rangers all had rifles. Five or ten minutes later we heard the shots. Mustaffa said those were prison guards with the rangers. Once a month they come to the Endamaghay "game protected area" to kill as many wildebeest as they can, to feed the prisoners. But he has never seen them this far out.

We decided to head north over the small mountains and walk in the low valleys beyond the mountains to escape any possible danger.

"We become invisible now. No one will find us. Do not worry, Jemsi," said Sitoti, sensing my fear.

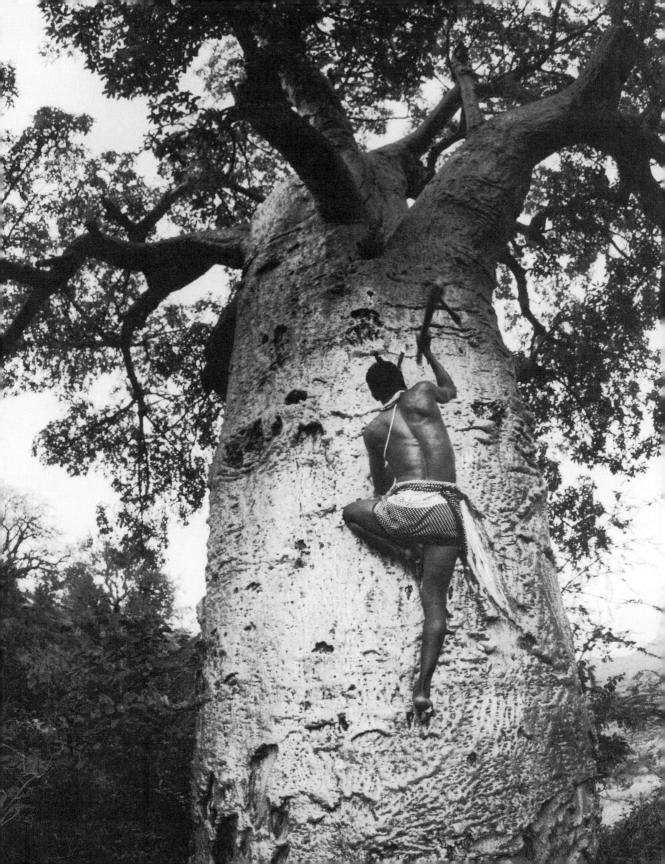

6

The Mountain of Nudulungu and the Ancestor Spirits

We came over a rise of hills and headed down into the next valley, walking on stony animal trails. It seemed like everything was listening, every part of nature was aware of our step. The umber leaves moved in the wind over our heads. Short rains had showered the land the previous mornings and all life was rejuvenated. Drifts of wild yellow hyacinthlike flowers broke through the dry crust of the earth and butterfly wings hovered above in the foliage as we passed low through bush tunnels on paths worn open by *swala*.

As we emerged from the bush tunnels onto the valley floor, a sudden enveloping darkness swallowed us. Millions of butterflies covered our bodies; a moment of insect legs, wings, and tiny proboscises. Then as unexpectedly as they came, they were blown away by a gust of wind. A giant cloud of butterflies a mile long passed over the valley, disappearing behind the next ridge, leaving innumerable butterflies lying dead and dying on the wild flower earth. Armies of ants devoured the dead butterflies, reclaiming the wings' colors, powdery fibers, which gathered on their working bodies like pollen on a bee.

The newly sprouted grasses and refreshed trees exuded an after-rain contentment. Nature no longer felt scorched by the sun. It was now far more calming, inviting. Sitoti walked over to a baobab tree at the edge of a small savanna in the belly of the valley. We followed him to the fantastic shade of the baobab mixing with the long, slow winds.

The baobab tree is a mother, a provider. It has always been with the hunters. The tree provides honey, water, baby birds, vistas, good protection for the night. One begins to feel intuitively the nature of a tree. These hunters are aware of the characteristics of different trees. Some they will not sleep near, saying *shetani* or unfriendly snakes dwell in the tree.

Sitoti Climbing Tree

My legs had now adjusted to the long walks and the steep terrain. I was no longer dismayed in the face of distance, no distance seemed too far, no hill too steep. There is a strength that grows inside you from such walks, from sleeping on stones, from the hunger, from the cold. A toughness intertwined with a raw state of freed awareness, almost as if the strength and the energy of the land passes up through your feet and into your bloodstream. The panic disappears. The mosquitoes no longer bother you at night. You can sleep anywhere, eat almost anything.

Sitoti started carving pegs to climb the baobab while Gela and Mustaffa packed the stone pipes with tobacco. Soon Sitoti was halfway up the tree, standing on one peg and knocking in the other with a prehistoric-looking ax. It took him about three minutes, climbing peg by peg, before he was out of our sight. We heard a cry of exaltation as he disappeared into the tree. A honey bird came screaming by, flying about the tree.

"*Asali ipo,* there is honey," said Gela, smiling.

Almost every day, a honey bird swooped down close to our heads, begging us to follow. The hunters answer the bird with a whistle that sounds like its song. Ninety percent of the time the birds lead the hunters to honey or dry nests. If the hunter does not leave the bird some honey and wax, he believes the next time the bird will lead him to a snake's den.

Mustaffa quickly started a fire and headed up the tree with the smoking branches. To rob the nest of its honey, the Hadza sedate the bees with smoke so they will not be stung. But not all honey bees are stinging bees. Mustaffa shouted from the top of the tree, holding his hands out toward us, now dripping with honey. Sitoti's voice echoed from inside the tree.

"Jemsi, *asali safi,* the honey is good," said Mustaffa.

"*Bocho,* bring it down," shouted Gela.

"*Leta chupa, maji yapo,* give me a bottle, there is water in the tree," said Mustaffa.

I climbed up the pegs with the water bottle and looked down the narrow hole leading into the cavern of the tree.

Sitoti's hand covered in honey, holding a large gooey comb with bees still on it, shot up through the hole. Mustaffa quickly grabbed it and broke it in half, throwing down the smallest piece to Gela, who caught the honey with care. "*Wadudu wakali,* the insects are hot," shouted Sitoti. I looked down into the hole. About fifteen feet below, Sitoti's chest and back were covered with bees. The inner trunk was hollow, maybe ten by ten feet. Sitoti was sticking his hand into the inner wall, pulling out chunks of comb, blowing off the bees, taking bites out of the comb, and throwing the rest onto his shirt, which was piled high with the honeycomb.

The honey nest was huge. Usually at this time of year, one only gets two mouthfuls from a common nest, but sometimes that little bit of honey is so sweet you have to sit down and rest. For many days honey was all we ate to sustain ourselves. There are around seven different species of honeybee in the Lake Eyasi region. The Hadzabe harvest them all, if "harvest" is the word. They promote the honey production by creating appealing dens for the bees, placing rocks in tree holes so the bees have a place to start a nest. After raiding a nest, they often leave combs partially intact, so the bees have the means of reestablishing their honey source. Each Hadzabe clan seems to have its own secret honey route, usually in a hidden valley where the other families do not go. Honey is the sweet ichor of the barren, semidesert landscape.

A small pool of cool water rested in the tree's roots. I dropped an empty water bottle down to Sitoti and headed back down the tree. Sitoti and Mustaffa were soon to follow with a feast of honey and fresh water.

"*Maji safi*, the water is good," said Sitoti, smiling. There were about thirty welts on his skin.

"These are stinging bees?" I asked.

"*Wadudu wakali sana*, the bees are too angry," he said, laughing.

Gela's eyes were glowing. All the hunters had silent, fixed smiles on their faces. Honey is the ultimate delicacy, it surpasses the dik-dik testicle. Mustaffa explained that the good honey will not be ready for about another four months.

"I do not know why there's such a nest at this time," he said.

"We are close to Nudulungu," said Gela, returning to his honey.

"*Nudulungu safi sana*, he is very good," said Mustaffa.

"*Mimi ninapenda Nudulungu.* I like Nudulungu," commented Sitoti, handing me a sweet section of the honey.

Soon I fell asleep listening the hunters' voices singing the honey song:

"*Ba-la-ko, ba-la-ko, ba-la-ko*, honey, honey, honey . . ."

When Sitoti woke me, night had come. The large fire illuminated the pale skeleton of the tree. Sitoti's face glowed in the firelight. Nothing could be seen in the wall of darkness outside the camp. A hyena broke the silence. The slow cracking sounds of the fire and the fluctuating light danced around Sitoti's figure. He was standing over me.

"Jemsi, Jemsi, *aamka, aamka*, wake, I dreamed of buffalo, the moon has left the sky, I am hungry, the others will not come with me. They will not wake. I am hungry, let us go."

* * *

Night hunting was becoming dangerous. We had spotted several lion tracks the prior morning and Sitoti was not familiar with this area, but the night was the easiest and surest way to find some food using my flashlight. This night Sitoti was hungry. And when Sitoti is hungry he's afraid of nothing.

Sitoti quietly handed me my bow and arrows.

"I hear the buffalo," he said.

I listened but did not hear anything, and hoped all would be OK. Hunting buffalo at night was insane. The African buffalo are among the most dangerous animals to hunt because of their size and speed. When one is wounded it waits for the hunter, or circles slowly back looking for the source of its wound.

"Sitoti, are you sure you want to go?" I asked.

"*Hamna shida,* no problem. The wind is in our favor."

As we headed out, a distant hyena cry echoed through the night. Our sight slowly adjusted to the darkness. We walked, vanishing through the portals of undergrowth, through grassless dust, lion silence, into leopard fear.

Thousands of red eyes appeared near a water hole, silent, reflected in the torch light. The animals were drinking the water. Sitoti crouched down.

"*Be-so-wako,* wildebeest. The other animals are watching the wildebeest; if the wildebeest are not attacked by lion, they too will come drink."

Sitoti started to creep toward the wildebeest over a small, wet marsh, low to the ground like a stalking cat. They reared their heads toward him, the biggest strutting back and forth. Its nose lifted into the air, taking in Sitoti's scent. On his third run, he grunted and broke into the darkness, the mass herd following him. Sitoti charged after them for about twenty yards but they were gone. The winds must have slightly changed direction, giving away Sitoti's scent. He returned.

"We must not follow the *be-so-wako,* there is lion waiting. Let us go now," he said and quickly headed in the opposite direction.

We entered a dense forest of acacia with no undergrowth. Towering old trees. Their large, interconnecting branches rubbed together in the winds. For some time we walked through the silence of the underforest. Sitoti always walked directly into the wind, changing course with the fluctuating movements of the wind, never allowing it to take our scent ahead of our steps.

Sitoti stopped and grabbed my arm, pulling me down to the ground.

"*Pale,* there," he pointed, slowly taking the torch from my hand. He aimed the light. In the distant light, just at the final reach of the torch, floated two large, red, glowing eyes the size of oranges, then two more appeared almost at the height of the trees.

"*Nani,* what is it?" I asked.

"*Tembo*, elephant."

We knelt down into the dust.

"*Polepole*, Jemsi. *Sisi tako karibu sana na tembo, tembo akipata harufu, sisi tuta kufa.* Go slowly, we are too close. If it smells us, we die. Let us go slowly. Wait! The elephant comes. Do not move!"

The mosquitoes seemed to sense my anxiety, swarming about my neck and face. I listened to the cracking branches and the whispers of elephant sounds passing. I could hear Sitoti's breath.

"*Wengi sana*, so many elephant," whispered Sitoti.

We waited for some time, watching the elephant legs moving silently, like an unhurried river. In the Serengeti, I had seen an elephant walking backward, its foot stopping an inch from a turtle, avoiding it and stepping aside. They have amazing control for their size.

"Sitoti, are they gone? Sitoti?" I whispered. *Where the hell is he?* I looked around me — nothing, only the leaves and grass.

"Jemsi, I am here, the elephant have passed," shouted Sitoti, standing in a small acacia looking over the landscape. Suddenly Sitoti's flashlight caught the yellow eyes of a dik-dik about a hundred or so yards away. Sitoti leapt from the tree and zeroed in, shouting for me to follow.

"Keep the light on its eyes," he said, handing me the flashlight before placing an arrow to his bow. Within twenty feet Sitoti let his arrow fly. It missed, but the dik-dik came running directly toward us. Sitoti quickly smashed the animal on the back of the neck with his bow, followed by a blow to its head. He looked up at me, grinning. "*Chakula*, dinner." He peeled some bark off a small tree and tied the animal's legs to his belt, and we headed back to camp.

Mustaffa and Gela woke when Sitoti started rearranging the fire. Sitoti skinned the animal and threw the innards into the fire. Sitoti told the men about the elephants. Mustaffa asked me if elephants live in America.

"No," I said. "But there is an animal almost as big as the elephant and far more dangerous. The Hadza in America, the Indians, used to wear the skin of this animal to hunt it."

"There is Hadza in America?" asked Mustaffa, rather surprised.

"There was, now only a few are left, but their lifestyle is gone. The *wazungu* cut all the trees down and killed the animals with guns."

"The gun is bad, *mbaya sana*," said Gela, shaking his head.

"What animal is as big as an elephant, and more dangerous?" asked Mustaffa.

"The bear," I said. "Its claws are the size of Sitoti's arms, and it is as fast as the lion. It can cut trees down with its claws, and hunts, eats men."

"I would run if I saw such an animal," said Gela.

"The bear walks like a human," I said.

"*Kweli*, is it true?" asked Sitoti.

"It is like a monkey human with the face of a dog."

"*Kweli?*" asked Gela.

"Yes," I said. "Sometimes it will come into the camp, and sleep next to you. Then, if you wake and move, it will kill you, or do the *jiggi-jiggi* with you!" I said standing, dramatically acting out the movements of the bear man. "If the bear sees you, there is no escaping. It is too fast to run from and too smart."

"I would run faster than the bear, I have medicine," said Mustaffa, turning back to his food.

"No, it is like the wounded leopard. It will find you, that is why American Hadza used to wear the skins of the bear to hunt it. The bear can also fly. It swoops down from the sky and will eat you."

"What happens if it wants *jiggi* with you?" asked Gela, slowly tearing off the meat from the dik-dik cranium.

"You die! Its penis is huge. But, you can talk quietly or sing to the bear and it will sit and listen. Eventually it will fall asleep. That is the time to leave. Once it sleeps it does not wake for many months. But you must not fall asleep while singing or it will definitely do the *jiggi* with you."

"I would never hunt such an animal! Too dangerous! Big like an elephant. Likes to *jiggi!* Flies into the sky! Does it have wings?"

"No, it flies with its claws."

"Too dangerous! I would hide inside a tree, *hatari sana*, too dangerous," said Gela.

"I would kill it with poison," said Sitoti, smiling, eyes wide open.

After the story, the men ate in silence for some time, absorbing the concept of a flying bear without wings, before they erupted into lavish Hadza talk about the bear. Sitoti started to perform what looked like a little Irish jig, while Mustaffa acted out how he would hunt the bear. Sitoti dove onto Mustaffa pretending he was the bear doing *jiggi-jiggi* with Mustaffa; they fell to the ground, wrestling. Gela burst out into long, slow beautiful laughter that eased into a song, and soon we had forgotten about the bear. Everyone listened to Gela, his voice was exquisitely rich, falling and rising, disappearing into breaths, returning in slow dreamy chants. Sitoti and Mustaffa joined Gela, drifting into a meditative state, lying together, legs and arms still intertwined from the wrestling.

We broke camp at dawn, walking out into the open land, inhaling the fresh air, listening to the birds. By late morning we came to a huge kopje (rock island) in

the sea of the acacia forest. Some boulders were one hundred meters in length. This kopje offered good shelter for rest during the day. Its overhanging boulders created natural camps. There were many hyrax, similar to a prairie dog, to hunt. The hunters would grab a baby hyrax, its scream luring in the adults to shoot.

Lion also preferred to rest in the kopjes, so one had to be careful. The hunters, with an innate awareness, scouted the rock crevices and water holes for signs of lion. If they came across a lion downwind they would probably try to kill it for food. They weren't afraid. In fact, they were afraid of no living creature.

Gela shouted out from the highest rock of the kopje, "Nudulungu, there is Nudulungu!" Mustaffa and Sitoti both looked at me, surprised at what they heard, then smiled, grabbed their bows, and headed up the kopje.

Nudulungu rose at the other end of the greater valley, separated by many smaller valleys — an immense finger of stone rising like a spearhead from the center of a large kopje, slightly crooked, prehistoric in the distance. It released heat waves and dark shadow, creating a slight uneasiness in the eyes of the be-holder. The land took on a new guise. We were now in regions seldom entered by man. We seemed to have entered the physical reality of legend and myth, where the symbol that has lived in the imagination of men for thousands of years is before one's eyes.

"Why do the Hadza no longer come here? These valleys are full of game," I asked.

"Some come, but many are afraid of spirits. Hadza believe these forests are haunted, they are afraid of Nudulungu. It is now a place for the ancestors. It is not a forest for the living man. That is why most Hadza do not come here. Let us hope we do not disturb the ancestors," answered Gela.

We sat staring at the rock. An enchanting warm wind wafted toward us. Epiphanies rose and were forgotten. Nudulungu provoked in the hunters a silence similar to one that comes over Mozambican fishermen in the presence of a whale. A respect for that which can destroy you.

"Nudulungu," whispered Mustaffa, transfixed by its image. "Nudu-lungu."

What was the significance of Nudulungu to these men? Why did it leave them slightly uneasy? Why did it leave me uneasy? Were they experiencing what I was experiencing? What do they know that I do not?

Gela and Mustaffa left to gather herbs to help protect us from the *shetani* before dusk. Sitoti and I made camp underneath a small rock overhang. The

evening wind was cool and there were no mosquitoes. The ominous foreboding had dissipated. A sensation of contentment, comfort, and protection rose. Sitoti seemed to feel this also.

He began to laugh, telling me how he hunted giraffe in the past. He said the Hadza sneak up on the giraffe and shoot it with poison arrows. It's all about tracking and understanding the wind. They don't know that hunting giraffe is illegal in Tanzania — it is the country's official symbol.

When Mustaffa and Gela returned, both of their heads were covered with round, spiky seeds that stuck in their hair. They decorated our hair with the seeds, saying the *shetani* will not enter our minds and drive us crazy. Gela tied mixed grasses that smelled like onion and rosemary to our necklaces, saying this will also keep the *shetani* away.

"Tomorrow I will tell the ancestors we have arrived. They will protect us," said Gela.

The following morning we headed off through bush tunnels, moving slightly east of Nudulungu, following the dry riverbed that ran along the center of the meandering valley. We climbed over a high pass and arrived at an elephant path headed in a similar direction. The elephants had exposed the sky, eating everything in their way. We followed the path, sweating, walking at the worst time of day. The sun was hot, we had to rest every hour or so. Nudulungu was still far. The vistas, distant views, are not always realistic once one sets out for the destination. Every kilometer we walked, every rise above the forest we came to, I always expected to arrive.

Toward the end of the day, Nudulungu rose before us again. Gela stopped to stare at the mammoth rock for some time, rolling himself a cigarette with a dried leaf. Mustaffa and Sitoti dug into their shoulder bags for their last bits of tobacco, crushing it quietly in their palms, placing the tobacco in their stone pipes. The hunters' eyes focused on clans of baboons living in the kopjes. Baboon screams broke the silence of the late afternoon, revealing our arrival to the spirits of Nudulungu.

"The baboons can smell us. The wind is passing our scent to them. They are gathering together in acacias for protection during the night," said Sitoti.

"We will hunt baboon in the morning before the sun because they are easiest to approach while they sleep. The black birds are flying toward the hills. The baboon will sleep heavy tonight. *Nyama safi sana*, good meat, good fuel, keeps malaria away. But they are very dangerous to hunt in the morning before the sun," said Mustaffa, pounding the swollen scars across his chest, a remembered pain entering his eyes. "Baboon tore me, for three moons I could not walk."

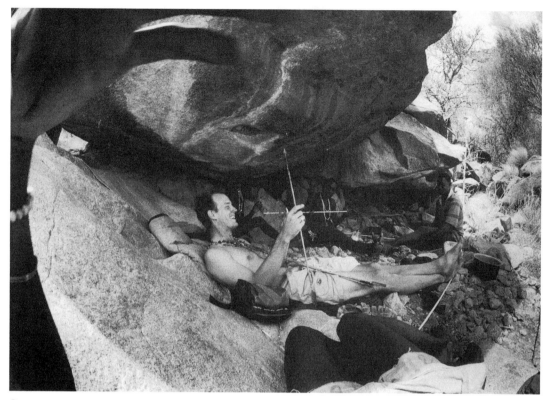

Camp

"No," said Gela, holding the grass tied to his necklace. "We will not hunt the baboon, we cannot kill any animals before arriving at Nudulungu, before talking with the ancestors. Tomorrow we will talk with the ancestors, today has passed." Mustaffa and Sitoti listened, respecting Gela's words.

"Why are the baboon dangerous to hunt?" I asked.

"They can be. The larger males come after you if they know they cannot get away, or if you are close to the tree. It is dangerous in the morning. I shot the female; the large male leapt on me from behind. I killed it with my knife," said Mustaffa, leaning to show me the second set of scars on the back of his neck.

The next dawn we continued to follow the same elephant path, which was also headed toward Nudulungu. After some time, the hunters noticed men's tracks following the path. The tracks merged onto the path from the hills in the east. The hunters became uneasy, not knowing what to expect. The men's tracks

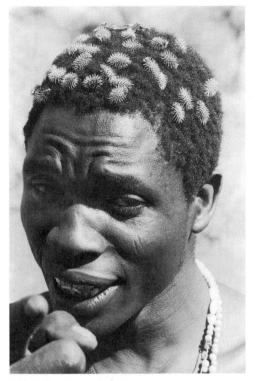

Mustaffa with Seeds in Hair

were several days old, and a foul smell was growing stronger and stronger. The hunters slowed their walk. Their eyes became stern and serious. The path reached a ledge with rising boulders, then wound down a steep slope into a small break in the trees, exposing a horrific sight. The odor was inescapable. Before our eyes were twenty rotting elephants with vultures eating their bodies. Dead men were scattered about; some had fallen near the bellies of the elephant corpses. Trees were torn from the ground. Bodies ripped apart by hyena and vultures.

"I dreamt of Nudulungu last night, he has sent this sign," said Gela, staring at the scene.

The hunters sat slightly hidden in the bush. Gela wanted to understand what he saw. I watched him examine the scene, making sure there was no danger present before taking a closer look.

"Poachers," said Gela.

"But why so many dead men?" I asked.

"*Sijui*, I do not know."

We debated for some time — should we carry on or go down? We did not want to be blamed for such a crime. If the rangers happened to come upon three hunters and myself in this area, the hunters would probably be hung or shot. I would go to prison. We waited until a little before dusk and quietly walked down the slope.

There were ten dead Mang'ati. There was one dead Maasai, and a dead man who looked like a Somalian. The Mang'ati were shredded with bullet holes like many of the elephants. The Maasai's whole chest was blown off, shot by an elephant gun. The dead Somalian had a Mang'ati spear in his back. The Mang'ati must have waited for the elephants, hoping to kill them for their ivory. Gela figured that the Maasai and Somalians had tracked the elephants from a different direction, following a group that were joining the larger herd. Possibly they had stumbled upon the elephants or heard the Mang'ati gun-

shots. Gela believed the Maasai and the Somalians had taken off with the tusks. The poachers were after any size tusk, since there were many young elephants dead.

"I do not understand the motives of such men," said Gela.

Vultures swam through the sky. Sooner or later, the Mang'ati would come looking for their fellows, they would see the vultures, or maybe they already had. Or maybe they never would.

"The men will rot in the bush, and will be eaten by the hyena. Only the forest will know what has happened," said Mustaffa.

"We must go immediately," said Gela.

The smell was too strong; we heard the hyena returning. Gela smoothed out our tracks with a branch for quite a distance as we disappeared into a bush tunnel that ran up a steep slope and down into a stony riverbed. No one could follow us.

We walked into the late hours of the night. It was too risky to start a fire. If the Mang'ati had already known of the attack they would be pursuing the Maasai. If they by chance caught wind of our fire they would try to kill us. There is a point when explanation is not possible.

The Hadza are shy and do not like conflict. Man's greed is hard for them to fathom. They have gone farther and farther into the bush to avoid conflict, to places where most cannot survive. But now there is nowhere else to go. The animals and the bush are being penetrated from every direction. The Sukuma farmers in the northwest of Eyasi are cutting all the trees down, farming the land, and hunting the animals. The Mang'ati, almost everywhere, are destroying the natural water holes, overgrazing the savannas, and cutting the trees down for their *waboma* (homes). The Mbulu in the southwest are also cutting all the trees down, turning the land into farms. Many of these people spit on the Hadza, calling them baboons, swamp men, the lowest of the low. The rangers arrest the Hadza for carrying bows near the game reserves, the white hunters try to get rid of them, and the tourists in the east are pouring in more and more.

"We just want to be left alone," said Mustaffa as we walked.

Not long before dawn, we sat exhausted, resting under an acacia. We were now far enough away from the atrocity to feel secure. Gela told a story about the time he met Nudulungu, the hero figure, when he was a boy. Nudulungu walked out from behind a tree and asked Gela if he knew where he could find some water. Gela was horrified at the size of the man and started to run. Finally Gela was breathing so hard that he had to rest. While leaning on a rock trying to recapture his breath, Nudulungu stood up from behind the rock and

said, "You should not run from a man who is thirsty. Child, come and eat honey with me." The large man then smiled at Gela, easing his fear. They sat with their backs on the rock and ate the honey. "I am from a mountain," he told Gela, "the mountain is named Nudulungu. One day you will go there. You will know when that day has come." He gave Gela a large honeycomb he carried in his shoulder bag, and said that Gela must give this honey to his mother and his sick brother. Gela agreed. He then pointed to a mysterious blue bird in a tree, a bird Gela had never seen before, and has never seen again. When Gela turned back to ask Nudulungu where the bird was from, Nudulungu had vanished. Gela ran home and gave the honey to his mother, and told the old people about the man he met. An old woman explained to Gela that the person he met was Nudulungu.

"My sick brother became well from the honey. And we were able to run and hunt together again. And my mother became pregnant shortly after eating the honey. I know today is not the day I will go to the mountain of Nudulungu. When that day comes, I shall go and sleep by a fire at the base of the mountain. You have seen the mountain, it will never leave you. We have entered the land of the ancestors, but now is not the time to witness their symbols. If we would have gone to Nudulungu, we would have died. Nudulungu warned us with the dead elephants and men. Let us think about them, that was the message we received," explained Gela.

"But why would we have died?" I asked.

"Nudulungu warned us with the elephants, man's greed killed those elephants, *tamaa* [greed]. The world is becoming *tamaa*. If the ancestors do not want you near their home, and you do not listen to their warnings, they will kill you. We have seen the mountain and it is aware of us. Is that not enough? If Nudulungu wants us, he will bring us there. We should begin our journey home," finished Gela, returning his attention to packing his stone pipe with tobacco.

We were eating the last of the dry meat when a voice broke through the silence of the night. The voice stopped. We heard footsteps approaching. Two young, handsome men came and sat down by the fire. They shook my hand dramati-

cally, smiled, and nodded their heads. Then they both erupted into laughter. Mustaffa and Sitoti were happy to see their laughter. But Gela looked strangely concerned. They said they were Hadzabe. Gela, Mustaffa, and Sitoti had never met them.

"Jemsi, these are Hadzabe from the bush where no other goes, they do not speak Swahili and know nothing of what we know from passing through Mang'ola," said Mustaffa.

Soon Gela was also very happy, sharing his *bangi* and tobacco. I boiled the guests some tea. They took a sip and again erupted into laughter because they had never drank from a cup or tasted tea. The *bangi* hit us hard. Before long, Mustaffa, Sitoti, Gela, and the two young men were all dancing. They said their names were Saco and Cha-e-a. Each man covered his midsection with a wildcat skin, a traditional Hadzabe dress, which I had never seen worn. Mustaffa and Sitoti said they stopped wearing traditional dress because the Swahili would cause problems, beating them up, calling them a disgrace to the country, "But what is a country to us?"

We needed some entertainment and freshness in our group, and these men were perfect companions after a long safari. I realized I hadn't heard Mustaffa and Sitoti laugh so hard since we left Endamaghay. Several times Saco and Cha-e-a felt my hair and touched my skin. They asked Mustaffa and Sitoti if I was *jini* (spirit).

"They have never seen a *mzungu*?" I asked Mustaffa.

"They do not know white man, they think you are a spirit or yellow Hadzabe," said Mustaffa.

The men invited us to their camp. They had seen our tracks while they were returning home after hunting buffalo earlier in the afternoon. They acted out the buffalo hunt for us. Mustaffa, Gela, and Sitoti stared with great excitement, responding to the men's buffalo sounds, agreeing with their story, and then sharing similar experiences they had gone through while hunting buffalo.

"*Bocho*, come eat with us," the two men demanded. In a moment's notice, all the men had their bows in hand and were walking through the night bush at an incredible speed. Left, right, across dry riverbeds, past kopjes, through tall grass, in and out of bush tunnels. Cha-e-a grabbed my hand as we headed up a long hill, weaving around massive boulders.

Soon a fluctuating light rose, illuminating the giant rock faces. I realized there were many large fires. Children's cries broke the silence around the fires. We wove past more boulders until we came to an immense fire near an angled rock wall the size of half a football field. Thirty or so men, women, and children were sitting about the fire or sitting in groups around smaller fires,

eating. Four or five buffalo skins hung drying on the rocks, and animal bones lay scattered about the camp. Bird feathers were tied to the entrances of many Hadza shelters.

As we entered the light of the largest fire, an old man came to greet us. He stared into my eyes for a long moment, then motioned for us to sit on a buffalo hide. He shouted to an old woman, who brought us a piece of dried meat. Before I knew it, she was feeling my hair. The old man hit her hand away and started to feel my hair, laughing loudly. Many Hadzabe came over to the fire, talking profusely with Mustaffa and Sitoti, while Gela was busy packing and passing his stone pipe to the others.

After eating and laughing with the others, I looked up and couldn't believe my eyes — hundreds of Hadzabe seemed to be gathered by the fire, talking, dancing, and eating. Gela passed me some tobacco.

After lighting the cigarette, I looked up, and again to my bewilderment saw all the Hadzabe standing or sitting silently, staring at us. Gela, Mustaffa, and Sitoti were also silent, setting their pipes down.

"What is wrong?" I whispered to Mustaffa. He grabbed my hand, holding it strongly. He was also holding Sitoti's hand, who in turn held Gela's.

Some Hadza were naked, many of them wore lion manes around their waist, or tied animal horns to their heads. Some of the older men held elephant tusks. A powerful gust came through the camp, blowing the fire to the side, feeding the hot coals. We covered our eyes to protect them from the dust. The wind stopped.

"Ancestors," whispered Gela.

Each Hadza face seemed to hold many faces — the faces of birds, lions, trees, snakes. They transformed into baboons, hyrax, vultures, zebras, and then back into their original human form, like chameleons. Suddenly, they cleared a path for an old man, who came dancing toward the fire, ostrich plumes on his head, lion claws around his neck. As he passed, each Hadza fell behind him, dancing. He did not acknowledge our presence, instead he looked into the sky. His face disappeared and returned in the flickering light. Stars seemed to fall from his skin and the night clouds curled around him. He towered over the fire, unleashing a slow cadenced chant. Then he leapt, floating for a moment. He gazed at us, then vanished into the flames. Each woman, child, and man followed him into the fire. Their bodies metamorphosed all they had seen and experienced before they disappeared, every sound they had heard, every animal they had killed, every tree they had rested near, birds, squirrels, dragonflies. A long, thin tapestry of images faded until we were the only ones sitting alone in the silence of the fire.

I wasn't sure how long we sat there before a pale bird flew in and sang

the most lovely birdsong. It landed on the other side of the fire, turning into a large butterfly; the movement of the wings captured our eyes as its colors transformed into the skies it had flown through. Again, a strong wind blew through the camp.

When we focused back on the fire, the wings of the butterfly transformed into the shapes of two lovers passionately making love. I glanced at Mustaffa. He was smiling, tears were in his eyes, staring, entranced by what he saw. The male lover disappeared into the female in his final thrust of pleasure. The woman sat breathing hard, her stomach visibly growing. She gripped into the earth, crying out, sweating, her body contracting. A child's head emerged from her vagina, blood pouring to the earth. The child fell out softly onto a small animal skin. The umbilical cord ran from its belly. Fluid and blood covered the child's body. The mother slowly disappeared — each cell of her body, each minute texture of her image faded into a slow wind that blew until there was only night and the crying child. Every phase of the child's life passed before us — his hunting, his killing of animals, his making love. He grew older and older. We saw him running in the savannas, brutal hunts of elephant, rhino, and lion, men dying by his side, sickness, the birth of his son. Each cycle

Cheeta

passed, until he was an old man sitting naked with his head down, crouched in a fetal position. He lifted his head slowly. And when his face appeared to us, it was neither young nor old, but held all faces. I saw myself. I saw Mustaffa and Gela in his face. He spoke with his eyes, in a language that wove through the intonations of songs and cries. I wept for what he told us.

The old man changed into a young woman, whose seductive glance made you wish her presence had never been revealed to you, because it left you with a lifetime of yearning. Then I found myself in a desert following her figure, over dunes, never gaining, sweating, dying in the pursuit of her image. Finally, as I climbed the last dune, she engulfed me, staring through me, bringing forth the secrets of my own soul, until she became the water, and I the sand, absorbing the wakes of her essence. I realized she was God.

"I am the water and life that will forever absorb into you," she said, passing through me.

I found myself in Sitoti's being and felt the murmur, the blood of the land, heard the sounds of singing birds clearer than I had ever thought possible, realizing how little I understood of Sitoti. I felt his fierce vision, afraid of nothing, searching, reading the language of the land for food. All was so vivid and alive — from the howls of the hyena to a leaf, rain, and the cold. His figure appeared running toward me. He lifted me up from a bed of grass, holding me gently in his hands. We began laughing. He pointed to buffalo in the distance and started to run after the herd. I followed him. We ran faster and faster and soon became the buffalo. The flesh, the thunder of the lungs coming up through the ears, a power that felt like wind, the sound of the hooves hitting the earth, and I came to know that the sounds are forever left with the earth. We felt the pain of arrows in our sides and fell dying, without anger or fear, into a slow sleep.

My eyes opened to the fire. Sitting, staring at each of us, was a huge, ageless man holding a spear, summoning us back from our vision. His head turned into a *swala* head, then slowly transformed into a lion that unleashed a roar that brought utter terror. Sitoti screamed in agony. The man looked into Gela, and when he spoke butterflies followed his words. He looked into Mustaffa, then Sitoti, communicating a message to each, heard by no other. He looked into me, and in a language of birds and dying men he said, "You know who I am, blind searcher." His eyes bleeding tears. He lifted his palms and pebbles seemed to run from his movement. I gasped as I noticed blood pouring from the wounds in his giant hands.

"Forgive me," I said.

He laughed, not in sarcasm but in sadness and love.

"There is more to that word than you know. See all that you wish to see, fragile witness to what you do not understand. Hope when there is no hope. You blind seeker of a truth that surrounds you every day," he said, vanishing into rain.

I do not know how long we slept, maybe days. When I woke Gela was eating a dik-dik, Mustaffa was humming to himself, and Sitoti was still sleeping on his back, his arms spread wide open. They looked emaciated.

"Eat, Jemsi," said Gela, handing me the leg of the dik-dik. He did not explain what happened, but his eyes confirmed the experience.

Sitoti woke at dusk, like a wild-eyed child, laughing, explaining the whole story of his vision to the other hunters, who nodded in agreement. He seemed to possess a new strength, and refused the meat Gela offered him, miming every experience in detail. His eyes were chilling as he told his vision of the woman and the experience of the hunts. This sparked Mustaffa, who spent the next hour describing the power of his vision.

Gela didn't say anything, nor did I. Sitoti and Mustaffa had confirmed all, and there was no reason to go further into it. I turned around and saw the giant rock wall. There was a huge red cross etched into the wall.

"Where are we?" I asked.

"The mountain of Nudulungu," said Gela.

"How did we get here? I thought we were leaving Nudulungu?"

"He called us back, I guess."

"Why is there a cross on the mountain?" I asked.

"I don't know. Nudulungu made it with his spear before he vanished many generations ago," said Gela. "We must go now, we have witnessed many things," concluded Gela as he put his stone pipe back into his shoulder pack and organized his arrows.

We left Nudulungu forever. The closer we came to Endamaghay, the more the vision seemed to leave us. At one point Sitoti sat and would not move, saying his wife is leaving him, he must go back to Nudulungu.

"Your wife is in Endamaghay," I said.

"No, my dream wife!"

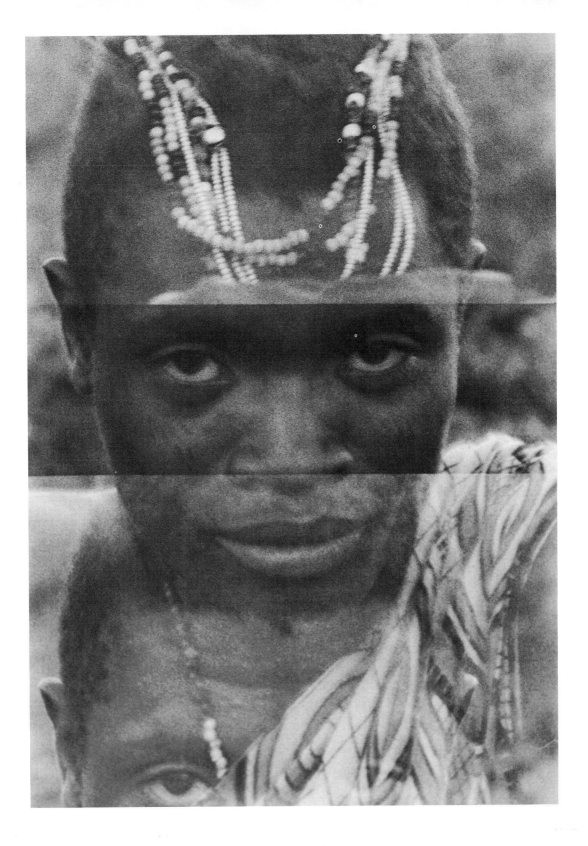

We carried on, until the experience seemed only like a dream.

Things remember themselves,* memories live inside your being although the conscious mind is not capable of grasping its totality. I remember hearing somewhere about the power of a revelation and the way it enveloped the core of the soul. I think it is not as important to try to understand the revelation, but rather to witness and experience it, making yourself a channel, a conduit for it to come through.

During the weeks that followed the vision, everything around me felt new, richer. I often sat down, confused, realizing how little I would ever know in this lifetime. Nevertheless, I felt open and totally free within the indescribable ambiguity of life. I felt attached to nothing, and I started to view the hunters as leaves in the wind. I found myself laughing at everything. Just laughing.

*Black Elk Speaks: Being the Life Story of a Holy Man of the Oglala Sioux, John Neihardt, Washington Square Press, Pocket Books, New York (1972). "I did not have to remember these things; they have remembered themselves all these years (41)."

Hunter

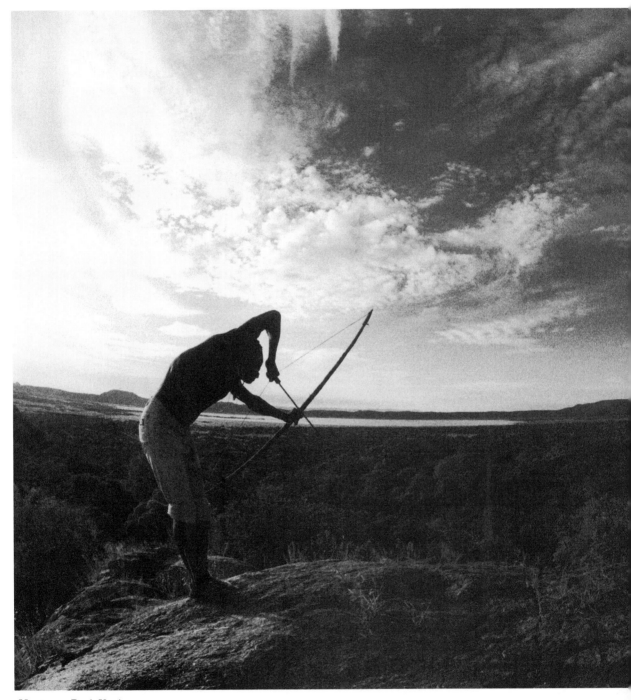

Hunter on Rock Kopje

The Coming
of the Rains

The wind is long and slow, brushing over the body in the cool night. The coolness stays with you in the dry season; it is not cold but soothing, relaxing. The white moonlight creates worlds of shadows among the trees, pockets of time. Sleep seems to drift into the moonlight, and you wake but find yourself staring into the fire or the tree limbs, listening to the wind, wondering if the conversation in the dream was real. You hear voices and look about, but see nothing. And sometimes you lie there and hear footsteps coming toward the camp. You try to move to free yourself from the dreamworld, but you cannot and suddenly, as the footsteps come closer, with all your strength you leap up and find yourself really awake. Confused between dream and reality, you look at the still bodies of the hunters, lying asleep, peaceful. One of the hunters turns over and you ask him if he heard footsteps. He tells you not to worry.

"It is nothing, maybe demon, spirit," he will say and go back to sleep.

You lay awake listening to the wind. Passing thoughts deliver early memories that seem to manifest in the moonlight and in the sounds of the moving branches, coming to life, appearing before you. Then the thoughts vanish. But the power of the moment is there.

On one such night, after waking, contemplating the above while staring out into the darkness, into the severity of the land, listening to its night language, I got up and walked to the fire. I heard hyena fairly close and feared they would come into camp after the drying meat of the impala Sabina had killed that day. So I threw an extra log on the coals and blew into them to ignite the dormant flame. I saw the flashlight and fumbled around for the batteries, putting them back in. It is better to take the batteries out when not using the flashlight in order to give them a longer life. I clicked it on, although the moonlight was sufficient to find my way around. The extra light revealed an army of safari ants headed toward Sabina's head. These ants sting like bees, and can be deadly if an army were to attack you while you slept. Often the large ants appear out of nowhere, advancing to some ant destination. Usually, one might see a small legion of a couple hundred, but at times, there can be a great army of thousands. I quickly tried to wake Sabina. Shouting, "*Wadudu wakali*, angry insect." I had to kick him in order to wake him up. Sabina is impossible to rouse. Some mornings we would leave him in camp (eventually he'd catch up the following night, having followed our tracks). After kicking him a third time rather hard, he leapt up, still half asleep. I pointed the light to the ants. He understood.

"*Asante*, thank you. *Wadudu wakali*, the insects are dangerous," he said, leaping into the middle of them, starting an uncanny foot dance — amazingly quick jumps as he brushed his feet with his hands. Like an idiot I tried to do the same and within two seconds severe pains shot up my feet and legs. About fifty ants clung to my toes and shins. When Sabina was finished he came over and helped me pull the creatures off.

"My feet have medicine. Your feet do not know the ants and the ants do not know your feet, so they will attack. They run from mine," he said, laughing at my expression of pain. I pointed the flashlight to where the ants had previously marched; there were no ants to be seen anywhere in camp. His medicine foot dance had worked.

I found the water bottle, hoping to wash the sting from my feet. There was no water, so I started to walk off to the water hole about a hundred meters away.

"Jemsi," shouted Sabina as he laid back to sleep. "Do not forget your bow and arrows. The night can be dangerous. Here, take mine."

I took his bow and headed off to the water hole, down a small path arcaded by wild bush palms. The Datoga had noticed we were camping in the area, so they fenced off a large portion of the water hole with thorny acacia branches. This water was too dirty to drink anyway, so earlier Sabina and I had

dug a second hole a few meters from the fence. The fresh water of the under-ground spring rose into it, perfect for drinking. We hid this hole with fallen palm branches so the Datoga would not claim it for themselves. They are ex-tremely selfish when it comes to water. In many regions they have destroyed all the natural water sources by digging deep holes to get at the water. The wild game can no longer drink and soon disappears from the area. This has hurt Hadza clans living far in the bush; no animals to hunt.

Once I reached our water hole, I carefully put the clean water into an old plastic container, flashing the light every few seconds around the area to make sure there were no dangerous animals that might also decide to drink at this time of the night. I heard footsteps behind me and turned quickly to see Sabina standing by, watching me. He and I had been on safari now a few weeks, ever since the Mang'ati witch doctor's emissary had shown up at the "big tree" camp in Mang'ola a month or so after we returned from Nudulungu.

"You must go alone on safari now! The old man sent me here to tell you this," the skinny man said before demanding a bottle of *pombe* for his valuable information.

"Why do Sabina and I have to go alone, maybe you are telling us this because all you want is *pombe*, and you think you can always ask for *pombe* af-ter we do what you tell us," I stated. The emissary laughed at what I said, and excitedly sat down.

"The old man is simply warning you that something may happen if you do not go. It is your choice to go or stay, as it is your choice to give me *pombe* or not. Nothing will happen if you do not give me *pombe*, but if you do not go on safari alone with Sabina, something bad may happen or something good may not. The people call the old man a *mganga* because he sees what is un-known to others. It is your privilege that he only wants *pombe* for the infor-mation he gives you," said the skinny man.

"OK, here is your money for *pombe*. The witch doctor is a smart man, he has chosen a wise spokesman."

"*Asante*, thank you," the emissary said, taking the money. He stayed at our camp the rest of the night eating, drinking, and sharing stories with us.

"Come, Jemsi, I heard leopard. It is hunting," said Sabina calmly. I filled the rest of the water container and we headed back to our camp. There were many dik-dik and impala near the camp.

Sabina took the flashlight, searching for the leopard or whatever else he might see, and partly to make sure the path was clear. Sabina was always watching out for me. He was the first hunter I met when I came to the Lake

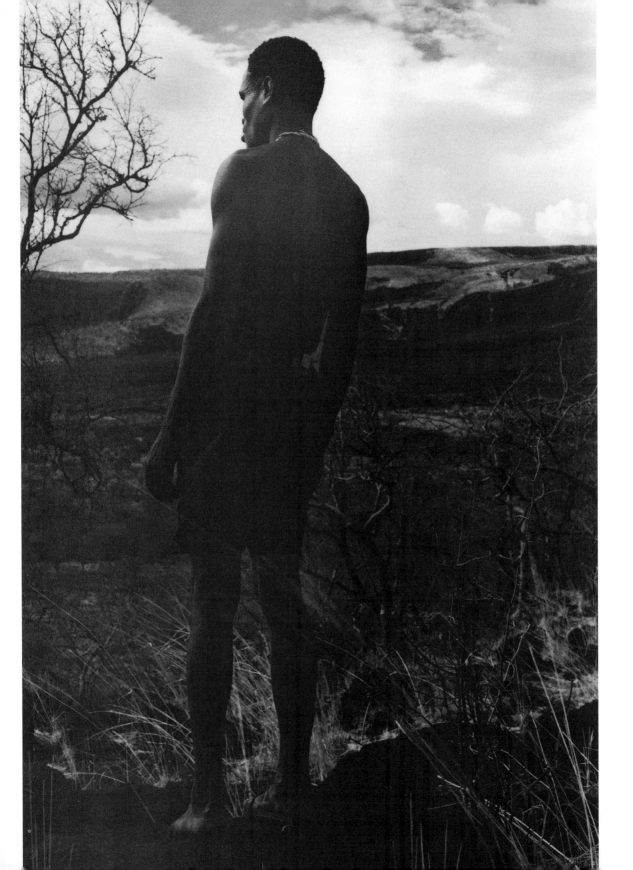

Eyasi region. He was famous for his hunting, probably the last of the young men who still understood the language of the land. I imagine he is around my age but it is difficult to tell. And when I asked him how old he was, his answer always changed. Sometimes he was sixty or forty-five. If I told him he looked younger than sixty, he might then say he was ninety-two. I often tried to explain relation of numbers to age, but this did not concern him in the least. He usually disturbed my explanation with questions concerning other objects of his curiosity — dances, white women, stories of the American Hadza, the bear, food. His statements of age were not exaggerated or rooted in sarcasm, he literally did not know, and did not care to know. Numbers made no sense to him, since he had never gone to school and did not spend much time in the Swahili villages. He only repeated random numbers he had heard somewhere.

One day, walking through a bush tunnel with Sabina and three others, the hunters began arguing about what year it was.

"It's nineteen eighty-four," said Sapo.

"No, it's nineteen seventy-three," said Localla.

"It's eighty-four!"

"No, ninety-five!"

Then Sabina spoke with the confidence of an expert, "It's eighteen eighty-four! Right, Jemsi?"

"It's nineteen ninety-seven, and who cares anyway," I finally confirmed.

"See! I told you," said Sabina, elated.

Sabina's father died of a cough when Sabina was a young boy. His mother died shortly after, of an eye infection that made her crazy. He believed his parents had been poisoned by another Hadzabe, because his father made money tracking for white hunters. Sabina and his sister lived with Mzee Wapo and his wife Caeooa after the death of their parents. Mzee Wapo hunted and his wife gathered roots and berries all over the Eyasi region from Matala to Sanola, Yaeda, Mongo wa Mono, Sponga, Gilgwa, Endamaghay, and finally Mang'ola. Mzee Wapo enjoyed the different seasons and the food that could be found in different areas within these seasons. So Sabina learned a great deal living with them.

"Do all Hadza travel around the lake like Mzee Wapo did?" I asked.

"Some do, but not as far as Mzee Wapo. Mzee once loved food, but now he likes *pombe*." Mzee Wapo developed a terrible drinking problem in Mang'ola, and no longer travels searching for food.

Sabina explained how Mzee Wapo still possessed a knowledge of reading the land that now has been lost. Mzee Wapo taught Sabina many ways to hunt *na-ko-ma-ko, bo-po-ako, dan-jo-ako* (zebra), and about the ways of other animals.

Sabina

"Do you remember your father well, Sabina?" I had asked him one evening as we sat by a fire.

"I was still young when my father died. He was leaving our family often to hunt with the white man. I remember that my father had a funny walk because a rhino speared him through the leg when he was a young man."

"And your mother?"

"My mother taught me to use a bow and how to hunt small birds when I walked with her to dig up roots," said Sabina, rolling himself a cigarette. "If I am alone and hungry I will dig for roots. Most Hadza men will not admit that, because digging for roots is the work of the woman. But men learn where to locate the roots walking with their mothers when they were boys."

Sabina's hunger was incomparable. He had an insatiable appetite. And this is what led him away from the towns and

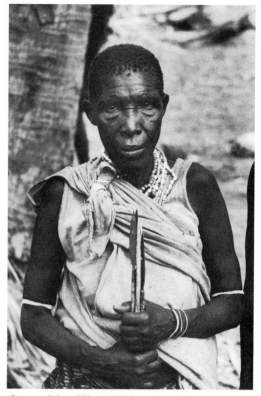

Caeooa, Mzee Wapo's Wife

the new life many of the Hadza are falling into. Sabina loved meat. As the game dwindled, he hunted longer hours and walked greater distances to find the animals. The other Hadza were always amused by Sabina's excitement over eating. They did not directly tease him because it did not concern them, but if we were all eating together, Mustaffa and Musa might look at each other and start laughing at how furiously Sabina was tearing into his meat, or how excited he would become before eating his food, or how quickly he could skin an animal and prepare the meat. This is why he was such a great hunter, because he would go to any measure to get his food. And once dedicated to his purpose, nothing would stop him.

He shot a civet one night, the size of a large house cat but longer, leaner, and definitely meaner. The civet ran up a tree covered in a sharp, thorny entanglement of green vines. Sabina went immediately up the tree after the cat. He reached into the cat's hiding place and grabbed it. The cat began attacking Sabina's hand, its screams cutting through the silence of the night. Sabina started growling too and either threw himself off the tree or was thrown by the

Hunter Climbing Tree

force of the cat leaping out of its hiding place. He fell about seven feet onto his back, still holding the cat's neck, both screeching as they fell. A second after falling, he was up smashing the cat's head onto the ground, swinging the cat by its tail. He did not even glance at us and ran back to camp, holding the dead cat while talking to himself, the excitement taking him into a kind of trance. Mustaffa and I quickly followed, laughing. By the time we reached the camp, Sabina had already skinned the animal and its hairless body was sizzling on the fire. He was sitting immensely relaxed, soaking his chewed-up hand in a calabash bowl filled with water. He had lost about an inch of flesh, but the flesh was still hanging on by flaps of skin. I carefully cleaned the wounds and bandaged his hand. In no time he was fine. In fact, that night he went to a Hadzabe dance and in the morning there were two young Hadza women sleeping by his side.

Sabina was a great tree hunter. In areas where it was impossible to spot the game he would climb any tree and disappear into its limbs, balancing, sometimes, on the uppermost branches, for hours on end, until he spotted game. I often had trouble locating him in the tree. There was nothing abrupt about his ascending or descending a tree. He could climb any tree without stopping his movements. Boom, he was up. In a way, I found this a bit spooky. There was something of the feline in him. Legend has it that the witch doctor can turn into the lion or the leopard at night.

Sabina followed one law and that was his own. He was so complex that it was difficult to predict his actions or reactions. Sometimes he would tackle me out of the blue and demand to wrestle. He often painted curious archetypal signs all over his body. He then would run around the town of Mang'ola scaring the Swahili and demanding free drinks of *pombe*. He also loved to paint wiggly archetypal lines on his shoes and dance to tunes he heard in his head — crazy, arm-waving Elvis-type dances that kept all the other hunters' eyes glued on him. He had a long, slow-growing temper, but when it snapped he would strike like a snake without warning. I once saw him reach for his knife with awesome speed. We were at a Hadzabe dance. Some Hadza men from Matala, who were extremely drunk on *pombe*, started accusing Sabina of telling all the woman to come to our camp, which he may have done. Sabina just sat there absorbing their accusations. Finally he said, "I don't like your noise," and pulled his knife. The men backed away and sat down. Sabina had once stabbed a man and they knew this.

When I asked him how and why he had stabbed someone, he said clearly and simply, "The man stole my bow and when I went looking for him, I found him with my wife. After I stabbed him, I disappeared into the bush for

Sabina Sitting

Sabina's Hands Holding Out Tobacco
and Dried Leaf

a year and when I returned, the man had healed and apologized to me. I found a new wife."

Sabina did not like violence, though his circumstance at times demanded it. I knew that at some point in his childhood Sabina had been severely hurt emotionally. Possibly it was his parents' death, or possibly facing the prejudice of the Swahili, or maybe the later pain that rose from the loss of his first wife and the death of his baby — a tapestry of pain that never overwhelmed him but was always there. I don't think it concerned him, but the pain could be read in his face. At some point, his confidence in others had been shattered, which left a profound impression on his outlook. When life became extremely tough, this pain mask undulated most acutely at the corners of his mouth. He had mastered the struggle involved with surviving in the bush. But there was an unanswered question in him that he had grown to become. What that question was I don't know. At times, one saw his search rise in his eyes, then vanish into the movement of his hand. One saw it in the way he sat.

When Sabina and I came back from our first long safari, his young, beautiful wife came running up to him, holding her baby in her arms. The baby was pale and barely breathing. I will never forget Sabina's look of grief and helplessness. The child had been sick for some time. Sabina had taken the child to witch doctors and hospitals, and believed the baby was getting better. But that morning the child just let go, as if he was waiting for his father's arms. The boy gave a little cry, then he died. Sabina sat there under the tamarind tree as gentle rain fell, kissing his dead baby's eyes. He did not cry.

Sabina was an excellent father to his one living child, a little boy named Na-ko-ma-ko, who was a daddy's boy. When Sabina was in camp, the child would not leave his side, imitating every move Sabina made, the way he

ate, carved arrows, walked. And when Sabina would leave on safari the boy would not stop crying. One evening, Mustaffa nudged me and pointed out Sabina and his three-year-old boy eating meat, standing with the exact same posture, the boy eating with the same passion as Sabina, making similar eating noises.

When I first came to visit the Hadzabe, Sabina took me on a two-week safari. He taught by example, whereas Mustaffa possessed a great ability to eloquently explain the ways of the Hadzabe and the ways of hunting. Sabina made simple statements, unless you pushed him to explain in detail — to let the river flow — detail which was brilliant to listen to. When Mustaffa began coming on our safaris, Sabina was always present but gave the leadership role to Mustaffa and quietly retreated to the background. Mustaffa had such a dominant personality and a gift for teaching that I was immediately taken by his intelligence. The other hunters sensed this, and naturally let Mustaffa play his role. But I later found out that I was Mustaffa's prey, and that he was one I could never truly be friends with, due to his expectations. He would be there for me, but wanted more than I could give him, and when I realized he was mimicking my frowns and smiles, I no longer completely trusted him.

If I ran out of money in the bush Sabina stayed by my side and hunted, whereas Mustaffa quickly disappeared. When I finally realized Sabina was the one to trust, he organized our long safaris and decided where we would go. The people he chose were genuine and never asked for anything in return — men like Localla and Sapo. With Mustaffa, the final destination of a safari was finding a *pombe* bar. For Sabina, Localla, and Sapo the final destination was the fireside and the sharing of stories. As Localla once said to me, "Now you are with real Hadzabe, not Hadzabe from the town. Mustaffa is crazy from the *pombe,* he cares only for the *pombe,* nothing else. We will take you to places Mustaffa has long forgotten about."

On the longer safaris when life was very difficult, Sabina became silent, stern, enduring the thirst, the hunger, the cold. Every physical movement he made seemed premeditated; he wasted no exertion. If everyone ran out of tobacco, one could be sure Sabina still had four or five cigarettes. He would always secretly slip me a cigarette, motioning me to follow him to a surprisingly comfortable spot without flies, where we could enjoy the tobacco in privacy. The Hadzabe share everything, so if we were to light these cigarettes in front of the others, we would only savor one or two puffs. Sabina always assessed the situation, knew what would happen before it occurred, knew that we would run out of tobacco and there would be no means of finding any at our next

destination. He also hunted this way and was not afraid of any situation. He was one of the few men in his age group who had killed more than three lions, alone. He never complained about the lack of game.

There was also an innocence about Sabina, a crack in the voice, a laugh that was untainted and pure. When he was in awe or bewildered, this innocence was also seen in his body language. When I first saw it clearly, Mustaffa was taking pictures with my camera. Mustaffa suggested that Sabina try the camera, which in a way revealed an important attribute of Mustaffa's character. Mustaffa understood that Sabina was becoming jealous, and he also knew that Sabina would love taking pictures with the camera. Mustaffa called to Sabina, holding out the camera to him. Sabina shuffled over, his shoulders drooped. He was giggling to himself, a smile covered his face. He was totally dumbfounded by the idea of using the camera. Sabina looked like a child stepping into the sea for the first time when he took hold of the camera. It wasn't long before Sabina handled it with ease, as did Mustaffa. They were always courteous with each other, never arguing about who would take the camera, but always wishing to be the one to carry it, load it, shoot. When they worked as a team there was nothing like them. I witnessed Sabina's innocence a second time, as we walked into a small hotel room in Karatu and later when we walked through the doors of a disco in Arusha. Karatu is a growing town on the main safari road to Ngorongoro Conservation Area. Arusha is the second-largest city in Tanzania. Sabina continually asked to be taken to Arusha. Finally, after spending four months with him on this last journey, I said, "OK."

In both Karatu and Arusha, Sabina followed me as I had followed him in the bush. When we walked into the disco, he grabbed my hand. He was nervous and startled at what he saw. Soon, however, he would not stop dancing. And when it was time to leave the disco, he quietly followed me out into the predawn street, not walking by my side but following my footprints, as if I was leading him on a hunt.

In the towns his silence and inner quiet amongst all the charlatans highlighted his integrity. One evening I watched Sabina standing, talking with the men from town, all of them hoping to get my money through him. He seemed so poised compared to them, with a natural sanctity that they did not have. I never clearly understood this quality about Sabina until he was standing with these thieves. He glowed with an honesty, a confidence, and in their foolishness they thought they were better than him, teasing him for the sandals he wore, made from old car tires.

"I need new shoes," Sabina later told me. "The men say that I should not

wear these shoes if I am to be your friend and go with you to places in Arusha."

I told him those men were stupid puppets of consumerism, followers of a wide, easy road that make the so-called "*bwana mkubwa*" (big man) rich and the poor man lose faith in himself. I tried to explain that what he possessed, both as a person and a hunter, were qualities they did not have. He seemed to understand. After two days in Arusha he said he wanted to return to his *nyumbani* (home).

"*Shetani mkubwa,* the big demon lives in Arusha," said Sabina.

I was most intrigued when Sabina took on the role of a mother — when the opposite side of his severe masculinity emerged. He was in balance with his feminine side, which rose to the surface when he was either saying good-bye or explaining a subject in great detail. He became proud, smiling, unexpectedly gentle, like a mother admiring her child. He would examine your questions with an unconditional quality that made you feel as if you were his son. But strangely, this feminine side could suddenly vanish if the question pierced into his pain. Then the aloof, sad boy manifested himself and he walked off, establishing a solitude that no one in their right mind would interrupt.

In Arusha, we sat in the hotel room most of the day, not interested to walk in the overcrowded city. Sabina would pull out his *malimba*, a small, hollow, wood box with ten or fifteen aluminum vertical strips used as musical keys clamped to a horizontal anchor. He began playing a never-ending improvisation, urging me to participate in his songs. He enjoyed this activity very much, often saying, "*Safi sana*, Jemsi, *safi sana*. This is very good, very good." He felt, heard the music passing through him before he would pull out his instrument. I knew it was coming when his lips silently moved to the songs entering his mind. His eyes looked at you, asking you to participate, relaying the silent signal that the playing would begin. But he could also recognize if you were not willing or ready to participate, and then he played himself.

When we finally did walk through the town of Arusha, he said little and just followed me. His presence was so quiet and so much like air that at times I would look around for him before realizing he was behind me. Others often noticed him, stared at him, unable to understand what was different about him. When people would call out to me, he would stop me and say, "They are calling you, why do you keep walking?"

"Sabina, they want my money. I am a white man."

While in Arusha, he was always talking to people with such a genuine

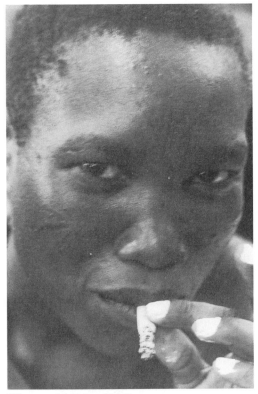

Woman with Painted Nails

interest that they often seemed taken aback by him, eventually asking him for advice on certain issues. I was concerned for his naïveté.

During our visit Sabina, to my surprise, picked up a young lady who worked in the hotel's adjoining Ethiopian restaurant. He asked me for the keys to the room.

"I am meeting the *dada* this afternoon. She is coming over to the room for lunch."

"What kind of lunch, Sabina?"

"*Chakula cha Sabina,* food of Sabina," he said, laughing.

Later when I returned to Arusha alone, the young woman asked me, "Where is your friend, the engineer from Mang'ola?"

All women seemed to love Sabina. At times around the fire, when we talked about oral sex, the other hunters would laugh or gag at the idea, but Sabina, with all the cool in the world, taking in a drag of his cigarette, explained why he enjoyed oral sex and how he performed it.

"Of course you would enjoy it," Mustaffa said. "Your head has gone *chizi* from the *bangi*. The *bangi* smokers do stuff like that. But maybe that is why so many women like you."

"I am sure it is one of the reasons," Sabina said confidently, not taking into consideration, probably because he was not aware, that he was a strikingly handsome man.

At four o'clock in the morning, the ground loses the last bit of its remaining heat from the sun and the wind becomes cold. Sleep is difficult. The warmth of the fire travels through the ground. The last morning I spent with Sabina, he woke at this time, slowly lifting himself to place more logs on the fire. Sitting still by the roaring flames, the arc moon silhouetted in the sky above him, his physical presence seemed to vanish and return. He held an inner space that

was somehow in union with the outer physical reality. Without looking at me, staring into the flames, he said, "Jemsi, come sit here by the fire with me; you're sleeping next to a snake hole."

Sabina and I made it back to the camp after fetching the water from the small hole we had dug earlier. The sting of the ants had now disappeared from my feet.

"In which direction do you think the leopard went?" I asked Sabina.

"He went to the water where the ostrich drink. The rain is coming tonight. We will find a girlfriend of mine and sleep at her camp. She lives not so far from here," said Sabina, looking into the air, sensing the coming rain. "We must leave now."

We gathered our bow and arrows, a cup, a cooking pot, and the dried impala meat, and we walked for an hour or so before Sabina spotted the eyes of two dik-dik with the flashlight. He handed me the flashlight and shot them both. We did not have to chase either animal, they were immediately paralyzed, but we did have to crush their heads with the backs of our bows to kill them — large males about forty pounds each.

Finally we came to a Hadzabe home under a baobab tree. Sabina whispered into the entrance. There was no answer. Sabina whispered louder. Again a long pause, then a young woman pushed away a branch of thorns that protected the entrance from hyena. She looked out at Sabina and said, "Come in."

The hut was dark. It smelled of acacia smoke. The young woman still half under her blankets started to blow on the coals. She broke off a few small sticks from a pile of branches, placed them on the coals surrounded by smooth rocks, and blew again. The sticks burst into flames and the upside-down bird-nest home, seven foot by seven, five foot high, was now illuminated with a warm comfortable light. The walls of the hut were made of sisal stalks and branches and the exterior was covered with grass to keep the rain out. The young woman was beautiful. Sabina handed her one of the dik-diks as a gift and left the hut to skin the other. I sat near the fire. The woman put the dik-dik in a small bag and hid it in the corner of the hut under some cloths. She then sat up and stared at me. She placed her fingers to her lips and imitated smoking a cigarette. I reached for my last pack of Sportsman (a Tanzanian

brand), pulled one out, and handed it to her. I felt something move behind me and leaned forward, startled. The young woman started to laugh. I turned around and there was another young woman half-covered by a large blanket. She held out her hand, demanding a cigarette. I gave her one. She smelled it and asked, "*Tumbactayo*, tobacco?"

"Yes," I answered.

She got up, covered her firm bosom with an old *kanga,* put the cigarette into her mouth, leaned over me, and pulled a small stick out of the fire and used the burning end to light her cigarette. She placed her hand on my shoulder to lift herself up and walked over to the other side of the fire to sit with her friend. Both the young women began to giggle.

"Jemsi," said the one who had just sat down.

"Yes, I am Jemsi," I said, and decided to growl and imitate a lion coming after them. They screamed. One of them threw a stick at me that cut my forehead. They quickly jumped up, grabbed my head from my cupped hands, and poured water into the wound. They washed it out, pressed a cloth onto it until the blood stopped, and returned to the other side of the fire. The young women began giggling again.

When Sabina returned the women immediately took control of the meat, cutting pieces to put into the fire. Sabina said something in Hadza language and the young woman whom I did not notice in the beginning moved to sit next to me. Sabina sat next to the other woman.

"*Dada safi sana,* the woman is nice! *Ndiyo,* yes?"

"*Ndiyo,* Sabina."

Sabina started to sing a quiet song as the woman giggled and prepared the meat. I reached to move a piece of burning meat and the young woman slapped my hand. Sabina started to laugh.

"*Polepole,* Jemsi, *dada kali,* slowly, slowly, Jemsi, the sister is tough."

"*Ndiyo,* yes, I know," I said, pointing to my forehead. The women told Sabina the story and he started to laugh again.

"What is your name?" I asked the one who had slapped my hand.

"Mela," she said without looking at me.

"And yours?"

"Zita," she said, smiling.

Mela took a large piece of dik-dik meat, furiously cut a small bite off it, grabbed my chin with an unusually strong grip, and put the meat into my mouth. She looked at me and touched my hair. I laughed, Sabina laughed. She quickly pulled her hand away and looked down into her lap. I grabbed the meat and cut her a piece. Without looking at me she took the piece with her teeth and looked at her friend with a shy grin. Both the women began to sing.

Sabina joined them as he crushed the thigh bone of the dik-dik to suck the marrow out. Zita grabbed the bone from his hand. Sabina let her have it and reached for another piece of meat.

A half an hour later the rain started to pour down. I was happy to be in this warm hut snuggled up close with a young woman, eating meat. Sabina was now under the covers with Zita, playing with the flashlight. Mela went back to her bed and pulled a blanket over her. I looked for a comfortable spot to sleep.

"*Bocho*, come, sleep here," said Mela, lifting up her blanket, tapping her hand on the ground next to her.

I lay down and she put her hand over my eyes and sang softly in my ear. When she finished singing, she unwrapped her *kanga* and pressed her warm body into my back.

The sound of the rain, the breath, and the fire eased us into sleep.

For the next few months the rain came down in unprecedented force. All the Sukuma, Datoga, and Mbulu homes on the Lake Eyasi basin were swallowed by the once-dead lake. The German flower seed farm disappeared under the Baray River in Mang'ola, scattering the fields and bush with seeds that later blossomed into the colors of sunflowers, cosmos, daisies, marigolds, zinnias, and roses. The rainwater violently rushed down the dry riverbeds from Sansa-ko to the Kidero mountains and all the surrounding hills. Ancient baobab and acacia trees disappeared into the roaring rivers. One old man could not recall so much rain in his lifetime. Many of the valleys filled, becoming new lakes.

"*Eyasi ana njaa sana.* Eyasi is very hungry," said Sitoti one morning as we sat washing ourselves in a small riverbed flowing from the morning rains down to Eyasi.

In a matter of weeks, the dry semidesert land was transformed into lush green meadows. Butterflies and wildflowers of every sort appeared. The dried water holes once again offered water to the animals. Buffalo, wildebeest, giraffe, elephant, lion, and zebra all returned to the valleys, ridges, and grasslands they had long ago left. Old Hadza camps disappeared under the green carpet, their abandoned homes devoured by fast-growing weed vines.

The Hadza returned to the caves from which they had long been absent. The ancestors that dwelled in such places were glad to hear the voices of the young children, the mothers' soft words, hunting stories, and laughter echoing through the rocks. Grasses grew to the size of small trees and were dangerous to walk through due to the poisonous snakes. The giant boa constrictor, "*chatu, e-cha-kwa*," returned to the high regions, hunting the small dik-dik, impala, and gazelle. Fresh mold grew on the cave walls and was used by the hunters for various ailments. The water was pleasant to drink. The nights were plagued by swarms of newly hatched mosquitoes, intermingled with the glowing bodies of firebugs. Clouds of busy dragonflies shadowed the bright afternoons. Mornings broke through the night, bleeding light profusely through the rain clouds, initiating an indescribable symphony of birds celebrating this new abundance of life. Roads became rivers, and so the Lake Eyasi region was cut off from the outside world.

The land developed a new countenance and with it another way of life. The nights became dangerous due to the prides of lions that had followed the game, and the snakes who did not seem to spend much time in their flooded holes. Sabina returned to camp one morning after a hunting trip with teeth holes in his upper right arm. He was resting on a rock in the afternoon sun when a *chatu* snake, the size of a palm tree, bit his arm and started pulling him toward its body to crush and swallow him. He stabbed the snake many times in the head before it let him go.

After six months of living with the Hadzabe my whole being had changed. Time is an elusive concept in the bush and I wasn't totally sure how much time had passed. The calendar claimed six months, but I swear it could have been years. I had lost twenty pounds, but was definitely stronger; the land and lifestyle granted me a lean, leopard strength. I felt absolutely free.

Often in the markets, a Hadzabe man or woman danced wildly alone, hearing the music of some radio. All the Swahili people of the town would gather around laughing and making fun of the Hadzabe dancer, sneering at him, calling him a fool, yet secretly filled with envy. And the dancer didn't care; he or she was enraptured by the music, flying above the derisive onlookers' pettiness.

The Hadza never withhold from joy and pleasure. If it was two in the morning and someone started to sing, suddenly everyone could rise and begin dancing and singing. This happened innumerable times. In the middle of the night, one of the hunters, gripped with sexual volition, would walk miles to find some Hadza women and convince them to return with him to our camp.

There is an energy that surges through the Hadza, from the young boys to the old women. It is this energy they embrace, or it embraces them,

harvested from the hardships of the land and fueled by the natural food. And this energy is one of the elements of their freedom.

At the time when I was fully engulfed by and high on this new energy, I left for Zanzibar to see some friends, and partly to escape the extreme discomfort of surviving the rains in the bush. It took four days to arrive in Arusha, though normally it takes one. The vehicle was almost washed away three times by rain rivers, similar to mud slides. The vehicle was hourly stuck in the mud. Many deaths occur in the bush due to these rain rivers. A small river that looks crossable can suddenly become a six-foot wall of roaring water due to heavy rains in the yonder. From Arusha I flew to Zanzibar.

Once in Zanzibar, I felt as if all the buildings would crumble before the energy that now flowed through me, as if a primal cry had shattered the barriers of my inner world. The energy of the stars, the earth, the trees, the animals, the water, all seemed to channel through me. I no longer felt solidified to a programmed frame of time and space.

I mention Zanzibar to explain this energy, and why its liberating origin nearly destroyed me. I was experiencing firsthand the reason "civilized" lifestyles are devastating for the Hadzabe. It was not a severe change, but a new energy surged through me. I did not know how to, nor for that matter did I want to control it. For me, its roots were spiritual, but it contained a carnal, fearless edge. I was creatively on fire and sexually out of control, a lucid lascivious libido mixed with a self-destruction gripped and threw me around like a rag doll. The ancient man inside me had awakened and was struggling violently with the modern man. This chaos created a vortex of energy that flung my reason to the wayside.

The mental discipline that makes one restrain his/her action in the present, to protect one's future, was no longer functioning properly inside my head. I didn't care about the future, it was only a concept. And this new union with nature somehow made me unguarded against the seduction of the drink. Drinking while possessed with this energy is a rampage, a stumbling ecstasy, a wild, careless oblivion. There is nothing conservative about it — no control.

In Zanzibar I found myself hunting women for sexual pleasure rather than animals for food, and horrifically unconcerned about AIDS — playing a game of Russian roulette. *Was I absolutely insane?* I often asked myself, waking in the middle of the night from a recurring dream of an orange moon speaking a language I could never retain once I returned from the sleep world.

I moved into the Zanzibar Hotel with my fantastic and crazy gay friend Tom, who was at a similar stage in his life. The poorly run, dilapidated hotel was at

one time a rich merchant's home with spacious rooms, hallways open to the sky, and seaview terraces with Art Deco balustrades. The place must have been brilliant before the government took it over after independence was declared in the sixties. The hotel was in a good location and inexpensive.

We indulged while in Zanzibar, hitting the nightclubs, motorcycling to remote beaches, tripping on Ecstasy, hiring pimps, going to the speakeasies of the bush — places where the transvestites, whores, drug dealers, and questionable characters party the night away, free from the police and Muslim righteousness. Tom was writing a story on prostitution and another on Bi Kidude — a famous Taraab singer who had started performing again after decades of obscurity caused by insulting the last sultan. I thought it was a good idea if I took pictures for both stories.

We spent Christmas day on a sandbar off the southern coast of Zanzibar with many of the prostitutes and people of the night we had befriended while working on these stories. What a Christmas celebration — dancing, cooking fish on an open fire, drinking in the sea winds. Many of the people revealed their true faces. They were happy, or at least trying to be. But with their expressions of happiness you saw so clearly the horror of their circumstance, and the pain it produced. So many of the young women's hearts were scarred or maybe shattered; there was no way you could bring them back in this lifetime, their souls had retreated far away, to a secret place where their hatred for themselves and the world could not find them. They danced around wearing fake smiles. Others were still-shining young men and women who had yet to be ruined. But they too would eventually be swallowed by the perversion and pleasures of men coming to escape their jobs and wives. Tom called them Zanzibarian sin-flowers. A few of the women seemed to rise out of their circumstance, reminding me of old-time Venetian courtesans. They had gained cunning insight into human nature and were boisterous, full of laughter — love mamas. Some of them spoke many languages from living with various boyfriends in other parts of the world. But they had returned to Zanzibar, their home — a magical place of arrival and departure stained with cruelty and gentle *omani* (love, peace), layers of languages, customs, beliefs, colors, aromas, and secrecy.

In the Zanzibar Hotel I lived with two Zairian sisters; strikingly beautiful women. They were the only surviving members of their family. The rest had been executed by the freedom fighters against Mbutu. They escaped with the aid of a brother whose head had been blown off at the Ugandan border. He had distracted the rebels to allow his sisters to run across. They walked hundreds and hundreds of miles, traveling over lakes and down rivers until they made it into Zanzibar.

I met the one sister, Samantha, at the New Happy Bar — a dingy little den of iniquity. I watched her for an hour before talking with her. So fragile and exquisite. She was surrounded by meat-stuffed, fat government officials, drug addicts, and elderly Europeans all trying to get into her pants. She broke a bottle against a table and threatened to shove it through one man's throat after he violently grabbed her arm when she politely said she was not interested.

"We have nothing, how else do you expect me to make money?" she answered when I asked why she was in such a place. We made mad love for two days, before she demanded that her sister Jennifer stay with us.

The night after the big Christmas party, ten days into their stay, Samantha told me that Jennifer was lonely and could no longer sleep in the other bed. The unconditional love between the sisters was liberating. I became madly infatuated with them both, and felt terrible for their situation — no money, friends, family, and living illegally in Zanzibar. Samantha was eighteen and Jennifer twenty years old. They had enrolled themselves in a language school and studied every night, while Tom and I were out researching his stories. They waited up for me, always demanding to know why I was coming home so late. They did not trust Tom, saying that he was jealous of them.

"He is my best friend," I told them.

"But he likes other men."

"So what?"

One evening Jennifer screamed on the terrace.

"What is wrong?" I asked.

"Come see, uh la la," she whispered. I peeked over into Tom's adjoining balcony, where he was in full swing with a young lover.

"Is that a man he is with?" she asked.

"Yes, does it bother you?"

"Uh la la la," screamed Jennifer, running to hug her sister.

The next morning I left the hotel to take care of some business and when I returned the sisters were gone. I found out an immigration officer had taken them to the harbor. I ran and met them ten minutes before they were deported back to Zaire. They were crying violently, saying they would be killed if sent back. I tried to help, but didn't have enough money for bribes, and later found out that it was the jealous bar owner who had reported them to immigration. He was the one who grabbed Samantha's arm the night I met her.

I finally realized after a naked New Year's Eve party that if I stayed any longer in Zanzibar, I would be finished. I had no control and didn't care to find it. There was also a darkness attached to the recklessness. By shedding my cul-

tural baggage I was experiencing, only slightly, the chaos of the immense transition the Hadzabe are faced with. Who can ask anyone to leap thousands of years within one generation? I returned to the Hadzabe and the bush. The trip took many days, due to the destruction of the roads from the terrible rains, and thus began the journey to the rock paintings.

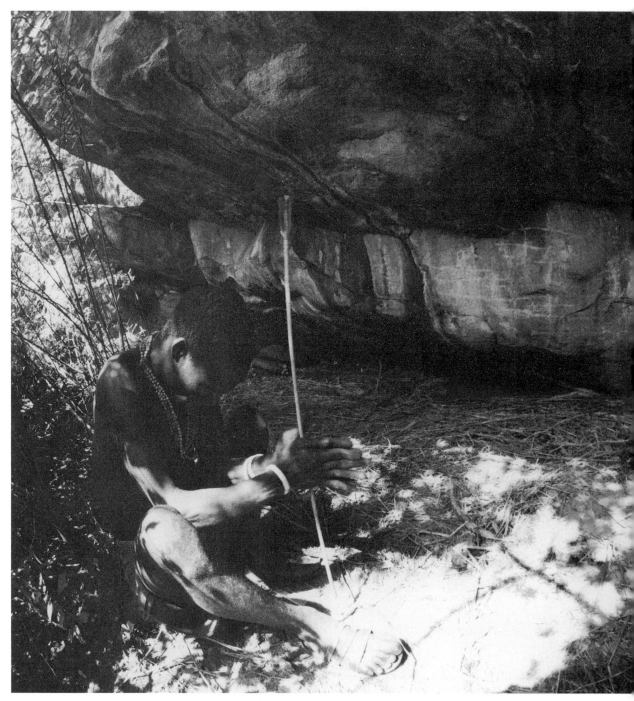

Making Fire Near Rock Paintings

8

The Search for the Rock Paintings

Sometimes a spirit appears. Moons pass away and are born again. You smell the coming rain and hear the trees drinking. The birds sing when the rain stops. While kneeling to smoke a cigarette one afternoon, clumsily, you crush a small flower; an intangible feeling presses into you, a pulse, a rhythm from the land. And while you inhale the harsh Maasai tobacco, you think that the evolution of your experience occurs without your awareness — unfolds as you hear the language of the root-tapping stick. And you dream one morning of young Mkoa, age three, with two big, yellow butterflies following his unsure steps, and when you wake he is staring at you, calling you *baba* (father), as he calls all the hunters, because he has many fathers. *Is there an underlying meaning in all this?*

When you see the fires in the distance, while walking up the escarpment after a successful hunt, some of the hunters begin shouting to the people sleeping in the Hadzabe camp.

"We have meat! Come help us, we are tired!"

The excitement pierces the night sky and the hungry women and children run out to help you. They carry the meat into the camp and throw the meat onto the fire, singing, their hands radiating

toward you, shooting furious, delicious energy that intoxicates your tired body with pleasure. And when you finally are about to fall asleep in the upside-down bird-nest-cocoon home, laughing is the last thing you remember, because Sabina walks up to the entrance naked after doing the *jiggi-jiggi*, politely handing you water, looking like a forest nymph under the full moon. He starts dancing as he laughs, singing, "The moon is bright and I wear no clothes, the moon is bright and I am happy." He tells you while he is dancing, "We will leave on safari in the morning with Nubea, the old man; we will find the rock paintings you search for."

For many years I had been asking about the rock paintings. The hunters said they exist, but never revealed their location.

"There are paintings over in that direction," Mustaffa might proclaim, pointing toward a vista. But nothing would ever come of it. In fact, we had set out on several safaris to find the paintings, but we always reached a blank cave or rock face. The hunters would tell me a magnificent story or history of the location but I never saw paintings. It wasn't until I learned a great deal more about their way of life that the guide to the rock paintings appeared.

We were camping in a place called Dongobash when an old man named Nubea arrived at our fire. He stood for a while staring at me, then greeted the other Hadza. He shook my hand and looked at me peculiarly, then sat down and became silent. He listened to the various conversations, gratefully taking some tea. An hour or so passed. Finally the old man leaned over to me and said, "*Nitakuonesha wewe mawe ya chorawa*, I will show you the drawings on the rocks."

"Really?"

"*Ndiyo,* yes."

He explained that many of the rock paintings are located in holy places, places the younger generation do not know of. These paintings are in and near abodes of the ancestors. But some old sites have already been ruined.

"The younger generation is possessed with greed and they will show the paintings to many tourists. When the Mbulu see the *wazungu* (Europeans) going to the locations, they discover where these rock paintings are. This will

continue to disturb the ancestors. The Mbulu are convinced the Germans hid treasures where the stones are marked with drawings. The Mbulu have already destroyed many of the rock paintings looking for these treasures. I will take you to these paintings, but if you show anyone where they are, you will die."

Nubea believed someone in the future would be born who could possibly understand the meaning of the paintings better than he could.

"There are messages the ancient people left for us. Only a few Hadza men know the layers of meaning in these paintings," he said.

"How old are the paintings?" I asked him.

He said neither he, nor anyone else, knew when a Hadza last painted on the rocks. The knowledge of making the clay dyes has been lost.

"People come into the culture who have a gift and too often their knowledge disappears when they die," said Nubea, who then gave an example of a man who made whistles out of tree bark that could imitate the sounds of various animals. For example, if the man made an impala whistle and he blew into it while hunting impala, the animal walked right up to the hunter's hiding place and he shot the animal for food. Before this man died, he tried to share his knowledge with others. He constructed as many whistles as he could. He demonstrated the way of making the whistles, but no one could repeat his skill. The old man died, a few generations passed, and eventually all the whistles had been lost. The knowledge was gone forever.

He understood I wanted to take pictures of the paintings. This was possible but, he said, "We must explain our situation to the ancestors at each rock painting. Some places are too dangerous and the ancestors may not agree with the idea."

"Why are they dangerous?" I asked.

"*Shetani,* witch demon, *wachawi,* demons and angry ancestor spirits," the old man said. "I dreamt that I must show you these paintings. Others have seen some of these paintings. But they were not always shown by a Hadzabe who knew them well. And too often, they are shown to outsiders by Mang'ati or Mbulu tribesmen, who do not understand the paintings. The Mbulu and Mang'ati have come across rock paintings on their walks with their cattle. It is not good for people to see these paintings without a Hadzabe who understands the medicine to communicate with the ancestors. Most of the Mbulu who destroyed various holy sites digging for treasure are now dead, the ancestor spirits killed them," said the old man, staring into the fire.

"You may take pictures of these places but do not disclose the location to anyone, not even other Hadza," continued the old man. He then departed, telling Mustaffa and Sabina that he would return in a few days' time.

* * *

We set out three times to find the rock paintings with Nubea. After forty kilo-meters on the first safari, we returned to Mang'ola, because Nubea forgot his medicine to protect us from the *shetani*. We reorganized and set out again, but this trip failed a mile outside of Mang'ola because Sabina and Sapo wanted to sell the medicine they had scraped off the cave walls at the market the next day. A few days passed before departing on a third trip, which was also unsuccessful. Nubea and Mustaffa decided that after getting sick from eating too much *tandala* meat, we would all die if we did not talk with Mzee Deo, a witch doctor. Finally everything was settled and we left, not realizing that we would be on safari for two months.

One extremely hot afternoon, a few weeks into the safari, the shade was so calming that sleep was impossible to escape; in the long, matted-down grass under a thick bush, we slowly delivered ourselves into its ease. I don't know how long I was asleep, but I will never forget the dream. I found my-self near an old stone next to an immensely wide baobab tree. I was sitting, staring at the porous texture of the stone blending into the tree bark. A hominid man suddenly walked out of the stone. He stood still for some time, then slowly lifted his bow and arrow toward the sun. With a Herculean pose he shot his arrow through the sun. There was a shattering moan, then silence. Butterflies poured forth from the arrow wound, floating to the earth as dry autumn leaves. When all the butterflies had settled in the grass, the hominid man vanished. Then Nubea's face rose from the tall grasses and long aqua flower petals blew in with the sudden wind. He was staring into the distance. I could not see what interested his stern, unfaltering eyes. His face broke open into white, flowering vines. Butterflies flew up from the grass and outlined his body as he began to walk toward me, still staring into the distance. An aroma of wild jasmine floated from the butter-fly wings as they undulated in the slight wind. Nubea smiled as his face slowly melted into a great savanna with giraffe majestically running through the brown grasses. The images then transformed into the sound of a small stream.

Nubea woke me; late afternoon sun shadows stretched across his face.
"Come," he said. "Follow me!"
"I was dreaming of you," I told him as I got up.
"Come," he said, turning to leave.
We quietly walked over a dry riverbed, passing the other hunters who slept in patches of tree shade, and walked up a steep slope. Great swarms of dragonflies buzzed above our heads.

"*Tutakwenda wapi?* Where are we going?" I asked.

"*Babu wa zamani alikuja kwa ndoto yangu.* My grandfather came to my dream, and led me to a painting on a wall. I did not know this painting existed until now. I am taking you there."

I followed him down slopes into ravines covered by newly blossomed wildflowers, past large kopjes. Nubea stopped and crouched, placing his arrow between his legs to shoot at a hyrax in the rocks. He missed and the hyrax ran off shrieking to warn the others. Nubea smiled and walked to fetch his arrow and we continued on.

His walk was strong. I watched his body move. Nubea did everything with care, from sharpening his knife to putting away his tobacco — his actions were executed slowly and usually with a smile, as though he was sinking inwardly into a meditative rapture. His presence held a monastic aura; a gentleness flowed out of every pore in his body. I imagined he was around fifty-five. Sometimes he seemed ancient, other times he was young.

Nubea never raised his voice, seldom talked, and was always smiling, willing to teach. There was a munificent kindness in his eyes, as well as a sadness. The sadness I think was born from watching his environment and culture slowly vanish. When he laughed it was like the forest laughing, but now, with so many trees being cut down, the forest seldom laughed, and so Nubea seldom laughed. After experiencing his laughter I waited for days to hear it again because it was so contagious. The other hunters were always trying to get him to let loose, break into his rolling, flowing chuckle that just kept building and feeding off others, ending with many teary-eyed hunters holding their sides and rolling on the ground.

We soon passed under the canopies of large acacia trees, through dimensions of forest light, until we came to an immense slab of rock that ran the length of a football field. Nubea knelt down at the edge of a stream and started to pick grass and small purple flowers. He handed me these and picked some more for himself.

"This will protect us from the *shetani*. We are going into a Hadza camp that has been forgotten by the Hadza now living. Spirits will be present."

We walked along the outer parameter of the immense boulder. Nubea stopped at a dense grove of small trees.

"We pass into these trees," he said.

At the end of the trees was a long fissure in the giant rock, three meters wide. The lower part of the opening was hidden by tall grass. Nubea peeled the grass away with his bow and we walked through the passage, stepping over

bones unmoved in the parched earth for seemingly hundreds, maybe thousands of years.

"Rhino bone, buffalo bone," Nubea said.

The passage was a thousand or so meters long and the steep walls were stained yellow and white by hyrax urine. At the end of the passage, we came to a clearing open to the sky, surrounded by immense boulders on four sides. The rock faces angled inward to the earth, offering shelter from the rains. Yellow butterflies and dragonflies were flying about the grass in the middle of the space. We were both aware of a feeling, of power in the space, and looked about carefully.

"Did you know of this place before, Nubea?" I asked.

"*Hapana*, no, I have only found it when you slept. I followed my grandfather."

"Where is he now?"

"He is inside of me, he is in the rock," said Nubea as he sat and started to make a small fire. I looked around in awe. Every rock face was covered by thousands of red clay suns etched into the rock. Nubea lifted himself from the fire and started to chant, talking to the ancestors, placing the herbs he had gathered into the rock cracks. He told me to do the same.

"You must tell the ancestors why you have come and what you plan to do," he said.

As I placed herbs into various cracks, I explained my purpose to the sky and rocks, to the overlapping painted red suns. I found myself wanting to unload my worries. I spoke of my dreams. I asked them what would happen with the massive incursion of farmers, cattle herders, and tourists. Did they think the Hadzabe way of life would surely disappear?

When we sat back down by the fire, Nubea asked the ancestors to smoke with us. He carefully placed tobacco and *bangi* into the fire. Then he pulled a seed from his pouch and bit into it. He handed me a seed and ordered me to bite. He lifted himself and began spitting on all the cave walls, shouting to the ancestors. I followed and did the same.

When he finished, Nubea asked me to vow again that I would never show anyone this place, or any of the places that he would reveal. I vowed. His eyes glowed with wonder. He was happy and explained how his grandfather came to his dream and showed him this old Hadza camp that afternoon. "'Wake, Nubea,' commanded my grandfather, 'I will show you where I died,'" said Nubea.

"I dreamt of you near a large stone, and a man who split the sun with his arrow," I said.

"This is good that we dream together," he explained and packed his

pipe, which took a good ten minutes as he rocked back and forth, thinking, his eyes closed. (If you are ever in a great hurry for a cigarette, don't ask Nubea to roll it.)

We smoked in silence.

After an hour or so, Nubea opened his eyes and began sharing the knowledge of the rock paintings; turning suns, lizard-birdmen, arrows, homes, fingerprints, feathered hunters. Many of the images had faded to an almost indecipherable point, but Nubea could read them. Giraffes were being devoured by lions, demon men were flying to destroy a hunt. The suns signified the amount of days the Hadza had stayed at a camp or the amount of time it took to track down an animal, or the best time of day to hunt a certain animal. The suns were drawn over and over each other, woven, chained, looped together, creating clear zigzag lines of passing time, demonstrating the positions and movements of animals in the valley below from dawn until dusk. He showed me how the ancestors had used their knives to apply the red and white clay pigments onto the cave walls.

I walked closer to examine the suns and found another small fissure in the giant slab of rock, hidden by the grasses. It led to the western side of the giant rock wall. Two elephant skulls rested in the middle of a space and again the wall was covered with archetypal suns. Old-growth trees, used to make bows that the hunters must have transplanted here hundreds of years ago, created a dense wall of tree limbs, allowing no one to see the rock wall from the outside. I heard Nubea call out my name. As he neared the fissure I had just passed through, he shouted out, "Wait!" He pointed to wasps preparing to protect their fragile nest near the fissure, dangling on a small tree limb. The wasps started to attack him.

"I will come around through the trees," he shouted. The east side of the rock slab was open to the old-growth forest.

When Nubea found his way, he seemed a bit frightened by the elephant skulls and the *shetani* scarecrow figures drawn on the rock face blending into the red suns.

"These skulls are omens and the demon figures represent how many years *shetani* have guarded this area. You are watched over. You walked through the wasps' nest without being stung," he said and sat down to make another fire. Again he began asking the ancestors to protect us from the *shetani*.

The images of the walls disappeared in the setting sun as we left the ancient configurations, walking down a steep hillside through the trees. The rains had brought white-flowering blooms to the baobab and their evening aroma was

Sapo

heavy in the air. Nubea pointed out plump, round fruits hanging heavy on the limbs of a bush tree.

"*Chakula cha nyani*, green monkey fruit. Good place to hunt monkey."

A while later he noticed marks on the ground.

"Mama leopard has just killed mountain *mbuzi*, mountain goat. She has dragged it that way," he said, pointing to the trees in the distance.

"Is the leopard dangerous?" I asked.

"Only if you hunt it. Six men may hunt a leopard; the one who shoots it is the one who dies if the leopard does not die first. The leopard smells the arrow and knows exactly who shot it. When I was a young man, a European asked me to help him hunt leopard. He said he would use his gun and I could eat the leopard. I thought, *Why does he want to kill a leopard if he does not want to eat it?*

"I showed him where the leopard lived and the *mzungu* shot it in the stomach. The leopard disappeared into the bush. It is not good to shoot a leopard in the stomach. After unsuccessfully tracking the wounded beast for a long time, we headed back to the *mzungu's* camp, far from where we shot the leopard. As the sun came down I sat with the *mzungu* talking about where the leopard might die. 'In the morning we will look again,' the *mzungu* said. We did not notice that the leopard had followed us back to camp. Suddenly the leopard leapt toward the *mzungu* from behind. It must have smelled the gun resting on the *mzungu's* lap. The *mzungu* ducked when he heard the growl of the leopard. It scratched the back of his neck. The leopard then turned and leapt again at the *mzungu's* throat. I stuck out my arm and jumped in front of the *mzungu*. The leopard knocked me into the sitting *mzungu* and bit my arm and tore my chest. I stabbed it in the neck with my knife. We fought on the ground. The *mzungu* shot the leopard in the head with the small gun he carried on his waist. The leopard and I did not get up, the leopard was dead but it had

Tandala

stolen my strength. For many days I rested. The leopard is very dangerous
to hunt," explained Nubea, showing me his leopard scars on his forearm and
chest.

As we came close to the small camp where the others had been napping,
Nubea reminded me not to reveal the cave's location, but it was OK to talk
about what we had seen. So that evening, while we ate fresh dik-dik meat,
Sabina and Mustaffa sat wide-eyed listening to the story of our afternoon —
the dreams, the rock images, the *shetani* blending into the suns carved on the
rock surfaces. They agreed with Nubea, saying the meaning behind the *shetani*
in the suns was a sign of danger; possibly that was why the camp was aban-
doned and then forgotten long ago by the Hadzabe.

"But if the campsite is dangerous why would your grandfather show it
to us?" I asked, concerned.

"I don't know," answered Nubea.

"The elephant skulls must have been left after being eaten, but I don't
know why they would carry elephant heads to the camp, unless they had killed
them very close," said Mustaffa.

* * *

"The next rock painting is near Sponga. We must leave early in the morning," said Nubea. That night he shot a *swala* and attributed the success to his grandfather.

The following afternoon, the hunters made camp under a mammoth-size baobab. Sapo disappeared from the camp shortly after we arrived. Sapo was a strong hunter around fifty years old. He was an old friend of Nubea and possessed the ancient skill of hunting, which is why Nubea brought him on the safari. Sapo was a calm man who said little. When Sapo was young, a government official stopped him near Mang'ola one day as he walked along a road. The man asked if Sapo wanted to be a policeman. "Why not?" answered Sapo. "Come now," the man said. So Sapo jumped in the vehicle and later became a policeman. He went to the police academy in Arusha. They taught him how to read and write. He served on the police force in Dar es Salaam for three years after graduating. One day he took the money he had saved and returned to his home, never leaving the bush again.

As we were preparing the new camp, clearing out the weeds, thorns, and collecting firewood, a Mbulu evangelic minister arrived out of nowhere.

"Jesus is coming!" he shouted, startling us. "Devils, wake before you die."

"Where did you come from?" I asked the Mbulu, who was holding his Bible to the sky.

I was a bit perturbed with these ministers. The year before when Gela and I were returning from a safari, extremely thirsty, a water tree we hoped would have water was dry. In the late afternoon we stopped by a Mbulu farm hoping to quench our thirst. The owner said he would only give us water if we listened to the word of God. He wanted us to sit down and hear his sermon. I told him he knew nothing of Jesus and we left, our tongues still swollen to the roofs of our mouths.

"Devils!" shouted the Mbulu minister, who was now on his knees genuflecting near the baobab tree. "Repent before the hellfire!"

"Would you like some money?" I asked the angry preacher.

The man quickly jumped up and shot out his hand. I handed him one of my large, black plastic spiders. The spider was hidden in my clenched fist. I placed it into his palm and with my other hand turned his fingers over it. The preacher slowly opened his hand, his smile vanished, and a look of horror swept over his face. He pulled back his trembling hand, dropping the spider to the ground, and took off running.

I had given each of the hunters a plastic tarantula or snake from my supply (a gift from my mother). Often in the bush or in the towns, people would bother us for cigarettes or money. The plastic insects warded off the "human

hyenas" and usually the reactions created lots of laughter. The hunters were ruthless pranksters and used tools of deception with glee.

"*Mama, hapa shilingi kwa watoto.* Mother, here is some money for your children," Sitoti might offer.

The mama would say thank you, reaching her hand out, bowing in gratitude. Her reaction at the sight and feel of a snake or spider made her jerk backward screaming. Most recovered, but one old grandmother hit Sitoti in the head with her root-tapping stick, knocking him almost unconscious.

Soon after dusk, Sapo returned from hunting, dripping in sweat and blood. He was carrying a large limb on each shoulder, the meat of a greater kudu. He told us he had placed the rest of the meat high in a small acacia and sprinkled medicine around the meat so the leopard would not steal it. He killed the animal in the foothills a few kilometers away.

"It walked very close to where I sat resting, so I shot it," said Sapo, exhausted. The beast did not die quickly. Sapo had tracked the kudu for many kilometers before he found it dead. He cleaned the animal as the sun went down. He was happy to have returned safely to camp without the trail of hyenas. Normally he would have made camp underneath the tree where his meat was stored, but he had forgotten to bring his fire stick, and this area of the bush was not so dangerous to carry meat at night.

As the men cleaned and prepared the meat, an ugly-looking short man showed up at camp, accompanied by a small-statured Hadzabe. He sat down without asking to join us and ordered the Hadzabe to get him some water. Sabina passed the water to the little Hadzabe servant. Often, Mbulu passed by our camps; if meat was present, the hunters kindly shared, saying a year earlier, when their family was hungry, the Mbulu gave them corn, milk, or eggs. Part of the survival in the bush (now with the lack of animals) is the reliance on neighbors. The Mbulu, Datoga, and Hadzabe seemed to have found some degree of harmony.

Once the hunters began to eat the meat, I was curious to know why they were not talking to or offering meat to the ugly Mbulu man. Mustaffa called me over to the deserted side of the giant baobab, where we couldn't be seen by the others.

"The Mbulu is a witch doctor, a bad man. The Hadzabe man works for him. They will take meat and pass a spell onto us. They must not stay the night, his fingers must not touch the meat," Mustaffa whispered in my ear.

"Fine, tell him to leave," I said.

The ugly man began trying to charm us, talking about the rain, the milk

and fresh eggs he would give us if we passed by his home. He pulled out his blanket and carefully established a sleeping space. He was clearly planning on a grand meal of meat and soup and a quiet place to sleep by the fire. Sabina and Mustaffa started eating as Nubea and Sapo continued cleaning meat in the light of a second fire. The men definitely knew who the ugly witch doctor was and did not like him. I could see why — a nauseating smell exuded from the man.

Mustaffa told the *mchawi* to leave. He didn't seem to hear Mustaffa. Mustaffa put his meat down, grabbed his bow, and stood up.

"*Ondoka,* you leave," thundered Mustaffa.

The true face of the ugly man materialized, no longer happy with a "Give me something please" look on his face. He cursed Mustaffa, called him a *msenge* (homosexual), and a baboon. He squealed hideously, picked himself up and began to walk off. But his Hadzabe companion stayed seated. The Mbulu called for his Hadzabe worker.

"Come!"

The Hadzabe would not budge; shaking his head, trying to break the spell of the Mbulu. The little Hadzabe's eyes were fixed on the meat. His head began shaking wildly. He saw meat, and he would do everything he knew to get *nyama*! Work, loyalty to the Mbulu? No way! What was work when here was meat? The ugly witch doctor stopped and cursed all the Hadza. Mustaffa shouted out, "If you curse the Hadza one more time I will shoot a poison arrow through your mouth!" The ugly witch doctor jogged off into the night.

"What have you done for us? If you were our friend, we would give you *nyama*! But you have hurt us in the past! Go without filling your stomach," Mustaffa yelled at him.

After the witch doctor had gone, his Hadzabe servant fit in perfectly amongst his tribesmen. Sabina threw him a big piece of leg meat. The man reached for it in midair with such passion that he lifted his whole body off the ground. He placed the *nyama* in the fire while dancing on his behind, talking a thousand clicks a second, and laughing at the same time. They all began talking rapidly, excited by their fellow's energy and the *nyama*.

"*Kazi gani.* What is your work for the Mbulu?" I later asked the man.

"I hunt the monkeys and wild pigs that come into his cornfields."

"Does he pay you?" I asked

"*Ndogo,* little."

"This Hadzabe is not a strong hunter, crazy in the mind. That is why he lives with the Mbulu," said Sabina. "He is not Hadzabe, he is Mbulu."

"*Sawa,* OK," said the little Hadzabe, too interested in his eating to answer any more questions.

"Maybe he is *msenge,* fag for Mbulu?" I said, playing the game with Sabina.

"Are you *msenge?*" asked Mustaffa.

"*Sawa,* OK," said the man, totally lost in his meat, ecstasy filling his eyes.

I soon fell asleep, exhausted from the day. In the middle of the night, when I woke, the Hadza were still eating. They were talking about some hunt, clicking and imitating animal sounds. I heard hyena near the camp and asked Sabina if the *fisi* (hyena) would come for the meat.

"If the *fisi* comes, I will kill it. Don't worry, go back to sleep," he said quietly.

But I was not tired and got up to sit with the men.

"Why do people paint?" Sabina asked me.

"Why do people hunt?" I asked him.

He thought about my answer and returned to eating. I became inspired by Sabina's question and decided to tell them about Arthur Rimbaud and Vincent van Gogh, and they all listened intently.

"Rimbaud at nineteen left writing poetry, departed from the wind talk of God. He struggled for his money in Abyssinia and Harare, ignoring the poetic muse. It's like ignoring the urge to hunt. Rimbaud later died of cancer in his knee, and many believed the cancer was the result of forsaking his art form."

"Maybe he will come back," said Mustaffa.

"*Pole sana bwana,* I am very sorry for the man," said Sabina.

"I am also sorry," I said.

I stood up and acted out van Gogh's life, how he painted the trees and moving leaves, and heard the stars whispering to him.

"I hear the stars," said Sapo.

"Van Gogh lost his mind to demons or maybe to God. He had an insect that buzzed in his ear once every few months. The insect made him *chizi* [crazy]. One night he cut off his ear with a knife."

"He cut his ear off to stop the voice of the demon," said Nubea.

"If you are not strong, the voice of God or the voice of the demon can make you crazy," said Sabina.

The little Hadzabe/Mbulu servant sat staring at me with his mouth open. *What in the hell are they talking about?* he must have thought. Mustaffa and Sabina were now accustomed to my philosophical musings.

Mustaffa then told a story of his friend, who would steal radios, socks, and jackets from the town of Mang'ola.

"He just went into the homes and took a radio, or a jacket. And the next

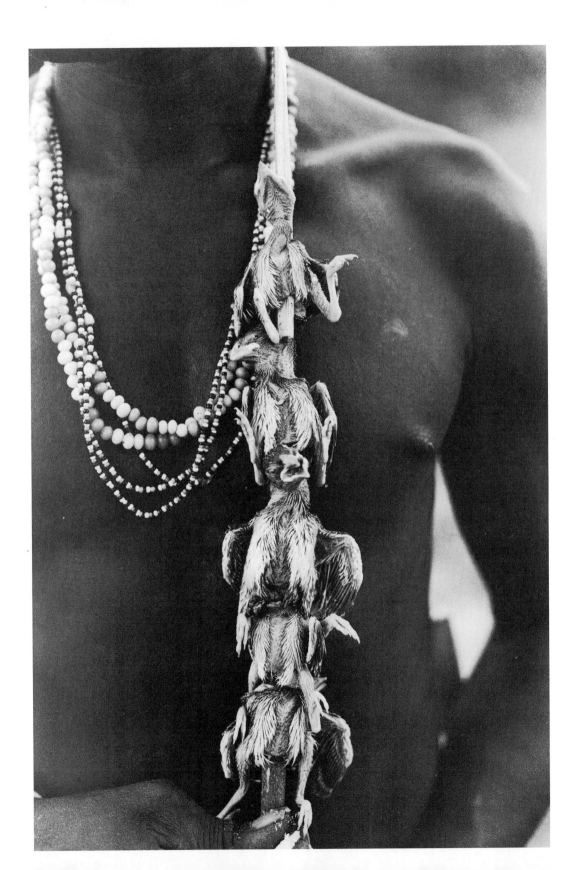

day he would strut through the town with the jacket, listening to the radio, drinking at the *pombe* bar. When the owner eventually saw the man, he shouted, 'That is my radio and that is my jacket!' The townspeople tried to capture the Hadzabe and burn him to death with petrol, but he was too fast. He shot them with arrows and ran to hide in the bush. Many times he came into the town and stole. Soon several Hadza wore the stolen goods, walked around, went to the *pombe* bars, because my friend gave others what he stole as gifts or traded the goods for arrows and for *jiggi-jiggi*. The Swahili would just ask for their clothes back, because they couldn't accuse anyone."

"Didn't they remember the guy who shot them with the arrows?"

"He was a Hadzabe who lived far in the bush. He stole many things for a short time. He shot people with bird arrows so he wouldn't kill them, then he disappeared. The people were afraid of him, so they did not try too hard to find him. Now they don't remember which Hadzabe he is because he hasn't been to town in many years. He lives somewhere near Sukuma — a seven-day walk from Mang'ola."

The next morning rain clouds were in the air and one could hear the chant of coming water. Nubea smelled rain in the wind. Sapo rolled up the kudu skin he was drying. We all left the camp shortly after the rising sun and headed toward a place called Ju-wa-ga-wa. Nubea knew of a rock painting that was hidden there in the kopjes.

"*Iko pale, hatari sana!* The painting is there, it is old and dangerous," he said the night before, pointing in the direction of Ju-wa-ga-wa.

Mustaffa had named the little Hadzabe/Mbulu worker Water Dog because, in exchange for the meat, Sabina made him fetch the water. He wanted meat so badly that he passed through any trial to get it. He became the hunters' servant and the butt of their jokes. They made him do all the unpleasant, yet necessary work needed to prepare a camp. A sort of initiation. Many of the newcomers on our safaris would be granted this position. But Water Dog was such a character that his initiation was far more severe.

It took eight hours of walking to reach Ju-wa-ga-wa. On the way we discovered a valley of crying baby birds. Thousands of starling nests hung from the tree limbs. The hunters dropped their bows and arrows and ran to the nests. Other than honey, baby birds are the ultimate delicacy. The cry of the baby birds filled our ears. The men started cutting limbs down, knocking the nests out of the sky with sticks and stones, collecting all the soft bodies. For a few

Sabina Holding Baby Birds

hours the men did not stop eating. First they made baby-bird soup, then ke-babed the birds and roasted them in the fire.

After eating, the men wrapped the hundreds of remaining baby birds, still alive, in their sleeping blankets. As we walked, the starling mother birds followed us, pursuing the cries of their babies.

Around sunset, we found a nice acacia to camp under, high on a hill.

In the middle of the night, lightning exploded over our heads as we slept under a large plastic sheet I had bought in Karatu. The rain poured down. A dreadful experience, being wrapped in plastic for the night. I kept drifting in and out of sleep, and thinking about the hardships of the ascetics, the saints, the willpower certain people have mustered in the past to transcend their environment and physical necessities. That night I could not conceive of the idea of fasting or living without warmth and shelter for too long. I was battling an almost uncontrollable craving for a steaming margharita pizza with fresh garlic.

Around 4 A.M., I got up to go to the bathroom. Of course I normally would try to hold it until the rain stopped, but I was plagued by severe diar-rhea (most likely the result of eating too many baby birds).

As I was squatting to relieve myself, a mud slide suddenly swept me away down the steep hill and into the valley below. At first I did not know what hit me, rolling in a thick body of rocks, trees, and mud. When I finally came to, realizing what had happened, I wasn't sure how long I had been ly-ing at the bottom of the valley half-buried in mud. *Had I been knocked uncon-scious?* Naked, my shorts torn off, I began pulling myself up the steep slope, gripping small trees and rocks, slipping every few steps. My arm was pulsating with pain. My body started to shake when I finally reached the top. I shouted out to the men, aware that hypothermia was setting in, as the night was ex-tremely cold. No one answered. I walked a half kilometer trying to find the camp, but still found no one.

Finally in the distance I heard a faint answer and followed it. I reached the camp; the men had gathered around the fire holding the plastic above their heads and over the fire. It was still raining, but not quite as hard. The men were also cold. All the blankets were soaking wet. Thank God for the petrol we brought on the safari, knowing it would be difficult to find dry firewood.

"Where are your shorts? It is not good to walk in the rain at night with-out clothes. See, you are shivering. One can die in the cold," said Nubea.

"I was taken by the mud," I said, huddling close to their body heat and the fire. "I was taking a shit and it just swept me away." Sabina started to laugh.

"It is dangerous in the rain," he said.

Miraculously the rain soon stopped. We threw the plastic off. Sabina

grabbed the flashlight, he wanted to see the mud slide. That is when he noticed the blood all over my arm and leg.

"Jemsi, you are cut bad on your arm. Look," he said.

There was about a three-inch gash near my shoulder.

"*Ze-ni-co a-ti-be*, give me water," he said. Sapo handed Sabina the water jug and he washed out the wound. He then crushed some seeds that he carried in his shoulder bag. He dropped them into a pot on the fire and waited for the seeds to cook. We dried our tobacco in the hot ashes. The seeds turned into a sticky syrup. Sabina pasted the substance onto the wound; immediately the bleeding stopped, but it stung like a bastard.

We were smoking and laughing when we heard the mosquitoes.

"What is that?" I asked.

"*Mbu wanakuja.* The mosquitoes are coming," said Sapo, pulling his wet blanket over his head.

A massive, blood-thirsty cloud of creatures furiously descended upon us. This was worse than the rain; an onslaught that made one want to jump into a body of water. There was nowhere to go or hide, so we wrapped ourselves again in the plastic, shouting at each other to seal off all openings to the outside, but there were too many holes in the plastic. It was a miserable night!

In the morning, covered with mosquito bites, I woke to the laughter of the hunters. Water Dog was high up in the tree we slept under shouting at the men below. He held a bird in his hand. Sabina and Mustaffa were yelling, "*Mkubwa yani*, big monkey," and shooting him with headless arrows. Water Dog was leaping from limb to limb trying to dodge the arrows. The arrows were not shot with much force. One arrow smacked Water Dog in the chest; he let out a yelp and leapt to the next limb. Mustaffa aimed and hit Water Dog in the side of the head. He fell ten feet, bouncing off the tree limbs before catching himself on a branch just before the final twenty-foot drop to the soft ground. He held on tightly, but his grip failed him when he was hit in the hand by Mustaffa's second arrow. He yelped again and let go, falling to the earth. Water Dog rolled over, moaning, still hanging onto the bird. With surprising agility, he leapt up, growled underneath his breath, and charged for Sabina. Sabina did not budge an inch. Water Dog dove at Sabina's neck. With a swift foot, Sabina kicked him in the chest, and Water Dog went sprawling in the opposite direction, gasping for breath, rolling on the ground. He lay still, whimpering. Just as I was thinking this was the meanest exchange I had ever seen between the hunters, Water Dog began laughing hysterically. Sabina walked over and lifted him up, brushing his back off, pointing out the arrow marks to the others. A proud look came over Water Dog's face as he began

Giraffe Family

to recount each wound he suffered in the tree and the dramatic fall. He explained the great struggle holding on to the last limb, terrified before the abyss that separated him from the ground.

"Mustaffa's arrow was a snake flying to kill me," he said, holding his hand, bending each finger, theatrically acting out his failing grip. Water Dog then fell to the ground, his eyes closing, demonstrating the pain experienced from hitting the earth.

"OK, enough, Water Dog. Go fetch the water," said Sabina, laughing.

In the early afternoon, Nubea and I walked up an escarpment. Huge trees had fallen from the rain and mud slides of the previous night. We passed the remains of an old Hadza camp. It took an hour to reach the top of the escarpment.

The highland of the escarpment was about a mile wide and ten miles long, with lush meadows; it was an island in the sky. Climbing the escarpment was too much trouble for the cattle herders. It was a fragment of land only a few clans of hunters ventured to, and one could feel the silence like a thick syrup. An undisturbed pocket of time, ancient memory gathered there, grown into the leaves and the limbs. Elephant memories seemed to leak from the bark cracks on the old baobab trees.

As I followed Nubea, I would not have been surprised if he changed into a *swala* or a tree, so well did he walk through his land. Each of his steps absorbed space, blending into the grasses and the trees. He reflected the forms of the life around him as he passed.

Nubea stopped and pointed to the parched, sun-dried bones of an elephant he had killed when he was a young man. Grasses grew from the thigh bones and eye sockets of the beast. He explained that normally he did not shoot elephant, but at the time his family was very hungry and his child was

sick. Certain parts of an elephant are good medicine for a child. He shot the beast and hid in a tree. The elephant did not react much and the next day it died here in this spot.

Bird Eggs

"We moved our camp to the elephant and ate the elephant for many nights. Hadza from camps below came to live with us and eat the elephant," said Nubea.

"Did you take the tusks?" I asked.

"The Hadza have little interest in tusks. A Mbulu may have stumbled upon them and taken them to sell, or perhaps another Hadzabe whose mind is polluted. Possibly the tusks just sank into the ground," answered Nubea.

We walked to the northern side of the meadow and stood on the edge of the highland that dropped down into the Eyasi Basin.

"This is an old Hadza camp. I have come here every year since I was a boy for the honey, after the rains."

The distant waters of Lake Eyasi were vast, with sections covered by thousands of pink flamingos. The hippos had returned to the lake by the hundreds. The old camp was in a perfect location; one could see over the landscape for miles and miles. Nubea pointed out the tree where his grandfather was killed one afternoon by a toothless lion that leapt on him and mangled him with the strength of his jaws, cutting him up with his few claws. The old lions, once driven away from their prides, are the most dangerous because they are hungry and weak and humans are easy prey. Nubea had tracked the lion for two days and shot it through the neck.

Nubea pointed out a herd of Mang'ati cattle in the distance, and explained how in colonial times the Mang'ati were killing many Hadza. The Hadza eventually joined together and killed as many Mang'ati as they could. After this the Mang'ati no longer bothered them. One evening in a camp down in the valley, his wife quietly called to Nubea. She said there were

Hunters and the Giant *Tandala*

Mang'ati coming to kill them. So Nubea hid in a tree and waited for them to come for his wife.

"As they tried to rip my wife's clothes off, I shot them like monkeys, until they were all dead. I never killed a man until that day, and will never again," said Nubea.

We moved on, walking through neck-high grass. Nubea knocked down the grass with long sweeps of his bow. He stopped to examine a tree and found a little nest of honey. He smashed the bark open with a rock. We ate the sweet honey in silence. Finally Nubea spoke. He said once there were lion, buffalo, elephant, thousands of gazelle, and now there is only the cow of the Mang'ati.

"The animals have run away. The Hadzabe will stay here, but without the animals eventually we will perish, then all will perish. Why are the forests eaten by the corn and bean? When there is famine we are the ones who give them refuge, but without the forest there is nowhere for us to go, there is nowhere for them to come when the sun dries up their corn and bean. The earth will swallow our song. Then it will swallow theirs."

We lifted ourselves and continued on. Soon we came to a dense grove of bow-wood trees and stinging nettles blocking a passageway to a rock face. Painfully we crawled through a small opening and found the path that led up

the kopje, worn down by thousands of years of Hadza walking up and down the path. It wound through massive boulders for fifty meters or so. The path ended at a large space sheltered by a massive slab of rock that angled down to the earth, which must have offered the Hadza shelter from the rains. But now no man would sleep here if he wanted to return to his home alive, explained Nubea. Before I had time to examine the rock face, Nubea pulled a necklace from his pack and placed it around my neck and told me to also wear the necklace that Mustaffa's mother had given me. I took the necklace from my pocket and put it around my neck. "How did you know I had this necklace?"

"I know such things," Nubea said, motioning me to be silent.

He then started blowing spit around my feet, ankles, waist, chest, face, arms, and hands. He took grass bunches mixed with flowers and wild herbs and put them behind each of my ears. He told me to follow him and began blowing spit onto the rock walls, handing me a seed to bite so I could do the same.

We sat back down and started a fire, Nubea asking the ancestors to smoke tobacco with us. For some time we sat staring at the rock face. I did not understand the images, layers of images. Two colors existed. Older red images of men with bird beaks, suns with arrows through them, and spirit men floating above elephants and giraffes. Patterned over these red images were fingerprints and chaotic strokes of white paint seemingly thrown onto the wall to create a Jackson Pollock-like collage. I stared at the wall drawings for some time trying to figure them out, then a greater image formed and terror arose. I suddenly understood why Nubea took these images so seriously. My eyes had not seen the greater picture, so I hadn't understood the significance and the power of them until that moment. The strokes revealed a train of spirit dancers that seemed to move as you watched them. From the east to the west wall they danced. The western images vanished into the red symbols, as the eastern images grew into two monstrous spirit figures embodying the same movements I had seen in the movements of the Hadzabe dancers during their moonless dances. The trailing figure wore ostrich feathers and had owl eyes, mouthless, with giant claw hands. The front figure had four heads: the first head, a stocky middle-aged hunter, the second a howling ancestor spirit with the nose and chin of a witch, the third head was a hominid man, and the fourth of an ape. Within the heads were animal figures and the outlines of spirit faces looking down upon us. The red images were scenes of past hunts, roaming animals in the savannas, trials of the hunters, and sky fire falling into patterns of dead leaves and lion manes, men with oryx horns growing from their heads. Nubea explained that the red hunters were asking for permission

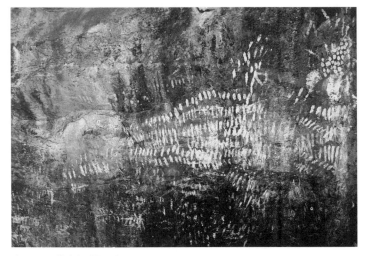

Ancestor Spirits Dancing

to kill the animals from the great *shetani*-animal-mother who dwelled above the dancing figures. A pregnant evil-smiling woman was painted with the white coloring, next to her stood a white mother-of-all-buffalo with a small, red buffalo inside her.

"There is the demon mother and there is the buffalo spirit mother. You now see," declared Nubea. We stared into the journeys depicted on the wall. The dancers possessed an illusory flutter movement I had seen in the old men and women while they danced under the pulsation of the stars. I say this because the older people appeared to lose and regain their physical form while they danced, as if they were becoming part of nature and a part of the ancestor world. The rock paintings appeared to be an artistic illustration of a Hadzabe's spiritual sight, consciousness, and plane of perception. I saw the connection the dancers have with their ancestor spirits and how the dance becomes a gateway, a passage of perception into the spirit world. This cave painting illustrates the manner in which a dancer, through the physical exertion of the dance, becomes spiritually receptive to the ancestors.

I looked into Nubea's eyes. At that moment, a dragonfly landed on his hand and his eyes turned to the insect. Curiously, he watched it flutter its wings. The dragonfly flew away and his eyes returned to the rock. As he studied the images on the wall, I studied his eyes. They seemed to be flowing through the oldest memories, conversing with the ancestors inside of him. I imagined that, through his experience, he recognized the layers of meaning in what he saw. His eyes were resplendent — faults of scarlet-yellow scarred with tributaries of stardust and snake scales. This man embodied nature. He was a watching stone. He only disclosed what I was ready to learn and I knew there was so much more. One saw it in the way he passed his pipe or in the way his hand floated back down to his side. He sensed my contemplation of him and

turned and smiled at me as if he knew that somehow I understood the wordless, indescribable sphere of what he was trying to teach me by revealing this place. A distant clap of thunder was heard.

"We must go," he said. "It is not good to stay here any longer."

"Why?" I asked.

"The demons will eat our brains."

"OK, let's go!"

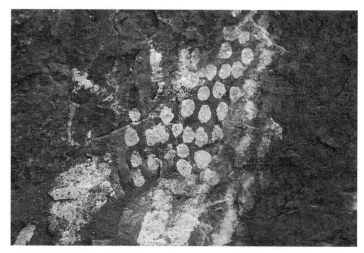

Facial Profile of Spirit Dancer

We headed back down the ancient path, crawling through the bow wood and into the meadow grass. We walked with speed to get to camp before the rains, because Nubea did not bring anything to cover his bow string and poison arrows, which the rain would destroy.

Nubea pointed out a hill where a rhino had charged his camp many years ago.

"I heard the children screaming, 'Rhino! Rhino!' Then we heard the rhino's footsteps coming up the path to our camp. I don't know why it wanted to kill us. We all ran and hid. One old man could not find a hiding place quick enough. The rhino stopped, looked about the camp, and saw the old man. It charged the old man. I leaned down from behind the rock and shot it in the side. The rhino halted. I jumped out and shouted at it to come for me and not the old man. The rhino listened and bounded for me. I shot it in the head. He stopped to shake the arrow from his head and then ran down the path. I followed the rhino for many hours. He died in the valley below, not far from the water tree near the camp. We ate the rhino for many days. But now there are no more rhino living in this valley," concluded Nubea.

"They have been killed for their horns," I said. "The Chinese use the rhino horn for sex medicine, so they have a stronger penis. The Arabs from Yemen use the rhino horn for dagger handles. This is a sign of wealth for the

Demon and Buffalo Mother

Arab. With the discovery of oil, thousands and thousands of men became wealthier. They wanted the horns to show their wealth and paid money to get them. Greed, *bwana*."

Nubea smiled softly to himself, and said, "Yes; *tamaa*, greed."

Back at the camp, Nubea and I described the rock paintings. From that night on, something changed between the hunters and me, not Nubea, but the other men. I can't really describe what it was, but the men were acting differently. And when we returned to Mang'ola or went to other Hadza camps, the people treated me with a slight trepidation. I later asked Sabina why he and the others had changed the way they act in my presence, why many of the Hadza were afraid of me in Endofridge.

"The ancestor spirits have followed you back from dancing spirit rock."

"What spirits?" I asked.

"*Wazee wa zamani*, people of the past."

"How many spirits followed me?"

"*Ningi*, many."

"Did they follow Nubea?"

"*Ndiyo,* yes."

"Why were they following us?"

"They were protecting you and wanted to be with Hadza by the camp-fire."

"Does Nubea see the spirits?"

"Yes."

"Are the spirits always following me now?"

"No."

"Is it dangerous to have spirits from the rock paintings following me?"

"No, Nubea has asked them to protect you from the *shetani.*"

"Where are the *shetani*?"

"Many places. They now know of you."

"Will they try to kill me?"

"Maybe, but spirits and medicine will protect you."

"Will the *shetani* follow me home to America?"

"I don't know. You have spirits with you now. You have gone to the old places," said Sabina, playing his malimba.

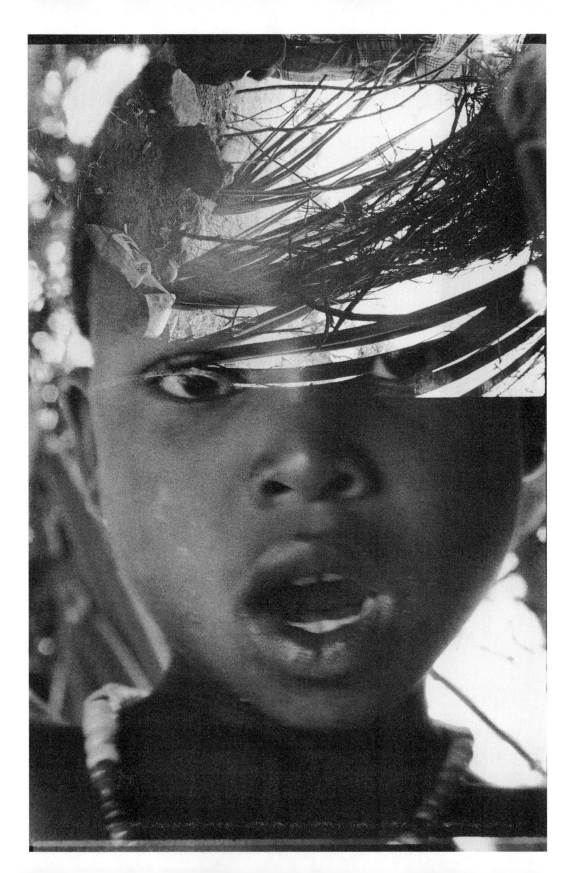

9

The Little Girl

I met Franz Brecht in the lobby of the Outpost Hotel in March of 1994. The hotel was a small, pleasant, inexpensive old German colonial home owned by a Zambian professional hunter and his wife. Franz was drinking, sitting comfortably, looking like a former seventies rock star turned weather-hardened Wyoming cowboy. He had spent many years in the United States living with American Indians, cattle herders, and motorcycle gangs. His necklaces, belt buckles, and knives were soul mementos from his wild days in America. But no matter how hard he had tried, he couldn't wipe away his Germanic ideals. He still spoke highly of his German background, his military training, and the fact that his grandfather was involved in the officer resistance against Hitler. His gentle heart was the most important attribute of his eccentric character, and I often reminded him of this fact — although his tough facade would never allow him to accept it. He loved animals and people. His rough appearance and, at times, words, were simply a matter of protection. He believed if people feared him, they respected him, and thus, his family would be safe.

Franz had established his farm in the Lake Eyasi region and knew the Hadza well. I always passed by his place on my way into the bush and bought onions, garlic, fresh papayas, and his "famous" herb mix, which was excellent seasoning for bush cooking. There was always a room available in the farmhouse, should I need a place to rest after a long safari.

Franz had a drinking problem, as so many of the farmers do. It was sad to see him wasting himself when he had such responsibility and was an intelligent, caring man. When he drank, his more undesirable qualities wreaked havoc with his character, as they often do. Either the "rock star," "cowboy," "guilty mercenary," or "disgruntled farmer" could manifest, or all four at the same time, which was a bit confusing.

Franz worked hard, as hard as anyone, but his work didn't always bear

the fruit it might have — due to the drinking. On the farm he didn't drink much, but when he came into Arusha there was nothing that could slow him down. When I saw Franz one afternoon in the hotel's restaurant, ten beers under, he shouted out, "I am going to Mang'ola. Are you coming?"

"Franz, you've been drinking."

"It doesn't matter, I always go like this."

He then commenced the most magnificent manipulation, convincing me to come to his farm that night. I wasn't sure if he needed money, a drinking partner, or just someone to talk to.

As we headed out of town, past the last police roadblock, Franz mentioned the possibility of being hijacked by bandits.

"It's rather stupid of us to drive at night," he said.

"And especially while you're drunk," I replied.

"Maybe, maybe not," he said.

He told me the bandits usually strike between Mto-wa-Mbu and Karatu. Their favorite spot for an ambush is a road called the hill of the elephant's back. On this road the driver can only escape by going backward, which is rather treacherous, because to the left is a steep drop-off and to the right a wall of earth.

"If we're caught there, we're screwed!" Franz said, giving me one of his rather dangerous and exciting smiles. At that point I started rummaging through my bag for a pocketknife.

"What are you looking for?" he asked.

"A knife!" I said seriously.

"Listen, James, you're not a killer. Leave that up to me."

Franz explained that as he was headed into town, a bandit had come onto the road and tried to hold him up, shooting his AK-47 into the air. Franz slowed down almost to a stop. When the bandit started to walk toward the car, Franz hit the gas pedal and ran him over.

"He flew over the hood of the car. I heard some gunfire behind me, but no hits. Possibly the others only carried machetes," he said. "We're dead if we stop and let them take the money. Armed robbery is punished by death here in Tanzania. The bandits won't think twice about killing us."

"Great!" I said. "From what I have heard, people are killed when they try to make a run for it. An AK-47 will rip through the Toyota. The bandits never seem to shoot if you give them your money. What happens if they come after us?"

"Don't worry about it, no one is going to get us. It's highly unlikely."

"But what happens if they try?"

"I kill them. We're not dealing with professionals here. I am a profes-

sional. I speed up and crash through them, unless they've rolled boulders onto the road. In that case, the first bullet will deflect off the windshield, which will explode the glass over us. I will then veer off and crash into a tree. The glass will have cut us up pretty bad. We will play dead. They'll see us bloody and not expect my sudden attack. You do whatever I tell you. I am the one who has been trained, you haven't."

"Whatever, Franz. I think if you crash into a tree, I'm getting out of the car and making a run for it. Why the hell did I let you get me into this?"

An hour into the drive I fell asleep. Soon after, I was abruptly awakened by Franz. "James! Get ready!" he shouted. "Look ahead, you see that? Flashlights signaling each other and reflections from gun barrels."

He was going about one hundred kilometers an hour, flying over the potholes in the dirt road. I thought the Toyota was going to break in half. We realized the "armed men" were really cattle herders from Sukuma walking their cattle to sell in Arusha, and not bandits. It was too late, the cattle herders tried desperately to clear their cattle off the road before the madman in the Land Cruiser ran over the cattle. The beasts barely made it to safety. The men shouted at us.

"Thank God!" I said.

"We are lucky," he replied. He then pulled a Marlboro cigarette from his pocket and with the same hand flicked his Harley-Davidson lighter. For a moment the flame illuminated his tired, determined eyes.

"Franz, you're insane."

"If I wasn't insane, I would be dead by now. There is only one thing in this world I want to do and that is to see my wife and babies. Nothing is going to stop me from doing this, even if it means driving at night."

Franz has two beautiful boys under the age of three and his wife is a lovely woman. She is quiet, strong, and honest to the core. Her parents were German missionaries, so she grew up in isolated spots throughout Africa. She can deal with just about any situation in a country like Tanzania. She keeps Franz balanced and the local people trust her. When Franz is binging, her strength keeps the farm running. Franz said his wife saved him from an early death, as a mercenary or from alcohol.

Life as a farmer, especially where his farm was located, seemed to be about the hardest profession on earth. Franz was constantly broke and confronting different disasters daily — from the goats and monkeys eating his harvest, to malfunctioning farm equipment, disastrous rainfall, drought, poisonous snakes, corrupt government officials, theft, angry workers, or sickness.

You name it, his family had faced it. Their hope was admirable, they believed eventually everything would work out.

"It takes five years to start a business," Franz often said to cheer himself up.

One could definitely envy the family's way of life. They "lived" life on a farm, spending days and evenings together. The children were constantly around their parents, fresh food, fresh air, and blossoming trees. They maintained a small garden and raised pigs and rabbits. In the evenings, they had long sit-down dinners after the hard day on the farm, and one could tell by the look in their eyes that they were filled with a peace of mind from working the land.

Franz is a visionary and he is the type of man that can make a vision come true, if he doesn't kill himself on the road one night, drunk.

Franz and I drove into Mang'ola about an hour before sunrise. He dropped me off at the side of the road, protesting that I should come to his place and rest. I told him I didn't want to. When he knew I was not coming, he asked me to keep my eyes open for a little Hadzabe girl that had been bitten by a dog. He had cleaned her wounds and was afraid that she was still very sick.

I continued my journey, walking the long road to Endamaghay, arriving at a Hadzabe camp in the late afternoon. That night Sabina, Janza, Mustaffa, Gela, myself, and other Hadza sat quietly around the dying coals of a fire waiting for the "moonless whistling dance" to begin. The children had been sent away, as they always are for such a dance. The dance was called to cleanse Janza from the *mchawi*, bad spirit, that possessed his soul. He had been vomiting and defecating blood for two weeks and looked like a skeleton. He sat quietly like the Grim Reaper with his sleeping cloth wrapped over his head, chicken blood and feathers smeared over his neck and face. His thin fingers reached out for the stone pipe passed to him, he inhaled and coughed violently. I told him he shouldn't smoke while being so sick, but he said this was the first evening he wanted to smoke some tobacco.

"You're getting better then," I said.

A few weeks earlier, before I left for Arusha, he had been living under a little grass shelter eating herbs administered by a Sukuma witch doctor. Mustaffa had spotted him one afternoon, while we were hunting, under a canopy of small trees. It was an obscure, sacred spot where the Sukuma witch doctor brought his patients. At that time, Janza could talk, but he could not move. The witch doctor came up and introduced himself. Mustaffa and I sat down with the man and drank some tea and ate cassava. He asked Mustaffa when he thought the rain was coming.

"It is hot now, the rain will come next month," answered Mustaffa.

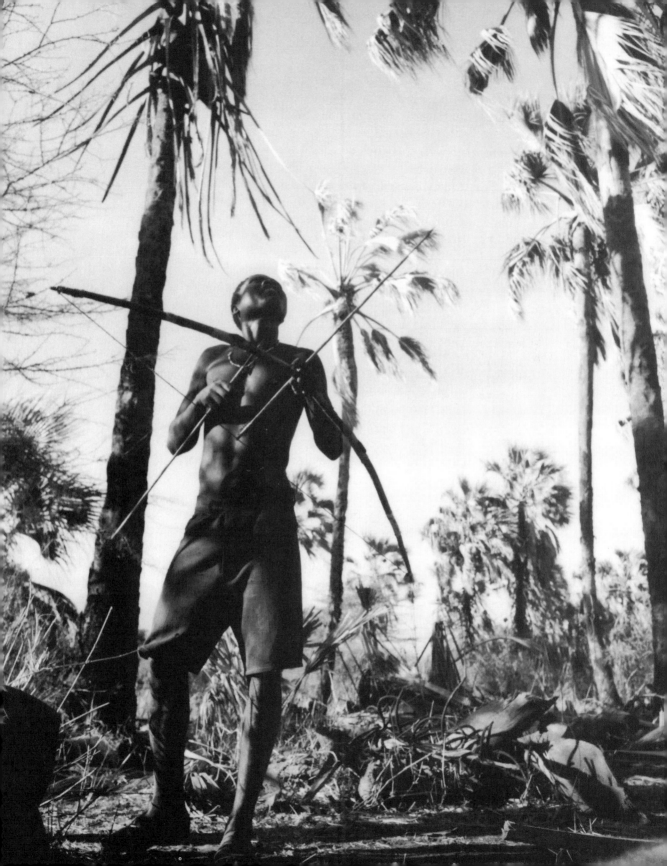

The witch doctor was a gentle-looking man. He said he had learned the medicinal art of exorcising demons from his grandfather — a famous *mganga*. His eyes were kind. He seemed worried about Janza, saying the spell was strong. Strangely enough, the witch doctor's name was Philipo. He was married to a Hadza woman and seemed very much a part of the Hadza in Endamaghay. Janza had exchanged a large portion of dried buffalo meat for the four chickens the witch doctor sacrificed the afternoon before the dance.

"Why don't you go to the hospital, Janza? You probably have some *ndudu*, insect or bacteria in your stomach," I said, as we waited around the fire for the dance to begin.

"I will go when I feel strong," he whispered politely, both of us knowing he would never go. He did not want to offend my suggestion. Most of the Hadza do not like the hospital, mainly because they are treated like second-class citizens by the nurses and medical officers.

Janza explained that a man "witched" him at a *pombe* bar, for sleeping with the man's wife. He blew three liters (a term used for ejaculation) in the wife and there are three spirits that haunt his dreams. Janza was convinced of this, and it was difficult to tell him otherwise. He was single, drank too much, and was rather a bush Don Juan. The village life definitely had its negative effects on his character. The Hadza who don't live close to the towns and seldom mix with other tribal peoples live harmoniously in their quiet world without the devastation of alcohol and the riot it brings to the mind. The Hadza near the villages are not so calm.

Janza was a keen hunter and supplied his small Hadzabe clan with most of their food. He spent his days wandering Endamaghay's game control area — many of the animals from the Serengeti and the Ngorongoro Conservation Area migrate down into Endamaghay, so it is somewhat protected by the government. Janza was a part-time watchman for the government and was proud of his piece of paper given to him by the rangers. He dismantled traps, stopped people from cutting trees, and reported to the rangers any unusual poaching activity. His income was around ten dollars' worth of shillings a month, which he used for drinking. So once a month after his payment, he went into the small town of Endamaghay and stayed drunk for three days, usually getting himself in trouble. Sometimes he did not return to the village for months after those drunken days due to beating up someone, stealing food, or raising hell — actions that never would have occurred if the alcohol was not present, because when sober, Janza is a quiet man.

People feared Janza both in the bush and in the towns. Sober, he did the ranger's job very well. He owed no favors and was afraid of no one. His job benefited both the government and Janza, because the game control area was

far too vast for two rangers and Janza had the opportunity to find food for his family. Janza was most vicious with the tree cutters.

"If the trees are gone, the animals will disappear and the Hadza will starve," he once said.

When a valuable hunter like Janza is sick, the whole clan, composed of about five families, becomes nervous.

The dance began. Janza's father slowly and eloquently put on the ostrich feather headdress and cloth wrap. The dancer passes these to the others when he is finished. The father listened to the women's shouts, answering them with whistle sounds. The rhythm slowly embraced his slanting figure as he waited, listening. He started to move. Suddenly he leapt with uncanny speed toward Janza and began to blow spit over him, spraying his saliva with exaggerated exhales. When he finished with Janza, he blew his spit over each person by the fire. Then he broke free from the spit blowing and turned toward the women's voices, leaving the fire for the open space and stars, to commune with the ancestors. The women's song told the *shetani* to leave and *Haine* (God) to enter. The men listened in silence, watching the fire and the dancer, and singing softly along with the women.

"God help Janza. God help us. We know the wind and the trees. God come, *shetani* go. God come, *shetani* go," the women sang.

Mustaffa leaned over to me. "He spits on us, it is medicine against the **shetani**," Mustaffa said. "Tonight is a small dance for Janza, tomorrow is a dance for the wind, for life, for us all."

In a way I wish I had never slept in camp after the dance or sat next to Janza. The following two nights I was plagued with the most terrifying dreams. Someone was staring at me from the trees, sleeping next to me, wanting to get inside of me, and when I woke there was no one. An ancient evil seemed to have come to haunt the people. They all felt it and wanted to move the camp soon. I say "ancient evil," because the initial form that emerged in my dream was a demon figure I had seen drawn on the rock walls. It watched me, as if trying to understand who I was and where I came from.

I may not understand this force, but I felt it. The Hadza definitely sensed it prowling, especially the older women. They seemed to be aware of this evil, a concerned expression clouding their faces. When they looked at me, they looked through me, searching for something, examining me before returning to their work. I often saw them cautiously peering over their shoulders and quietly telling the children not to wander off.

I told Sabina of my dreams the night they woke me up. He said, "You could just be dreaming as all men dream. You remember in Arusha when I

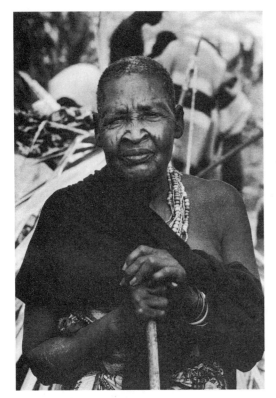

Old Hadza Woman

dreamt that my wife and son were dead and how it worried me? When I returned from Arusha they were fine. Also, sometimes I dream bad dreams before killing a big animal. Or you may be feeling Janza's demon that is trying to kill him."

Two days after the dance for Janza, Mustaffa fell terribly ill. He could not move or eat. He said the demons were destroying his sleep. The witch doctor was cutting chickens' heads off left and right, even for me after I told him of my dream.

"*Jana usiku mimi nilikua nahofu ya jini mbaya sana*, I feel the evil spirit in my heart but do not see it. There is danger when you cannot see the demon, but know it is there. You have seen the demon in your dream, I now know which evil it is. The evil is aware of you, it is seeking out your origin. Eat this medicine every sunset until the evil is gone from your dreams," said the witch doctor with eyes as serious as stone. He handed me a dirty cloth pouch with a black medicine wrapped inside.

On the third morning, Sitoti came running up to our camp set up by a small stream under a canopy of tree limbs and vines.

"*Matatizo mkubwa*, there is a terrible problem, come quick," Sitoti said.

He led me into the main camp. There were twenty old and middle-aged mamas all standing around a little cloth on the ground. Sitoti led me through the mama circle and pulled back the cloth. There before me lay the most beautiful little girl, wilted like a prune, her eyes open, staring off into some world of struggle and pain, no longer part of this reality. The child's life force was holding on, but her personality was no longer there, she was like a zombie. Her little lips held expression of struggle, but she was gone. The mother put the cloth back over the child's body. I looked up and all eyes were staring at me. They knew the seriousness of the situation.

"The child has to go to the hospital, she needs an IV — food and medicine directly into the blood," I said.

My words did not give them much hope. This was the little girl who had been bitten by the dog, the one Franz was worried about. The Hadza were convinced the *mchawi*, witch evil, had turned into the dog and bit the girl in order to steal the child's soul. An older woman further explained that the grandmother of the mother was angry with the mother before she died and the grandmother is using the *mchawi* because she wants to take the child to live with her in the world of the dead. "Well," Franz later said when I told him the story, "this situation is a tough one to deal with."

I tried to explain to the mothers that the child would die if she does not go to the hospital.

"I will walk back to get Franz and he will bring his vehicle out this afternoon to pick up the child and take her to the hospital." They all agreed, but I don't think they expected me to return.

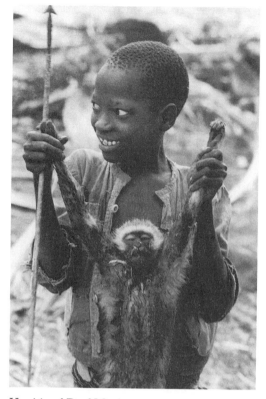

Hamisi and Dead Monkey

I walked back through the gauntlet of mothers and grandmothers and I could feel their energy focused on the child. These were strong women raised on the land; you could feel their motherly instincts, their struggle and hardships, their births, as all of them gathered together to bring the child back. They were praying for the child. A gentle energy more powerful than anything on earth was being absorbed by this little, wilting girl. If she was going to live another day, until we could take her to the hospital, it was because of this mother-love energy.

I headed to our camp to get the men together in order to go back to Mang'ola. The men and little boys were all eating my *ugali* and vegetable soup. Nothing was going to make them move too fast. The sick girl's father came running up and finished the last of the soup. The men passed their tobacco around and rolled cigarettes; a few of them started dancing with the satisfaction of tobacco and a full stomach. Soon everyone was dancing — even the little girl's father — one could not resist the young hunter Hamisi's beat. Hamisi

pressed his butt on Sapo's head and farted. Sapo chased after Hamisi and tripped over a rock, falling into the stream. Everyone began laughing. Sapo returned and sat by the fire, saying he could not hear because Hamisi's fart was louder than a gunshot and smelled like a rotting elephant.

Finally we began packing up the camp; everyone helped. This took some time. There was no real rush. The men had more faith in the witch doctor than myself or the hospital. After an hour or so, we headed on the long, hot six-hour walk down the barren road to Mang'ola.

Normally, we would not set out on a safari so late in the morning when the sun was burning. Within fifteen minutes my shirt was soaked with sweat. Listening to our footsteps moving across the powdery earth, I questioned my role in trying to help the child. *Should I intervene with the Hadzabe way of life? Was it my responsibility to try to help the little girl?*

"Leave it, Jemsi. If God wants to take the little girl, he'll take her. There is nothing we can do," Sabina had said.

And I thought, *He's right.* I slowed my pace and the natural walk began — resting in the shade when the sun was unbearable, smoking cigarettes, stopping at a few roadside *pombe* stands to drink and flirt with the women. Sabina asked one pretty, young Mbulu lady serving the *pombe* if she would go into the bushes with him if he gave her a "*zwadi mkubwa*, a big present." She refused and we continued on.

We made it back to the "big tree" camp in the afternoon. Sabina and I rested, leaning our backs against the immense tree. Eventually we fell asleep. I woke to the sight of a dead monkey that Hamisi was dangling in my face. "Hamisi, stop it." He walked over and threw the monkey in the fire to char off its fur. I don't know if it was the sight of the burning monkey, but I instantly knew I had to go see Franz. While the men were eating the monkey meat, I walked through the oasis, through the many onion and vegetable fields, through Franz's flower fields. As I came up onto the small porch, Franz was there brushing off his pants, his face marred with dirt. The first thing he said when he saw me was, "Have you seen the little girl?"

I told him the story, and apologized for bringing the news.

"What are you apologizing for?"

"Franz, you have so many responsibilities on the farm, I don't want to bother you with this matter."

"Well, whose responsibility is it, James? I am not going to refuse helping the girl now because I am busy with 'things' that have no value compared to a child's life. Plus I have already spent time and money driving the girl and her father to Karatu, so she could have a rabies test and of course the hospital had no way of testing or medicine for rabies. If she has rabies, there is no

hope. I' ll take a shower and be right out. Put ten liters of diesel in the Land Cruiser."

On the way to pick up the child, a forty-minute drive to Endamaghay, Franz told me about his days working as an emergency driver in Albania. He had his cowboy hat on, his long knives attached to his belt, and was in a very pleasant mood.

"The Albanians are good people, strong. They were always asking to use my ambulance for their weddings. I said it was impossible, but if they called in an emergency I would be obligated to go. If by chance it was a false emergency, I would have no problem driving them back into town. So there were at least three calls a week. I was driving back into town in a flower-covered ambulance, which was filled with a bunch of happy Albanians. The men were shooting their Kalashnikovs out the windows. Thank God the organization never found out about these wedding runs."

When we made it to the Hadzabe camp, the little girl had been taken to the witch doctor's abode, which meant another forty minutes of driving on a terrible road into the bush. The car was overheating.

"Shit, there is a leak in the radiator. It's time to pray, James," said Franz.

After stopping twice to refill the radiator, we arrived at the witch doctor's home — a grass hut. I introduced the witch doctor to Franz, and asked the doctor if it was possible to take the child. The witch doctor looked relieved, saying he had done all he could. The doctor led us to the child resting in the shade, her mother and father sitting, watching over her. When Franz saw the little girl he rolled his eyes and said, "I don't think we have much time." The child's father picked up the girl delicately and wrapped her snug against his back with a blanket; the mother went to gather the other children and some food. When she returned, we all rushed back to the Toyota Land Cruiser.

"I am scared shitless, because if that child dies, it's our fault, and in Tanzania you have to pay to have a license to help people with your vehicle. Also, the witch doctor will blame us."

"Don't worry, Franz, the father said he understands that if God wants to take the child he will. The father knows the hospital is the child's last hope."

So we drove and prayed. I mean, I really prayed. And to pray like that was quite an experience. The horrid intuition of the evil in camp was washed away with the prayer passing through me. I felt the evil could not touch us now.

"Believe that we're on a mission from God, James, and maybe the child will survive," said Franz.

"I believe."

"I feel like we're the Blues Brothers," Franz exclaimed.

When the Land Cruiser finally did overheat there was no hope that the Toyota could make it to the hospital that night. The closest water source was ten kilometers away. Yet a truck driver came out of the bushes carrying a huge water can. He took one look at the girl and offered the water to us immediately. Franz quickly got out of the car and opened the hood. He thanked the man for the water and began pouring it into the radiator. The water was running out too quickly — the leaks in the radiator were disastrously large.

"James, this water will leak out in ten minutes," said Franz, wiping the sweat off his forehead with his arm, cowboy hat in hand.

Another man appeared on the road walking toward the Land Cruiser. He took a look at the radiator and said, "Pour these tea leaves in the radiator, they will expand and clog the hole. I will sell them to you." He handed Franz a small bag of tea leaves in exchange for some money, and turned back into the bush. "Thank you," said Franz, dumbfounded.

It worked! The car no longer overheated.

The child was looking very bad. She was struggling with the bumpy ride, the road was taking the last of her energy. Franz looked back and said, "Jesus, have mercy." The father placed his fingers on the child's face to make sure the child's eyes would still blink. She blinked.

Suddenly Franz's windshield cracked and started to come undone. We grabbed the windshield and held it in place, praying, hoping the tea leaves would continue to hold. I quickly handed Sindiko, the father, a medal of Pope John XXIII, telling him to hold the medal against the child. A crazy and dear older friend had given the medal to me in New York City. His name is Martin di Martino, and there is no one on earth like Martin. Martin was all about understanding what "God" is. He spent hours and hours telling me about the energy. When he returned from Italy, a few months before I left for Africa, he said, "I finally got it."

"Got what, Martin?" I asked.

"I have always wondered what my connection with Michelangelo was since I was a little kid. So I took this trip to try to understand it and spent days looking at Michelangelo's work.

"It's all in the lower stomach, the energy. No artist before, during, or since has shown this energy like Michelangelo. When we're young we have it, but just don't realize it. Lots of times when people get older, they lose it without knowing what it is. We want and worship this energy and all have it at some point, but we close ourselves off. In each part of Michelangelo's *David* you can see this energy. In the *Pietà*, every inch of the dead Christ portrays

this energy, which is eternal life. Even though he is dead, you can see the life in Christ's veins, which was the miracle of Michelangelo. This energy is why everyone is fascinated by dick."

"Martin, come on."

"No, really, listen. Let's face it, ninety-five percent of the people are fascinated with dick, the other five percent are angry. Try to buy a pair of sunglasses or anything, it's all about sex, sex, sex. It is this energy that excites us. Men give that energy out, woman bring that energy in. Together they make creation. People act as if God made a mistake when she-he-it made us sexual, but God did it. For instance, this energy that makes babies also makes people more and more beautiful as we approach death, if we accept this energy and the blind faith that it needs.

"Here, this medal is special, I want you to have it. I climbed over the balustrade to place the medal on the tomb of John XXIII. I mean what was the worst that could happen? They lock me up with those beautiful Swiss guards and their ballooned purple-and-yellow-striped trousers?

"The immune system begins in the mind," he would say. Twenty years with HIV and he never fell ill. I was hoping the medal would give this girl a portion of Martin's strength and passion for life, for she was barely holding on.

We made it to the hospital and quickly rushed the child to see the doctor. The mission hospital was in a town called Barazani founded by two Spanish fathers. It was small with twenty rooms rectangularly surrounding a dusty courtyard. A large flame tree grew in the middle of the space. The tree was in bloom and one of its orange petals landed on the child's forehead as we entered the courtyard.

I was disgusted with the doctors, who did not seem to feel the same urgency to save the child's life. I understood that they are confronted with these situations every day, but that was no excuse. Finally, a Spanish nurse entered the room and started the process.

I understood now why Sindiko had run off the first time, a few weeks earlier, when Franz had brought him and his child to the hospital. The doctors said the child must spend a couple days there, but Sindiko took the child out in the night. The hospital was a foreign and intimidating atmosphere to Sindiko. The nurses were rude, the doctors were rude, children everywhere screaming and crying, and families were sleeping in the courtyard.

The Spanish nurse explained to Sindiko that he could sleep in the room with the child, but the child must stay for at least a week or else she would die. I told Sindiko not to worry about money and food, everything would be taken care of. This time Sindiko knew, and his eyes filled with tears as he witnessed

the doctor uncaringly pick up his daughter to weigh her and drop her back on the bed. She let out a cry. Sindiko, quietly and a bit intimidated, walked over to the child and pulled her shirt back down and folded her arm hanging off the bed onto her chest as the doctor wrote down her weight. Sindiko passed his hand gently over her forehead and started to sing her a little song. This was the only time I ever saw a tear run down any grown Hadza's cheek. A bewildered look came over Sindiko's face; he was now in an arena he knew nothing of, but I think he intuitively sensed this was his child's last hope.

"I'll make sure everything is OK, I'll check in on the baby once a week when I deliver vegetables to the mission," Franz said as we got into his Land Cruiser to leave.

Before I left to go back into the bush, I had heard the baby's condition had stabilized, but they still weren't sure if she had septicemia of the blood or rabies.

When I returned from the bush four weeks later, I went to Franz's farm first, to hear some news about the child. His wife was crying when I walked onto the porch. I could see Franz through the window sitting on the couch looking at his lap.

"How can the world be so cruel?" she said, running into their bedroom and slamming the door.

"Sorry if I am disturbing you, Franz," I said outside the screen door.

He looked up at me. "You're not, come on in."

I sat down in their small living room. He went into the kitchen and returned with two beers.

"The child's back in the bush," he said, handing me a beer. "My wife went to the hospital today and is still very upset. She saw the child convulsing on the bed, just moving her jaw with the medal of that pope still on her chest. The doctors said it's best if the mother takes the child back to the bush to die, there is no hope, they're almost sure she has rabies. And Sindiko has disappeared. The nurses said thieves tricked him into helping them steal building material. The police came in from Karatu and arrested the thieves, they were looking for Sindiko, but of course could not find him; because, as you know, it's impossible to find any Hadza if they don't want to be found.

"For a while everything was looking good. Each time I visited the hospital Sindiko was always there by the child's side." Franz paused for a moment and took a sip of his beer. "My wife took the mother and the baby and dropped them off today near the Hadza camp. When the mother was getting out of the car, she asked my wife: 'What about the baby? I thought the hospital was supposed to help her?' My wife tried to explain the situation in Kiswahili. The

mother sadly understood, nodded her head, and walked off into the bush carrying the baby on her back. My wife is still upset with the whole ordeal. When you came in she was yelling at me for buying the beers. She said, 'Christ, Mary! That child is dying and you're buying beer!' Well, what the hell does she expect me to do, we can't help everyone. I have been running my ass all over the area trying to help that child! There is nothing one can do if she has rabies. By the way, you owe us a hundred dollars in hospital fees," he concluded, taking another sip of his beer.

I told Franz I would wire him the money once I had returned to the United States, and left.

The next morning I explained to the hunters that we had to buy food for the Hadzabe in Mang'ola as a parting gift. I didn't have much money left and was planning on leaving for Arusha within a few days. My plane was scheduled to go back to New York City; I needed to start the landscaping season.

We bought three goats, fifty kilograms of cow meat, and a hundred kilograms of *sembe* — ground-up corn. On the way to the Hadzabe camp to give the mamas the food, the hunters convinced me to stop at a *pombe* bar.

"Just one drink, then we're headed back," I said to them. Famous last words. We brought our supplies to Mzee Rhapheala's and sat under a small acacia tree, sending one of the younger men into the bar to order a bottle of *pombe kali* (the strong stuff). Soon after, the storytelling, singing, and dancing began.

In the afternoon Sindiko showed up. We had a long talk. He said he didn't steal anything. And that was the end of it.

"Can you take the child to the hospital in Arusha? I have heard it is better than the one here. She is very sick," he said.

"If the child has *ndudu wa mbwa*, insect of the dog, there is no hope. But I still will take your child to Arusha if you wish. If the child dies in Arusha I don't know if I can bring her back," I said.

"If God wants to take the child, God will," said Sindiko, who was soon singing and dancing with the others. The idea of Arusha gave him some hope.

In the late afternoon, all of us were philosophizing about how the lorry trucks were the vehicles of greed and future destruction. The trucks were the symbol of the growing onion agriculture business in Mang'ola, which meant more trees would be cut down and farms plowed. Around 5 P.M., I drunkenly attacked a lorry truck with my fists, and rushed into a *pombe* bar demanding to fight with all the drivers. Mama Ramadan was in the bar and settled me down — one of her boyfriends was a driver. I told the hunters to put away their arrows, and we went back to our original bar, playfully wrestling on the way.

In the early night, we made it to the Hadzabe camp above Mang'ola, shouting to the women and children that we had food. They ran up and helped us with our load. The meat, *pombe,* and the returning hunters created quite an excitement. We danced the entire night.

I woke at dawn, with children sleeping and sitting around me in a small Hadzabe hut. We finished the last of the honey Sabina had collected in the bush. "Don't tell Sabina," I warned the children. Sabina had spent the night with one of his girlfriends and would be angry if the honey he was planning on giving his wife was gone.

Later in the morning, Sindiko called me to come out of the little Hadzabe hut.

"Jemsi, please follow me," he said, looking very sad.

"What is wrong, Sindiko?" I asked.

"The child died last night."

Sindiko led me to a small stick shelter not too far from where we had danced all night. Sindiko sat down outside the hut and was quiet. I wasn't sure why he came to get me. The mother was just staring into the sky. There were some older women sitting with her, also silent.

"*Pole sana mama,* I am very sorry," I said to the mother. She slightly acknowledged me with a nod and kept staring off into the distance. Sindiko was looking at the ground.

I stood there for some time, thinking of a quote from Michelangelo that Martin had told me, "If life pleases us, death, being made by the hand of the same creator, should not displease us."

I left for the "big tree" camp soon after I saw the child. Later in the afternoon, Sabina arrived. He said, "The Swahili came today, they had heard about the child's death and wanted to bury it. We told them to leave the child alone, we would bury the baby, the Hadzabe way. They didn't listen to us, and took the child. Many of the Hadzabe are now moving the camp. They say evil has come to Mang'ola. Last night the town burned two thieves to death. They poured petrol over their heads and lit them on fire. The thieves were blamed for crushing a store owner's head with a pipe to steal twenty thousand shillings (forty dollars)," explained Sabina, rolling himself a cigarette. He leaned down and pulled out a coal to light his cigarette. When he was finished he threw the coal on the ground and blew onto his fingers to cool them.

"The bodies are still smoking in the street, do you want to go see them?"

"No, Sabina, I don't."

"One of the thieves was Peter, you know Peter — the man who is married to the Hadzabe woman in Endamaghay," continued Sabina.

"*Kweli,* is it true? He wouldn't steal anything. Why did they kill him?" I said, totally stunned. Peter was as gentle as they come, I had known him for four years. In the past, Peter had taken me to his father's farm many times when I was hungry to eat sweet potatoes dipped in fresh honey.

"They didn't kill the real thieves. I know who the thieves are. The thieves tricked the townspeople into killing Peter and another innocent man. One of the thieves didn't like Peter. Peter's father tried to save his son, but by the time he arrived it was too late. The Hadzabe also tried to save Peter but the townspeople would not listen to us. His father knows who the thieves are and will kill them."

"I can't believe it. *Shetani yupo,* the demon is here," I said.

"*Ndiyo,* yes, *shetani yupo,*" agreed Sabina. "It is good that you're going tomorrow. I will take my family far into the bush away from Mang'ola."

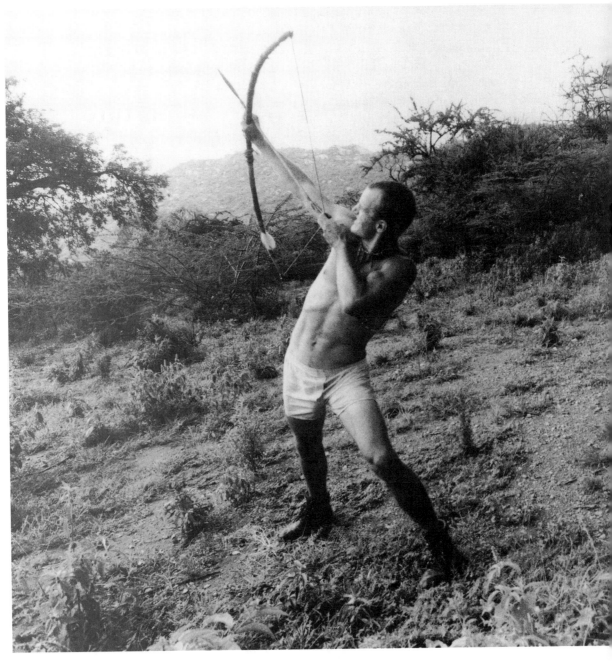

Dancing in the Dusk

10

Departure

The following morning I left for Arusha. Nubea, Sabina, Mustaffa, Sapo, Localla, and Sitoti all walked me to the *dala-dala,* an old Land Rover that would take me to Karatu where I would catch a bus to Arusha.

"We will see you soon, Jemsi," they said. As the Land Rover pulled away onto the main road, I waved to them and they all started to laugh. Sabina was jumping up and down, throwing both his hands into the air, then they began arguing over the clothes I left behind. Sitoti yanked out the shirt Sabina had between his arms and took off. Sabina immediately went running after him. The others turned around and walked back into the bush.

I returned to New York City, started building gardens, going to museums, eating at sushi bars, attending yoga classes, enjoying the western life. Yet somehow I was changed.

Often in the middle of the night, I wake speaking the few Hadza words I know, saying, "*Bocho, bocho,* come, come" to a little girl in the corner of my room, whose image always fades as I slip back into consciousness. I don't know if my relationship with the Hadza has done any good for them, I don't know if this book will hurt them or help them. I am not sure what I think anymore.

The last month I spent in the bush, while the girl was still alive, I believed the reason for going to Lake Eyasi, for finding myself there again and again, always searching, always waiting for something, leaving and needing to return — was simply to be there that morning to help that little girl. And I sometimes wonder if that was my reason for living. That in life there is one act, one crucial exertion of energy that transcends all others — a bridge is built for another to continue the life force. For never in my life have I ever felt so a part of everything, and thus, so good. Only in those hours with the girl have I ever been fortunate enough to feel the liberation of unconditional love. I would have given myself for that child to live. Is this the secret? Is this where the search ends and, thus, real living begins?

But I was powerless to save that little girl.

I always felt protected with the Hadzabe, as if a gossamer layer of magic energy surrounded us. I feel immensely fortunate to have been befriended by a people living in harmony with themselves and nature. To have experienced this harmony was the greatest lesson of my life. And when this harmony is gone, what else is there? Who else is there to learn from? Their way of life, I am afraid, will be destroyed. The oldest lineage of perception will disappear forever and merge into the grass and the trees, an entire dimension of time and space, touch, balance, existence; a language of the land, one of the last true human relationships with the land, will be extinct.

James Stephenson
1999

Epilogue

Sabina, what are you drawing?" I asked after he began his work. Sapo and Nubea both came over and sat next to the canvas. Sapo began fishing through the oil pastels.

"This elephant chased me one morning near Oldeani. I had to run, zigzagging through the trees," explained Sabina, pointing to the various images he had drawn. "I threw my shirt in the tree so the elephant would stop and smell it. It was a big bull elephant that wanted to kill me." Sabina then pointed to some green circles. "Long ago hunters made drums from stretched gazelle skins and would pound them to scare off a herd of elephants coming toward their camp. These circles are the drums."

Sapo began drawing a family of wild hunting dogs he saw one morning near Mongo wa Mono, pursuing an impala. Sabina drew a figure over one of Sapo's dogs.

"Sabina, who is that you're drawing?"

"Nudulungu."

"Sabina, what would have happened if we did not go alone on safari after the witch doctor told us to?" I asked. I had thought about the Mang'ati witch doctor during our morning trek.

"I do not know. Maybe we could have died or become sick if we did not go on the safari without the others. We are healthy and strong now, it was good that we went on the safari alone," he said while drawing the mountain of Nudulungu.

I joined Sabina and Sapo, drawing many suns around their figures, symbolizing what I had seen on the rock walls. Nubea also began to draw suns with arrows in the centers. Mustaffa was sleeping.

"Jemsi, who is that?" asked Sabina, pointing to the canvas an hour or so after we began.

"This is the old man who came to my dream, here are the berries he told me to eat in order to run fast like lion. This is the color of the sun when you and Sapo left to hunt the boar."

* * *

We painted about an hour every day during our longer safaris in the bush. Each of the hunters had his own style of painting. Nubea worked longer than the others, but then again it took him twenty minutes to pack his stone pipe with tobacco, and often a half hour to choose his colored crayon. Mustaffa could finish a complicated series of large images within ten minutes. Some days the hunters worked hours on the paintings, other days they would lay the canvas or paper out, look at it, then roll it back up.

The more the hunters painted, the more expressive and free they became in their use of colors and different paints. Sabina preferred using watercolors, Sitoti enjoyed acrylic paints, Nubea only drew with crayons, and Mustaffa used whatever was at hand. Sapo watched us paint for two months before he chose to participate. They were all particularly attracted to bright colors.

The hunters took great care of the paints, crayons, oil pastels, colored pencils, canvas, and paper. Each individual showed pride when carrying these materials on the safaris. Each hunter, child, and woman had his or her own style of painting. I never saw an image copied. The painted images illustrated another dimension to our journey, possibly a more realistic impression of the Hadza's perception and the interaction that occurred while I lived with them. By using this creative medium we established a deeper, more intuitive level of communication. Many times, when the hunters could not fully share their thoughts with me, they asked me to draw and paint with them.

I often wondered how much time had passed since the Hadza's ancestors had painted on the rock walls. What was the importance of painting to their ancestors? Why did they stop? The Hadza didn't seem to know the answer to these questions. It was clear that the Hadzabe no longer practiced a tradition of making images. They were, however, natural artists, at ease with this form; all onlookers seemed immediately to understand the story within the painting that the artist was sharing. Painting with the Hadza helped me understand the need to process and transform one's experiences through this creative medium. Their oral history found a form of expression through painting that communicated an experience on many levels of perception. A lengthy narrative does not have the same immediate power as the visual-cognitive impact of a painting.

In Zanzibar, Arusha, Karatu, and mostly in New York I continued to work on many of the paintings. When I returned to New York City, I lived in the basement of an old brownstone. I nailed these paintings to the stone walls, surrounding myself with the images. I spent weeks, months, and years on some of them. Painting helped ease the transition between these two radically

different environments and cultures. There was something I was trying to find by going further into these images. I often felt the land was communicating a message through the Hadza, a knowledge that could be grasped through the act of painting.

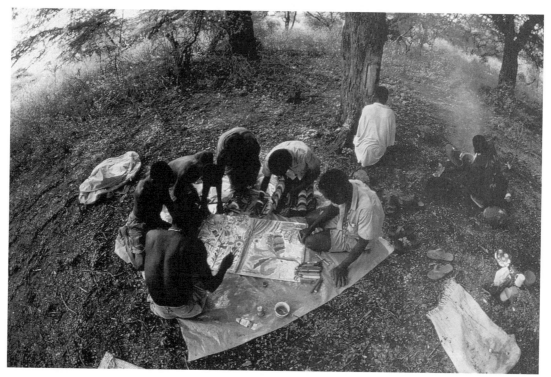

Hadza Hunters Painting

Portfolio

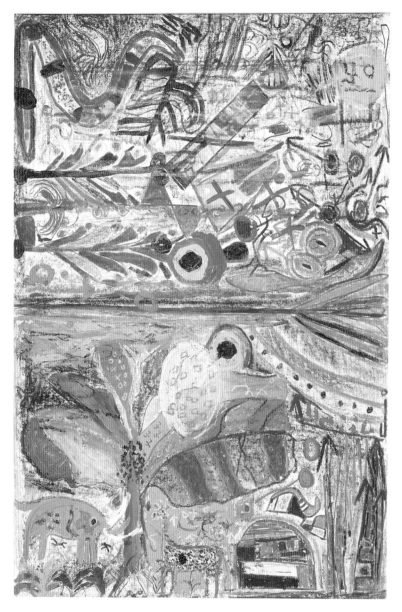

Moon and the Blue Elephant
Started in Mang'ola and finished in Zanzibar. The upper half of
the painting is the sky and the lower half is the oasis forest,
where a Hadzabe family, elephant, and giraffe live.
Mixed media on canvas, 36 x 23 inches.

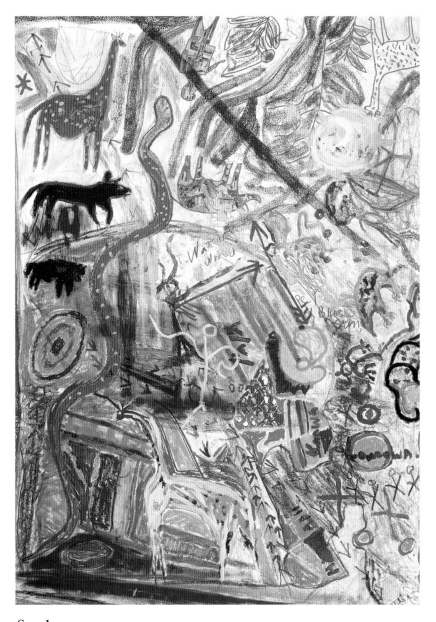

Sanola
Experiences on a safari to Sanola.
Mixed media on paper, 44 x 31 inches.

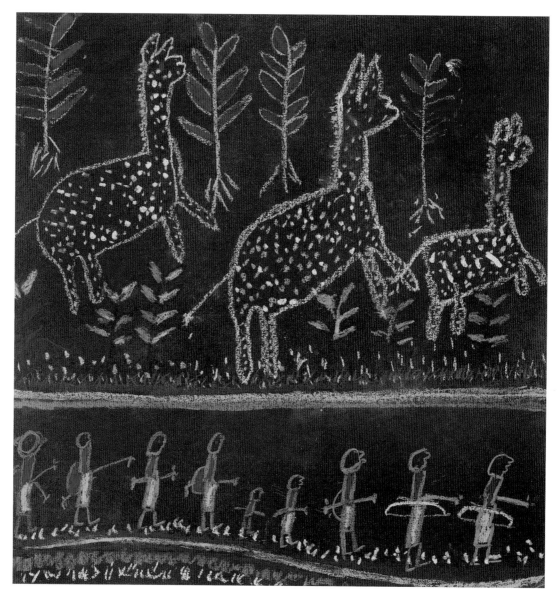

The Hadzabe Family

Sapo drew this painting in the oasis of Mang'ola. The painting depicts him and his family walking to a new camp. On the way they see a family of impala. In the lower right corner of the painting are women carrying babies on their backs.

Soft pastel on paper, 15 ¾ x 15 ¾ inches.

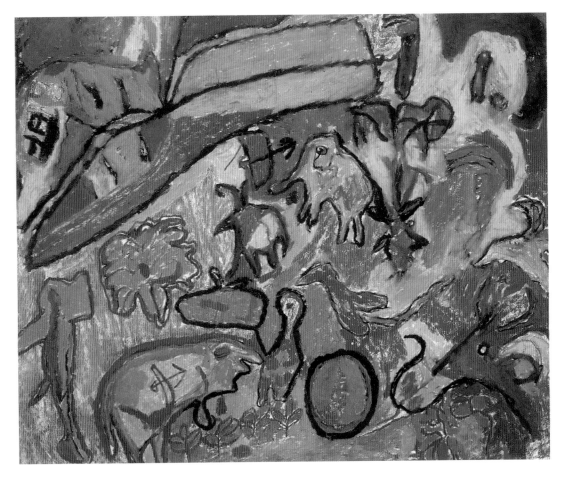

Giduye
A painting drawn by a Hadzabe named Giduye. The painting is a visual representation of a hunting trip in the bush.
Mixed media on paper, 28 ¼ x 35 ¼ inches.

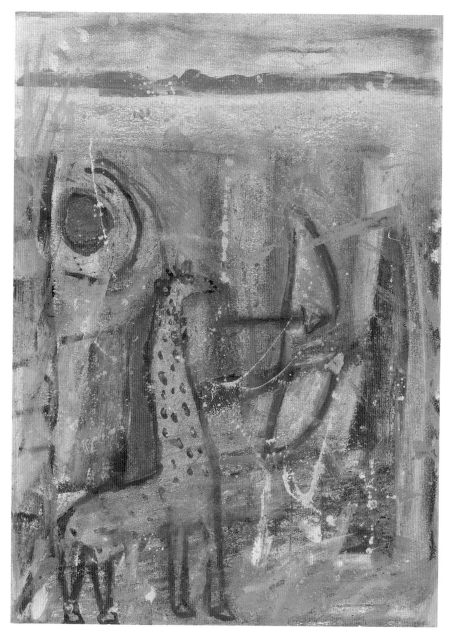

The Giraffe Hunter
Symbolizes the vision of a giraffe hunter.
Mixed media on paper, 14 x 10 inches.

Nudulungu
Drawn far in the bush on the safari to Nudulungu.
Mixed media on paper, 14 x 10 inches.

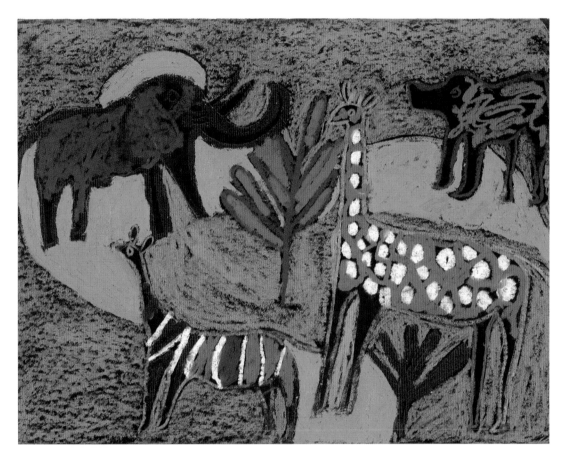

Sabina's Dream

Sabina woke up one morning and decided to paint. I asked him what he was painting and he stated, "My dream." In his dream he saw a baby giraffe, female *tandala*, elephant, and a baboon.

Oil pastel on canvas, 15 x 10 inches.

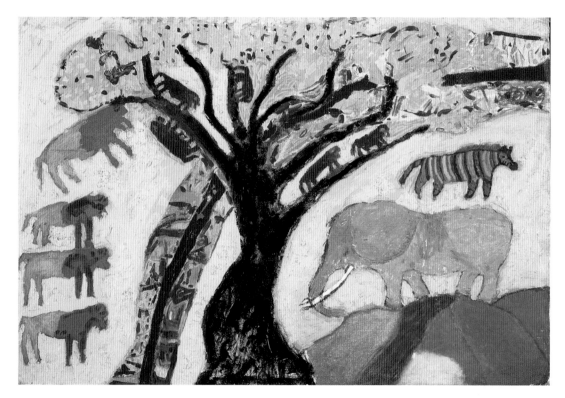

Mustaffa and the Rainbow

Mustaffa and I started this painting a few months before I left the bush in 1998. I finished it in New York City. One morning we were walking through the bush on a very hot day. Toward the end of the day it rained. After the rain we saw baboons returning to their tree. A rainbow formed in the horizon. A few years earlier Mustaffa had seen a hyena following an elephant near the same tree.

Mixed media on canvas, 36 x 23 inches.

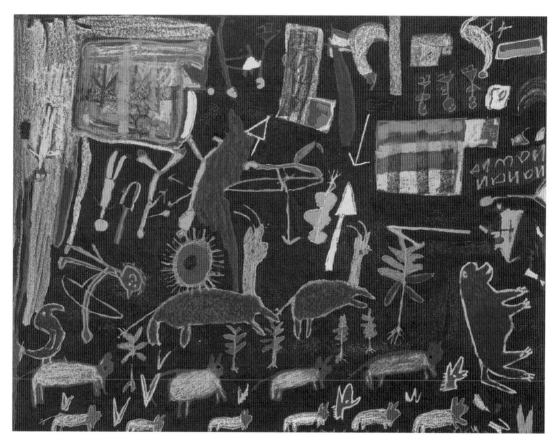

Red Demon and African Dogs
A collaborative painting worked on by Sabina, Sapo, and Jacobo. The painting was started in Mang'ola after the safari with Nubea and finished in New York City. On the bottom are African hunting dogs and *tandala*. The upper right-hand corner is a demon that Jacobo sees in his dreams.
Mixed media on canvas, 23 ½ x 31 ¼ inches.

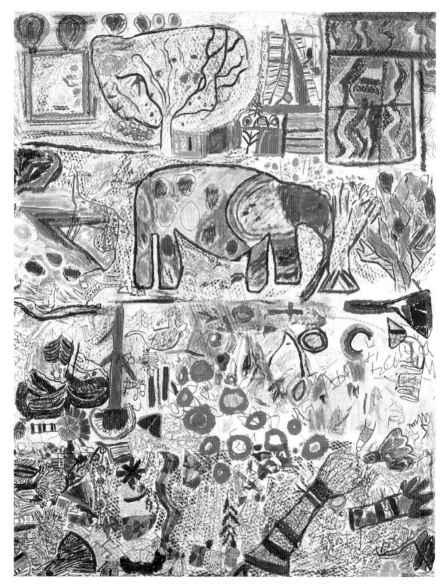

The Elephant That Almost Killed Sitoti
This was painted by Mustaffa, Sitoti, and myself in Endofridge.
Mixed media on canvas, 72 x 59 inches.

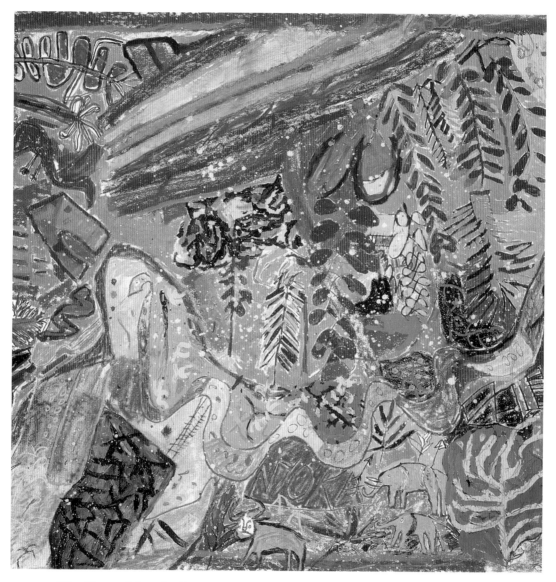

The Forest After the Rain

A collaborate painting that we began in the bush searching for Nudulungu. I finished the painting in Zanzibar. This painting portrays the life in the forest after the rains when the animals come out to feed.

Mixed media on paper, 36 x 40 inches.

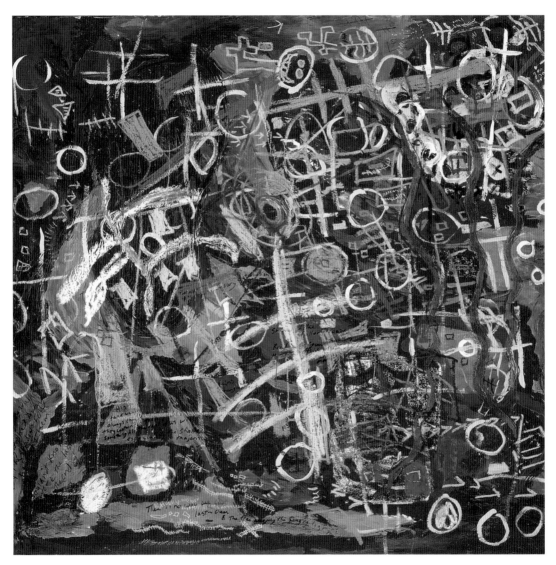

The Return to New York City

I started this painting with Nubea after seeing many of the rock paintings. I finished the painting the first week after I returned to New York City.

Mixed media on paper, 39 $\frac{1}{2}$ x 36 inches.